Painting Friends

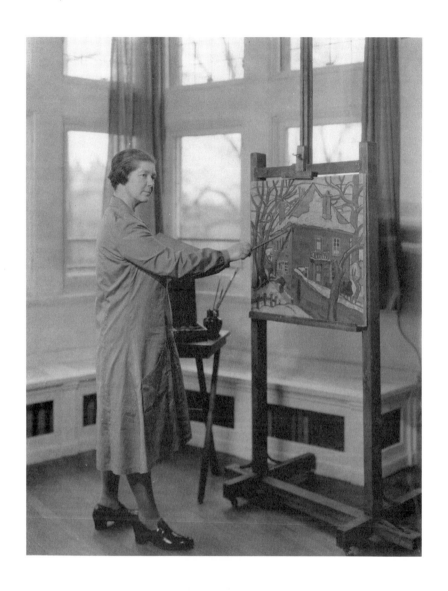

Ethel Seath at her easel in The Study art room.
Courtesty of Eric Klinkhoff.

Painting Friends

THE BEAVER HALL WOMEN PAINTERS

Barbara Meadowcroft

Véhicule Press

Véhicule Press gratefully acknowledges the support of The Canada Council
for the Arts for its publishing program.

Cover design: J.W. Stewart
Cover imaging: André Jacob
Front cover painting: *Autumn (or Girl with Apple)*
by Prudence Heward (1942)
Typeset in Perpetua by Simon Garamond
Scanning of colour painting: Caractéra
Printing: AGMV Marquis Inc.

01 00 99 3 2

Dépôt légal Bibliothèque nationale du Québec and
the National Library of Canada, third quarter 1999.

CANADIAN CATALOGUING IN PUBLICATION DATA

Barbara Meadowcroft, 1930-
Painting friends : the Beaver Hall women painters

(Dossier Québec series)
Includes index.
ISBN 1-55065-125-0

1. Women painters–Quebec (Province)–Montreal.
2. Painting, Canadian–Quebec (Province)–Montreal–History.
3. Painting, Modern–20th century–Quebec (Province)–
Montreal–History. I. Title. II. Series.

ND248.M43 1999 759.11 428 082 C99-900784-X

Published by Véhicule Press
www.vehiculepress.com

Distributed by GDS

Printed in Canada on alkaline paper

To the memory of my sister
Shirley Wales
painter, graphic artist,
and gifted pupil of Ethel Seath

*The author and publisher would like to thank the following
for their generous support in making this project possible.*

Dr. Richard M. Alway
Mrs. Lynda Gillmeister & Mr. Allan Case
Mr. John B. Claxton
Mr. and Mrs. F.A. Comper
Mr. Keith David
Dominion Gallery
Mr. Michael H. Dunn
Dr. and Mrs. Byrne D. Harper
Jim A. Hennok Ltd.
Mr. Alan Klinkhoff
Mr. Eric Klinkhoff
Mrs. Gertrude Klinkhoff
Mr. Gregory Latremoille
Mme Lucie Charbonneau & Mr. Gordon Lenko
Mrs. Mariitta Maavara & Mr. Michel Jaffré
Masters Gallery
Mr. David McCall
Mr. and Mrs. Carl Michailoff
Mr. Michel Moreault
Mr. A.K. Prakash
Mr. & Mrs. Fred Schaeffer
Mrs. Beth Rankin Smith
Senator and Mrs. John Lynch-Staunton
Mr. H. Heward Stikeman
Mrs. Shirley M. Stikeman
Mr. and Mrs. Donald R. Taylor
Mr. Chris Varley
The Wilk Family
Mr. and Mrs. Henry B. Yates

Contents

List of Colour Plates

PLATE 1
Henrietta Mabel May, *Yacht Racing*, 1914.

PLATE 2
Sarah Robertson, *Joseph and Marie-Louise*, c. 1930.

PLATE 3
Sarah Robertson, *The Red Sleigh*, c. 1924.

PLATE 4
Prudence Heward, *At the Theatre*, 1928.

PLATE 5
Lilias Torrance Newton, *Self-Portrait*, c. 1929.

PLATE 6
Emily Coonan, *The Blue Armchair*, c. 1930.

PLATE 7
Mabel May, *The Three Sisters*, c. 1915.

PLATE 8
Ethel Seath, *St. James's Cathedral from La Gauchetière Street* (renamed Mary Queen of the World Cathedral), c. 1925.

PLATE 9
Anne Savage, *Beaver Hall Square*, c. 1923.

PLATE 10
Ethel Seath, *The Canal, Montreal*, c. 1924.

PLATE 11
Kathleen Morris, *Market Day, Ottawa*, c. 1924.

Acknowledgements

One of the joys of writing this book has been meeting the families and colleagues of the Beaver Hall women, many of whom have become my friends. The families of all the painters have welcomed me into their homes, shared their recollections with me, and shown me their private collections of the women's work. Without their help this book would not have been possible.

I am particularly grateful to Naomi Jackson Groves and Anne McDougall for access to the Anne Savage/A.Y. Jackson correspondence and for their insight into the friendships that linked the Beaver Hall women.

I am also grateful to Isabel McLaughlin and members of the Heward family for access to a selection of Prudence Heward's letters to Isabel McLaughlin, and for their thoughtful comments on Heward's work. Forbes Newton and his wife Johanna drove to Niagara Falls to meet me, adding much to my understanding of Lilias Torrance Newton as a working mother. I am indebted to Marjorie Wellheisen for details of Nora Collyer's friendship with Margaret Reid.

My special thanks go to Anne Savage's former students—Tobie Steinhouse, Professor Leah Sherman, and Anne Hirsh—who helped me to appreciate Anne Savage's achievements as a teacher. Katharine Lamont, former headmistress of The Study, and Study Old Girls Margaret Gordon and Jill Crossen Sargent provided interesting details about Ethel Seath's teaching career.

The following have also provided help and encouragement: Richard Alway, Karen Antaki (Director of the Leonard & Bina Ellen Art Gallery),

Anna Brennan, Dr. Miriam Cooley, Dorothy Farr (Director of the Agnes Etherington Art Centre), Pepita Ferrari (Director of the film *By Woman's Hand*), Anne Goddard of the National Archives of Canada, Charles Hill (Curator of Canadian Art at the National Gallery of Canada), Norah McCullough, Joan Murray (Director of the Robert McLaughlin Gallery), the late Marian Dale Scott, and Frances K. Smith.

I would like to thank the Simone de Beauvoir Institute of Concordia University for providing an academic base during my work on this book. During research trips I enjoyed the hospitality of Ann and Claude Hannan in Ottawa, Patricia Morley in Manotick, Ontario, and Judy and Ian Campbell in Toronto.

I am particularly grateful to my friends Dr. Marianne G. Ainley, Ann Barr, Dr. Janice Helland, and Dr. Catherine MacKenzie, who read the manuscript and made many useful suggestions.

I must also thank my editor/publisher, Nancy Marrelli, and publisher, Simon Dardick, for their continuing help and for the confidence they have shown in this book.

Finally, I thank Eric Klinkhoff of the Walter Klinkhoff Gallery and all those who have contributed to the publication of this book. Without their help, *Painting Friends* could not have appeared.

Introduction

ONE BRIGHT SEPTEMBER DAY in 1987, I stood in the Walter Klinkhoff Gallery in Montreal, absorbed in a painting by Ethel Seath, *The Gardener's House* (c. 1930), that took me back to my school days. The old grey stone building it represented was the view from the art room of The Study, where Miss Seath had taught for forty-five years. Looking round at the works assembled for the Ethel Seath Retrospective, I realized what a fine painter she had been. In a few days the paintings would be taken down. And then what? Would she just be forgotten? I decided I could not let that happen, and I committed myself to finding out all I could about Ethel Seath and her world. After years of research and reflection, the result is this book on a remarkable group of painting friends.

Ethel Seath was one of ten women painters who came together in Montreal in the 1920s. The women were not a "group" in the art historian's sense of the word, but a network of friends who met at art school and formed ties that lasted all their lives. Their names are Nora Collyer (1898-1979), Emily Coonan (1885-1971), Prudence Heward (1896-1947), Mabel Lockerby (1882-1976), Mabel May (1877-1971), Kathleen Morris (1893-1986), Lilias Torrance Newton (1896-1980), Sarah Robertson (1891-1948), Anne Savage (1896-1971), and Ethel Seath (1879-1963).

In recent years, these painting friends have become known as the Beaver Hall Group.[1] The name is not strictly accurate, since only five of them belonged to the Beaver Hall Group, a society of male and female artists; so I prefer to call them the Beaver Hall *women*.

These artists began their careers at a time when there were few

professional women painters in Canada. By professional I mean a painter who trained at a recognized art school, exhibited regularly, and sold her work. Whether or not she earned a living from her art is not the deciding factor; many male and female artists have relied on jobs or private means to supplement their sales.

The Beaver Hall women were professional painters who played an active part in the Montreal art community. The older ones began exhibiting around 1912, and the younger ones after the First World War. Since Montreal had few private art galleries, painters were dependent on public galleries and on the annual exhibitions of private organizations. The Beaver Hall women exhibited regularly at the Spring Exhibitions of the Art Association of Montreal (AAM) and the annual shows of the Royal Canadian Academy (RCA). They took part in several Group of Seven shows, and when the Seven expanded to become the Canadian Group of Painters, Prudence Heward, Anne Savage, Sarah Robertson, Lilias Torrance Newton, and Mabel May were founding members.

The Beaver Hall women contributed to the British Empire Exhibition at Wembley, England (1924), the exhibition which led to the recognition of Canadian painting by European critics. Prudence Heward's painting *Rollande* was acclaimed in the United States, Australia, and South Africa, when it was shown in travelling exhibitions in 1930 and 1936.[2] Anne Savage and Sarah Robertson were singled out by the British critic W.G. Constable during the Coronation Exhibition (1937) in London, for their "largeness of conception and treatment, which gives everyday things new significance."[3]

The work of the Beaver Hall women was admired by fellow Canadian painters (particularly Arthur Lismer and A.Y. Jackson) and by art critics like Robert Ayre and Graham McInnes. Vincent Massey, one of the few private collectors to support Canadian artists in the 1930s, bought their paintings. The National Gallery of Canada (NGC) supported the women throughout their careers and held memorial exhibitions for Prudence Heward and Sarah Robertson in 1948 and 1951, respectively.

Despite these achievements, the place of the Beaver Hall women in

Canadian art history is uncertain. Robert Hubbard ignored them completely in his influential book, *The Development of Canadian Art* (1964). J. Russell Harper's *Painting in Canada: A History* (1977) draws attention to the "many outstanding women painters in this Montreal Group," and then dismisses them in three sentences. Dennis Reid names six of the women in *A Concise History of Canadian Painting* (2nd ed., 1988), but Prudence Heward is the only one he discusses at any length. The National Gallery, which has a large collection of Heward's paintings, seldom exhibits more than one work at a time. The same is true of the Montreal Museum of Fine Arts. Most Canadians could name the Group of Seven, but few people outside of Montreal have heard of Prudence Heward or Anne Savage. Why the discrepancy? Why is the Group of Seven so widely known and so well represented in Canadian art galleries while the Beaver Hall women are neglected? To find out about them and their work you have to hunt in out-of-print catalogues and the storerooms of museums.

In the late 1960s, the first wave of feminist art historians and curators began recovering the work of forgotten women artists. They found some of it attributed to male painters or catalogued as "school of" a master artist. Eleanor Tufts, Elsa Honig Fine, and others published overviews of women artists from antiquity to the twentieth century, and the works themselves were shown in Los Angeles, in 1976, at the exhibition *Women Artists, 1550-1950*.[4]

While the task of discovering and displaying women's art continues, scholars have been developing theories to explain the exclusion of women from art history. In the preface to *Old Mistresses: Women, Art and Ideology* (1981), Rozsika Parker and Griselda Pollock declare: "We need to understand the significance of that process by which art by women has been separated from the dominant definitions of what constitutes art, consigned to a special category, seen simply as homogeneous expressions of 'femininity.'"[5]

When the discipline of art history devloped in the 19th century, an ideology prevailed that described men and women as polar opposites. Women were associated with nature and domesticity, men with culture

and professionalism. The qualities attributed to the artist—genius, originality, and unconventionality—were considered incompatible with "femininity." According to a 19th-century writer: "So long as a woman refrains from *unsexing* herself by acquiring genius let her dabble in anything. The woman of genius does not exist but when she does she is a man."[6]

As women artists became more numerous after 1850, art critics and institutions tended to group them together as "lady artists," "female artists," or "paintresses."[7] While male artists were often the subject of two-volume biographies, women artists were usually discussed collectively, as in Ellen Clayton's *English Female Artists* (1876) and Clara Clement's *Women in the Fine Arts* (1904). This treatment reinforced the notion of women's art work as inherently different and separate from men's work. The tendencies in 20th-century art history to discuss painting in terms of schools with founding fathers, to concentrate on stylistic innovation, and to remove art from its social and political context, have all contributed to the continuing exclusion of women.

During the last thirty years, feminist writers and art curators have been reclaiming the work of Canadian women. The exhibitions *From Women's Eyes* (Kingston, 1975) and *Visions and Victories* (London, 1983), accompanied by excellent catalogues, and Maria Tippett's richly illustrated book *By a Lady* (1992), have testified to the quality of Canadian women artists.[8]

Interest in the Beaver Hall women was reawakened in 1966, when the National Gallery sponsored a travelling exhibition of their work. In 1975, paintings by five of these women were included in Charles Hill's important exhibition and catalogue *Canadian Painting in the Thirties* (NGC). Since then, retrospective exhibitions of several of the painters and the film *By Woman's Hand* (1994) have introduced Canadians to the rich legacy of the Beaver Hall women.[9] My involvement in the retrospectives of Mabel Lockerby (1989) and Sarah Robertson (1991) at the Walter Klinkhoff Gallery convinced me of the need for a book on these painters. At the same time, my reading of feminist theory alerted me to the

problems involved in trying to give value to women's work. In an important study of Victorian women painters, Deborah Cherry remarks that feminist social historians of art are turning their attention from individual works to examine the ways in which women are located within the art institutions and discourses of their time and place.[10] Following in this tradition, I have situated the Beaver Hall women in relation to the social and cultural institutions and practices of Montreal between 1920 and 1950.

"Friendship" is the underlying theme of the book. The alliances the Beaver Hall women formed at art school continued throughout their careers. They met frequently, particulary during the early years, offered critiques of each other's work, exchanged news of the art world, and encouraged each other to exhibit. Working within the male-dominated art world, the Beaver Hall women drew strength and confidence from their painting friends.

Chapter One

❦

Growing up in Montreal at the Turn of the Century

THE BEAVER HALL women were born in the last decades of the 19th century. The eldest, Mabel May, was born in 1877, just ten years after Confederation, while Nora Collyer, the youngest, was still a schoolgirl at the outbreak of the First World War. The painters were born in or near Montreal and spent most of their lives in that city. Except for Emily Coonan, an Irish Catholic, they belonged to the privileged Anglo-Protestant minority.

At the turn of the century, Montreal was the commercial capital of Canada. Its geographical position made it an important centre for the production and distribution of goods. Manufactured products from Britain came up the St. Lawrence River to be dispatched westward by rail, while the grain grown on the prairies was brought to Montreal for shipment to Britain.[1] The availability of water and power fostered the growth of industry, and cheap labour was provided by the newly landed immigrants.

Montreal's population was divided along ethnic and religious lines. The census of 1901 gives the city's population as 267,730, of which 60.9% was of French origin and 33.7% was British.[2] While the French Canadians were predominantly Roman Catholic, the English speakers were divided into Protestant (mostly Scots and English) and Catholic (mostly Irish), with a tiny minority of Jews. The city was further split by

the wide gap in living standards between the rich and poor. An 1897 report revealed that the mortality rates in the lower part of the city, a working-class area, were nearly twice as high as in the upper part.[3]

As Montreal became more industrialized in the 19th century, the middle class began to move away from the lower town with its factories and pollution, up the slopes of the mountain. The area favoured by the rich, known as the Square Mile, extended from Bleury Street in the East to Atwater in the West, and from La Gauchetière Street in the south to Mount Royal mountain.[4] Within these bounds were located the palatial mansions of the railway barons, Sir Hugh Allan and Sir William Van Horne, and the more modest houses of Montreal's businessmen.

At the turn of the century, residents of the Square Mile controlled approximately 70% of Canada's wealth.[5] Unlike the lower city with its ethnically mixed population (French Canadian, Irish, and British), the Square Mile was predominantly British, with the Scots outnumbering the English by more than four to one.[6] The British families formed what social historian Margaret Westley has called Montreal's Anglo-Protestant elite. As she shows in her book, *Remembrance of Grandeur*, the families of the Square Mile were linked by a network of business interests (the men serving as directors on each others' boards) and by family relationships: "nearly everyone was related to everyone else, by marriage or by blood."[7]

The Anglo-Protestant elite reflected the attitudes and values of the British middle-classes—including the assumption that they were socially and racially superior. Britain's exploitation of non-white peoples was justified by an imperialist ideology that saw British law and conversion to Christianity as gifts. Anglo-Protestant Montrealers, unlike the French and Irish Catholics, supported Britain's imperialist projects, such as the Boer War.

All of the Beaver Hall women, except Emily Coonan, belonged to this Anglo-Protestant elite. By the standards of the Square Mile, they were not spectacularly wealthy, but "comfortable," or (as in Ethel Seath's case) struggling. Six of the painters grew up in or near the Square Mile: Prudence Heward lived on University Street, Sarah Robertson and

Kathleen Morris in the area east of University Street, known today as the "McGill Ghetto," Mabel Lockerby on Mackay Street, Nora Collyer on Tupper Street, just west of Atwater, and Anne Savage (when not at the family farm) at the corner of Guy and Sherbrooke. Although there is no evidence that any of the painters met before art school, the families of these six probably knew, or knew of, one another. Anne Savage's father, John Savage (1840-1922), and Sarah Robertson's father, John Robertson (1840-1926), were members of the Victoria Rifles of Canada, and both families attended Knox-Crescent Presbyterian Church, of which John Savage was senior elder.[8]

Emily Coonan was an Irish Catholic, whose grandparents may have left Ireland during the potato famines of the 1840s. Her father, William Coonan (1850-1932), was a skilled machinist, who worked in the shops of the Grand Trunk Railway. Emily Coonan grew up in working-class Point St. Charles, where her family had lived for two generations. Her talent was encouraged by her mother, Mary Anne Fullerton Coonan (d. 1919) who made sure there was money set aside for Emily's art classes and her sister Eva's piano lessons.[9]

The other Beaver Hall painters were the daughters of businessmen. Arthur R.G. Heward (1860?-1912) was an executive of the Canadian Pacific Railway, while John Savage inherited his business, Albert Soaps, from his father.[10] Prudence Heward's and Anne Savage's families had been established in Canada for several generations. Prudence's grandfather, Chilion Jones (1835-1912), designed the original Parliament buildings in Ottawa. Anne Savage's maternal great-grandfather was John Galt (1779-1839), novelist and founder of Guelph, Ontario, and her great-uncle was Sir Alexander Galt (1817-1893), one of the Fathers of Confederation.

Sarah Robertson, Henrietta Mabel May, Nora Collyer, and Kathleen Morris were second-generation Canadians, whose fathers had come to Canada to make their fortunes. John Robertson left Scotland at the age of nineteen to join his brother's import business. By the time Sarah was born, he had his own commission house representing British firms.

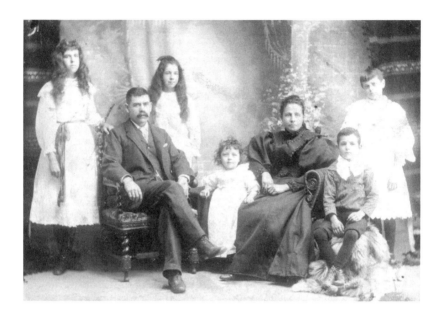

The Coonan family c. 1895.
From left: Daisy, William, Eva, Frank, Mary Anne Fullerton,
Thomas, and Emily.
Courtesy of Veronica Finn.

Edward May (1840-1916) started his career as a fitter for the Grand Trunk Railway, bought property in Verdun, and gave up his railway job to become a real-estate developer. By 1902, he was mayor of Verdun.[11] Mabel May's childhood was spent in Point St. Charles, where the Grand Trunk Railway had its sheds, and Verdun. She was in her early twenties when the family moved up the hill to Westmount.

Nora Collyer was the only one of the Beaver Hall women whose father went to university. Alfred Collyer (1872-1946) left England at sixteen. After graduating from McGill University, he joined the General Electric Company of Canada. Ambitious and hardworking, he formed his own firm in 1908, to manufacture electrical appliances.[12] Around the time of Nora's birth, the family moved to Tupper Street in Westmount, where they lived until 1916.

Ethel Seath's parents separated when she was in her late teens. Her father Alexander Seath (1848?-1924) was an importer of leather goods until 1899, when he went out of business. Anecdotal evidence suggests that he had a drinking problem, which led to the breakup of the marriage.[13] By 1900, Lizetta Annie Foulds Seath (1869-1951) and her five children were living on their own. Ethel Seath, the second child and eldest daughter, took courses in drawing and textile design, so that she could help support the family.

With the exception of Emily Coonan and Ethel Seath, the Beaver Hall women grew up in a comfortable middle-class world. Many of the families had summer cottages: the Savages had a cottage at Lake Wonish in the Laurentians, and a farm at Dorval; the Hewards had a large property at Fernbank, near Brockville, Ontario; the Robertsons had a house at Chambly, Quebec; and the Morris family had a cottage near Arnprior, Ontario.

For Sarah Robertson, Prudence Heward, and Anne Savage, these country holidays kindled a love of the outdoors, which they expressed in their paintings. As Anne Savage explained, "From earliest childhood I was always deeply impressed with the wonder of the country. . . . The beauty of growing things, from the bud to the scarlet leaf and finally the

bare branches, all held a mystery for me."[14]

It would be wrong to conclude, however, that the Beaver Hall women had idyllic childhoods. Very little is known about their early lives. Only Anne Savage has left us any recollections—and these were recorded many years later. Kathleen Morris had a congenital disorder of the nervous system that affected her speech and co-ordination. Prudence Heward was delicate, and may have already contracted the asthma that afflicted her as an adult. Lilias Torrance Newton's father died a month before she was born. How her mother Alice Stewart Torrance (d. 1926) managed to bring up her daughter and three sons is not known, but she may have had help from her family.

For most of the 19th century, women were excluded from higher education and the professions. They did not have the vote and played little part in public life. Feminist historians have suggested that an ideology of separate spheres for men and women was a powerful influence on middle-class society. Their arguments are based on the writings of unconventional women who complained of being excluded from public life, and on texts like John Ruskin's "Sesame and Lilies" (1864), which claimed that men's talents were suited to the public sphere and women's to the domestic.[15]

Canadian historian Alison Prentice and her co-authors argue that there was a "new and confining" ideal of domesticity in late 19th-century Canada. They point to the increased emphasis on women as mothers, medical concern about the effect of sport or intensive study on child-bearing, and the idealization of motherhood in the popular magazines. But how far did women conform to this restrictive idea of domesticity? Art historian Clarissa Campbell Orr suggests that the line between public and private may not have been as rigid as the metaphor "separate spheres" implies. She suggests that there was a social "borderland," whose boundaries women could extend or negotiate.[16]

The churches provided one such "borderland" for Canadian women. Acting through their local churches, middle-class women set up societies

to help immigrants and poor people, particularly young girls. Christian philanthropy, which was seen as an extension of women's domestic role, was endorsed even by moralists like the Reverend Robert Sedgewick, who believed that women's place was the home.[17]

In the late 19th century, women's voluntary organizations changed dramatically, as local units combined to form provincial and national networks.[18] In the 1870s, Baptists, Methodists, and Presbyterians formed female missionary societies, which raised money to train and support women missionaries throughout the world. Other national networks followed in the 1870s and 1880s, including the Woman's Christian Temperance Union (WCTU) and the Young Women's Christian Association (YWCA). These networks were a response to deteriorating social conditions, particularly urban poverty, alcoholism, and disease.

The work undertaken by the societies went far beyond traditional charity, as women became aware of the need for major reform. Convinced that alcohol was the cause of crime and family breakdown, the WCTU petitioned all levels of government to bring in prohibition, and in 1891 formally endorsed women's suffrage as a means to achieving this end.

WCTU members grounded their work in their Christian faith and in the widely-accepted belief in the moral superiority of women. By insisting that all their activities were undertaken in the interest of the home, to protect the home against the "licensed evil" (alcohol), women were able to stretch the boundaries of the domestic sphere to include their reformist mission.[19]

In October 1893, the National Council of Women of Canada (NCWC) was established to act as an advisory body for the hundreds of societies that had sprung up across the country. The immediate impetus for its formation was the meeting in Chicago of the International Council of Women, at which Lady Ishbel Aberdeen, wife of Canada's Governor-General, was elected president. In the interest of uniting as many women as possible, the NCWC adopted a non-sectarian position (unlike many of its specifically Protestant satellites) and moved slowly on contentious

issues like women's suffrage. The preamble to the 1894 constitution declared that "an organized movement of women will best conserve the highest good of the Family and State."[20] The rhetoric linking home and nation, the good of the Family and that of the State, served to legitimize women's intervention in a wide range of issues and institutions, since women could be seen as acting as guardians of the family.

The women of Montreal's English-speaking elite were deeply involved in what became known as the Club movement. They organized local branches of the YWCA and the WCTU and clubs to fulfil their cultural, educational, and athletic needs. The Victoria Armories were packed to the doors on 30 November 1893, for the inaugural meeting of the Montreal Council of Women.[21] This organization endorsed full political rights for women in 1909 and invited suffragists from England, including the militant Emmeline Pankhurst, to address Montreal women. In 1913, the Montreal Suffrage Association was founded to keep up the pressure on the federal and provincial governments.[22]

The NCWC worked to improve the legal status of women within marriage. By 1900, most English-speaking provinces had introduced the Married Women's Property Acts, giving wives control of their personal property and earnings. In Quebec, however, married women were deprived by law of the "exercise of every civil right except that of making a will."[23] The NCWC also played a role in the adoption of the 1925 Divorce Law, which allowed women to obtain a divorce on the same grounds as men—namely, adultery by a spouse—and in new provincial laws that recognized women as equal guardians of their children.[24]

The issue of women's political and legal status was part of a larger debate on women's role in society that continued into the 1920s. Toronto professor Goldwin Smith argued in 1872 that politics should not be within women's sphere, while humorist Stephen Leacock claimed in 1916 that the vote was unnecessary since women's chief role was motherhood.[25]

As girls and young women, the Beaver Hall painters would have seen discussions of the "woman question" in the Montreal newspapers and may even have heard it debated at the table. A friend of the Morris

family reports that Kathleen's mother, Eliza Howard Bell Morris (1862-1949), used to argue vehemently with her husband over women's rights, turning every meal into a battleground.[26] Anne Savage may have heard similar arguments from her eldest half-sister, Lilias Savage VanKirk, who was considered a "militant suffragette."

Until the late 19th century, most middle-class, Anglo-Protestant girls were educated by governesses or in private schools. In 1875, the High School for Girls was established by the Montreal Protestant Board of School Commissioners. This school, which charged substantial fees, prepared girls for domestic life and university entrance.[27] Cooking and sewing were taught, as well as academic subjects. Anne Savage attended the school for eleven years. She led the class in drawing and excelled in history, literature, and physics. In 1914, she took her McGill School Certificate, but failed the art exam, which was set by a McGill architect. Although she later made light of this failure, it must have been a severe disappointment to a young woman who wanted to be a painter.[28]

Nora Collyer attended Trafalgar School, a private girls' school, from 1910 until her graduation in 1917. Trafalgar School had opened in 1887, three years after McGill admitted its first women students. The curriculum was designed to prepare girls for higher education, although only a small minority actually went on to university. Nora Collyer, an only child until the age of 12, and very shy, benefited from the small classes and intimate atmosphere of a private school. Two girls whom she met there, Margaret Taylor and Jane Speir, became her lifelong friends.

Lilias Torrance Newton's education was interrupted by the frequent moves of her widowed mother. Lilias spent two years in a Kingston public school and two years at a private school in Lachine, before becoming a boarder at Miss Edgar's and Miss Cramp's School in Montreal.[29] Although she did well during her three years at Miss Edgar's, 1910 to 1913, she left school at sixteen to study art full-time.

Anne Savage and Nora Collyer were the only Beaver Hall painters who completed their secondary education. Emily Coonan attended St. Ann's Academy for Girls, a Catholic elementary school in Point St.

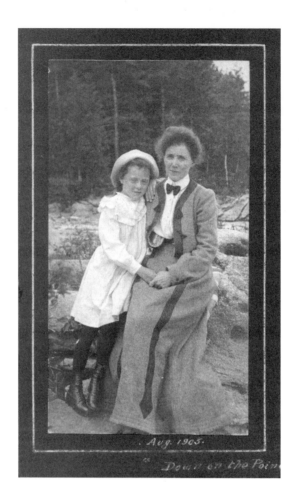

Kathleen and Eliza Morris at Marshall's Bay, near
Arnprior, Ontario, August 1905.
Courtesy of Greta Stethem.

Charles. The others were probably educated at home or in one of the many small private schools, known as Dame Schools. Kathleen Morris went to the Misses Gardiner's private school, but it is not known for how long. Sarah Robertson and her sisters were brought up by a governess and may not have gone to school at all. Although Prudence Heward's younger sister, Honor, attended Trafalgar School, Prudence did not, possibly because of her poor health.

Canadian universities gradually began to accept women for partial studies in the 1860s.[30] Many educationists were opposed to admitting women to degree courses, arguing that women's health would be damaged by the strain of competitive examinations, or that higher education would make women unfit (or less willing) to marry. Others supported higher education for women but in separate classes or institutions. In 1884, McGill accepted an offer of $50,000 from entrepreneur Donald Smith to endow a college for women. The endowment stipulated separate classes for women, and during the first decades separate education was the norm, at least in the junior years.[31]

Professional opportunities for women were opening up in the last decades of the 19th century. Teaching and nursing, traditional occupations for women, acquired professional status with the establishment of standards and training institutions. By 1900, six Montreal hospitals, including the Montreal General and the Royal Victoria, had established nursing schools. The McGill Normal School, founded in 1857, trained teachers, predominantly women, for the English-Protestant public schools. But women teachers were paid less than men (sometimes only one-third the salary of men), and had little chance of promotion.[32]

Anne Savage had two models of successful professional women in her family: her mother, Helen Galt Savage (1857-1942), taught at the Normal School in Fredericton, New Brunswick, before her marriage, and her half-sister, Lilias Savage VanKirk (b. 1871), trained as a nurse and became Head Nurse at New York's Mount Sinai Hospital.

In 1900, a few Canadian women were practicing medicine, most of whom had qualified in Ontario or abroad.[33] Although Clara Brett Martin

began practicing Law in Ontario in 1897, women were excluded from the Quebec Bar until 1941.[34] Other professions open to women at the turn of the century included pharmacy, journalism, clerical work, photography, painting, and other branches of the arts.

To become professional painters, women needed access to advanced training, professional associations, and employment. History painting, the most prestigious genre in the 19th century, required the study of anatomy and life drawing. But the institutions that provided this type of training, like the Royal Academy, excluded women. The idea of women drawing from the nude (male or female) contravened patriarchal concepts of femininity and propriety.[35]

Before 1850, many of the women who became professional painters belonged to artist-families and learned in their fathers' studios. By the mid-19th century, women were attending private art schools and organizing their own classes, while campaigning for admission to the Royal Academy schools.[36] Even after admission was granted in 1860, women were excluded from life classes. Finally, the Slade School of Art, which opened in London in 1871, made life study available to women, but in segregated classes.

Canadian women began to attend European art schools in the late 19th century. Sophie Pemberton (1869-1959) of Victoria, British Columbia, studied at the Slade School in the early 1890s, and Emily Carr (1871-1945), also from Victoria, enrolled in the Westminster School of Art in 1899. Two Ontario women, Laura Muntz Lyall (1860-1930) and Elizabeth Armstrong Forbes (1859-1912), studied at the South Kensington School of Art in London in the 1880s.[37] Some Canadian women chose to study in Paris, where there was a community of British and American women students, and where individuality was encouraged more than in British schools.[38] Although the prestigious École des Beaux Arts excluded women until almost the end of the century, other schools set up "ladies' classes," usually at inflated prices. The instruction was often minimal, but the women profited from discussing their work with each other and from visiting galleries and artists' studios.

Many of the female contributors to the 1895 Spring Exhibition of the Art Association of Montreal had studied in Paris, including: Florence Carlyle (1864-1923), Margaret Houghton, Etta Watts, Mary Hiester Reid (1854-1921), Mary Bell Eastlake (1864-1951), and Sophie Pemberton. Florence Carlyle's painting *La Vieille Victorine*, of an old woman who had posed for Millet's *Angelus*, had been exhibited at the Paris Salon the previous year.[39]

Canadian women also attended art schools in the United States. Mary Ella Dignam (1860-1938), Mary Bell Eastlake, Elizabeth Armstrong Forbes (1859-1912), and Mary Phillips (1856-1937) studied at the Art Students' League in New York.

In 1886, a number of Toronto women, under the leadership of Mary Ella Dignam, formed a club for the study and practice of art. They found studio space, hired models, painted together, and critiqued each other's work.[40] In 1890, this club became the Women's Art Association of Canada (WAAC), which, by 1900, had established branches in seven other cities, including Montreal. Besides encouraging the practice of painting, the WAAC organized lectures, held competitions, and sponsored art exhibitions.

The Montreal branch of the WAAC, later known as the Women's Art Society (WAS), was the idea of Mary Phillips, founder and principal of the Montreal School of Art and Applied Design.[41] Established in 1894 to provide support for professional artists, the WAS also aimed to encourage amateurs and improve public taste. Within a few years, however, its priorities were reversed, and its primary activity became promoting art and handicrafts. In a recent thesis, Heather Haskins suggests that similar transformations took place in many women's arts clubs at this time, since it was considered more acceptable for "ladies" to support culture than to develop their own talents.[42]

In May 1896, the WAS held an exhibition of Canadian and American women painters, at the request of its parent organization, the WAAC. According to Mary Phillips, the Montreal branch was divided about the desirability of large exhibitions of women's work. "Our own best women

artists [held] strongly the opinion that a work of art should stand or fall on its own merits and should not be labelled by the sex of the artist."[43] The dissenters in the WAS feared that all-women shows would merely encourage critics to see women's work as inherently different from men's.

Some turn-of-the-century critics argued that a woman's painting should reflect her "femininity." A reviewer in the prestigious London *Studio* praised the work of the Canadian painter Elizabeth Armstrong Forbes for its "womanly" qualities, saying: "The charm of womanliness in art has not been appreciated by the gifted fair, so they have wasted their time and impaired their talents by attempting to be manly."[44]

Women's art clubs and large exhibitions of women's work were an attempt by female artists to compensate for being excluded from, or marginalized within, traditional art associations. Although women painters were admitted to some Canadian professional societies, it was usually on special terms. The Ontario Society of Artists (OSA), incorporated in 1872, accepted women as exhibiting members, but denied them any power within the organization. Similarly, the Royal Canadian Academy (RCA), founded in 1880, accepted women members, but did not allow them to attend business meetings or sit on the Council.[45] Only one woman member, Charlotte Schreiber, and nineteen associate members, were elected in the first 53 years of the Academy's existence. Considering that the RCA had nine women associates in 1900, when there were relatively few female artists, it would appear that the RCA became more reluctant to admit women artists as their numbers increased.

Besides the professional societies, there were clubs like Montreal's Pen and Pencil Club, established in 1890, where male artists met for informal discussion. The founders of the WAS recognized the benefits of such clubs. Speaking at the WAS's inaugural meeting, Mrs. A. Carus-Wilson claimed that the WAS would "do for *women* artists what the Pen and Pencil Club is already doing for men artists in Montreal."[46]

It was difficult for artists, male or female, to make a living in 19th-century Canada. There were very few galleries, private or public. The

National Gallery, founded in 1880, depended on gifts and bequests and had little money for acquisitions. The only large exhibitions were the annual shows of the Royal Canadian Academy (RCA), beginning in 1880, and the Spring Exhibitions of the Art Association of Montreal (AAM), from 1879. Women found it easier to gain access to the Spring Exhibitions of the AAM than to the shows of the RCA, which gave priority to its members. A review of the Spring Exhibition of 1895 (*Montreal Star* 7 March 1895) singles out seven women painters for special mention, including Mary Hiester Reid and Mary Bell Eastlake. Women sometimes exhibited together; the WAS, for example, held small shows in its studio. They bought one another's works, and some may have found female sponsors. The same review in the *Montreal Star* mentions the interest that Lady Dufferin was taking in Florence Carlyle.

One field in which women had some success was illustration. Agnes Moodie Fitzgibbon illustrated several books on flowers, including *Canadian Wild Flowers* (1868) by her aunt, Catharine Parr Traill.[47] It was more difficult, however, for women to break into the male world of newspaper illustration. Ethel Seath, who worked for the *Montreal Star*, was the only female contributor to an exhibition at the AAM organized by the Newspaper Artists' Association in 1903.

Some women painters worked as art teachers in girls' schools or gave private lessons in their studios. The list of art institutions compiled by Mary Ella Dignam for *Women of Canada* (1900) names four schools founded and conducted by women (including Mary Phillips' school in Montreal), and several others that employed women teachers. The more prestigious institutions, like the Ontario School of Art and the AAM, rarely employed women, and when they did, it was at the lower levels. For example, Alberta Cleland (1876-1960) taught the elementary classes at the AAM school from 1898 to 1939.

Very little has been written on Canada's early women painters, apart from a chapter in Maria Tippett's book, *By a Lady*, and some useful catalogues and M.A. theses. Existing information suggests that the first generation of French-speaking professional women painters did not

emerge until the 1930s, after the opening of the École des Beaux Arts in Quebec (1922) and Montreal (1923).[48] More research is needed on early women painters, French and English, on the contexts in which they worked, and the critical reception of their painting.

The Beaver Hall women, growing up in Montreal, had little opportunity to view the work of women painters. They would have seen women's work at the AAM Spring Exhibitions and the RCA shows. But they would have found few, if any, paintings by women in the AAM's small permanent collection or in the exhibitions of art from private collections sponsored by the AAM. An inventory of 19th-century European paintings in Montreal collections between 1880 and 1920 cites 1,388 works, of which 15 are by women.[49]

Several of the Beaver Hall women had artists in their families who served as role models. Prudence Heward's grandmother, Eliza Maria Hervey Jones, who published a book on dairy farming, wrote and drew.[50] Prudence's mother, Efa Jones Heward, had artistic skills, as did her older sister, Dorothy, who studied at the AAM school.

Anne Savage credits her aunt, Minnie Clark, with awakening her desire to paint and teaching her to look at everything with a view to "doing it." As a child of six, Anne watched her aunt sketching the maple trees outlined in snow and said, "When I grow up, I'm going to be an artist." Her aunt encouraged her, saying, "You can, but you must remember that you mustn't give in."[51]

Lilias Torrance Newton and Kathleen Morris were inspired by male family members. Lilias's father, Forbes Torrance, had been an amateur artist and a founding member of Montreal's Pen and Pencil Club. When Lilias broke her leg at the age of ten, she whiled away her convalescence by drawing and studying the sketchbooks left by the father she had never known.[52]

Kathleen Morris spent three months in the household of portrait painter Robert Harris, her mother's cousin. Harris made a sketch of the seven-year-old Kathleen, bare legs dangling from a straight-backed chair, and encouraged her to draw. Writing to his wife from Toronto, he said,

"Tell Kathleen to have a fine picture of me done by the time I get back."[53] Once awakened, Kathleen Morris's interest in art, like Lilias Torrance Newton's, was encouraged by a sympathetic mother.

Anne Savage, Lilias Torrance Newton, and Kathleen Morris began drawing early, as did many of their contemporaries. Drawing was part of a young lady's education at the turn of the century. But few women became artists. Most painted for their own enjoyment, like Anne Savage's Aunt Minnie, or used their talents for the benefit of their family, like Efa Heward. The Beaver Hall women wanted more. They wanted to be professional artists. To fulfill that dream would take years of study and hard work.

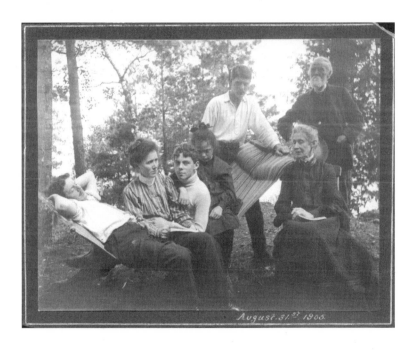

Morris family at Marshall's Bay, August, 1905.
From left: Alfred Morris, Eliza Bell Morris,
Harold Morris, Kathleen Morris, James Morris,
Kate Bell, and James Bell.
Courtesy of Greta Stethem.

Chapter Two

Coming Together

ALL OF THE BEAVER HALL women attended the Art Association of Montreal (AAM) school at some time between 1902 and 1924. It was there that they received their professional training and formed the friendships that were to nourish them throughout their lives.

The AAM, now known as the Montreal Museum of Fine Arts (MMFA), was founded by Anglo-Protestant businessmen and incorporated on 23 April 1860.[1] It aimed to raise public taste through loan exhibitions, build up a collection of its own, and give instruction in the fine arts. Exhibitions were held in rented space until 1879, when the AAM moved into its new building on Phillips Square.

The AAM school opened in October 1879. From the beginning, female students were in the majority, partly because men had other options. The RCA, for example, offered free classes in life drawing, to men only. The AAM charged substantial fees, $40 a year, and attracted mainly middle-class students.

After an uncertain beginning, the school was transformed by the arrival of William Brymner (1855-1925), who became director in 1886. Having trained at the Académie Julian under William Bouguereau and Tony Robert-Fleury, Brymner modelled his own school on the Parisian academies.[2] For 35 years, he divided his energy between teaching and painting. Believing that a thorough study of form would benefit all students, whether they intended to practice art or not, he designed his classes to "fit pupils, should they so decide, to become professional artists."[3]

In the early 1900s, when the Beaver Hall women began to arrive, the school had a structured programme. Brymner taught the Advanced section, which included the Antique, Life, and Afternoon Painting classes, while Alberta Cleland (1876-1960), his former pupil, took charge of the beginners.[4] Classroom space was barely adequate until 1912, when the AAM moved to the present site of the MMFA on Sherbrooke Street West. The neo-classical building, designed by Edward and William S. Maxwell, accommodated the school in two large, well-lit studios on the top floor.

Mabel Lockerby and Mabel May, the first of the Beaver Hall women to enrol, arrived about 1902.[5] Mabel May was in her mid-twenties, having postponed her studies to help her mother with the younger children. Both she and Mabel Lockerby were over thirty when they first exhibited at the AAM Spring Exhibition—a fact they attempted to conceal. Mabel Lockerby shaved five years off her age and Mabel May seven.[6]

Emily Coonan and Ethel Seath began their training at the Province of Quebec's Conseil des Arts et Manufactures (CAM). The CAM was set up by the Quebec government in 1872 to train an elite work force. Its schools, which were free, emphasized drawing, but included carpentry, shoe-making, and other crafts. Women were excluded in the early years, on the grounds that the courses were intended to improve Quebec's industries, not to provide instruction in fine art.[7] Before the end of the century, however, the CAM admitted women and gradually introduced courses like painting, which had no industrial application.

In 1895, the CAM moved into the Monument National, the imposing new French-Canadian cultural centre. It was here that Emily Coonan and Ethel Seath attended classes in the late 1890s. The school had improved greatly after French-born painter Edmond Dyonnet (1859-1954) took charge of the drawing class in 1893. He threw out the drawing books with their "ready-made" images and forced the students to draw from three-dimensional objects.[8]

Emily Coonan transferred to the AAM school in about 1905—a bold step for a young woman from Point St. Charles, and one that reflects

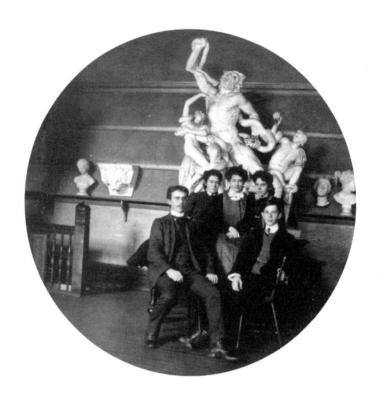

Students in the Antique class of the Art Association
of Montreal in 1903. Mabel Lockerby is in the
back row at right.
Courtesy of Gwen Floud.

her determination to be a professional painter. The fees must have been a considerable burden for her family, at least until 1907, when she was awarded a year's free tuition. Ethel Seath studied drawing at the CAM with Edmond Dyonnet and lithography with Robert Harris. Only after she had established herself as a newspaper illustrator could she afford to attend classes at the AAM.

Kathleen Morris, Lilias Torrance Newton, Prudence Heward, and Nora Collyer began their training as young girls, entering the Elementary classes between 1906 and 1910. These classes were held in the late afternoon for the benefit of those who attended regular school. Lilias Torrance Newton was only twelve when she enrolled in Alberta Cleland's class, commuting from her mother's home in Lachine. Anne Savage, who was eighteen, went directly into the Advanced section because of the excellent teaching she had received from Ada James at the High School for Girls.

All of the Beaver Hall women, except Ethel Seath, spent at least five years at the AAM school. Mabel Lockerby studied from 1902-11, and possibly longer. A sketch of Lockerby (in tailored blouse and large feathered hat), dated 26 January 1913, by fellow student Nina May Owens, suggests that Lockerby was still at the school in 1913.[9] Sarah Robertson, who entered the school about 1909, was still there in 1924. Although ten years of training was considered normal for a painter, it was unusual for students to stay that long at one institution. Male students, like Randolph Hewton (1888-1960) and Edwin Holgate (1892-1977), left for Paris after only a year or two with Brymner. Because of family circumstances, many of the Beaver Hall women did not have the option of studying abroad. A shortage of money and domineering parents made it difficult for Sarah Robertson to travel even to Toronto, unless she was staying with friends. Prudence Heward, who could afford to study in Europe, did not go until after the AAM closed its Advanced classes in 1924.

Staying on at the school provided the Beaver Hall women with a place to work and models to work from. Scholarships and prizes helped

them pay their fees. All the women (except Ethel Seath and Kathleen Morris) benefited from at least one scholarship. Sarah Robertson won the Women's Art Society Scholarship (worth a year's tuition) in 1919 and 1923 and shared the Kenneth R. Macpherson prize for the best painting in 1920.[10] As William Brymner pointed out in his Annual Report for 1919, the scholarships "keep good pupils in the Class who serve as a stimulant to those not so advanced."

The encouragement of their teachers and fellow students was a welcome antidote to the frequent belittlement of women painters by art historians and critics. In 1912, a writer reviewing the AAM Spring Exhibition referred to "a little coterie of young women artists in our art school which is producing work of much quaintness and originality."[11] Citing Emily Coonan and Mabel May among others, he added, "their work makes pleasant bits of colour about the walls."

Many conservative writers and educators continued to regard women artists as dilettantes. When the provincial government established Montreal's École des Beaux Arts in 1923, it was with the understanding that the men would train to be artists, while the women would use their training for the benefit of their families.[12] In 1929, Jori Smith, the most promising student in her class, was overlooked for the École's travelling scholarship. As justification, the Director said that they could not use government funds to sponsor a woman who would probably abandon painting when she married.[13]

The AAM school was in many ways a protected space. Its high percentage of female students encouraged women to see painting as a normal activity for them. The school was small: the Advanced class usually numbered between 26 and 36, while the total enrolment varied from 60 in 1904, to about 100 in 1920. The atmosphere may have been rather exclusive, however, due to the many upper-middle-class students. Jori Smith, whose father was a self-made businessman, attended the school in 1924. She later said she felt poorly dressed and uncultivated compared to the other students. Emily Coonan may also have felt disadvantaged. Unlike the other Beaver Hall women, she did not make any lasting

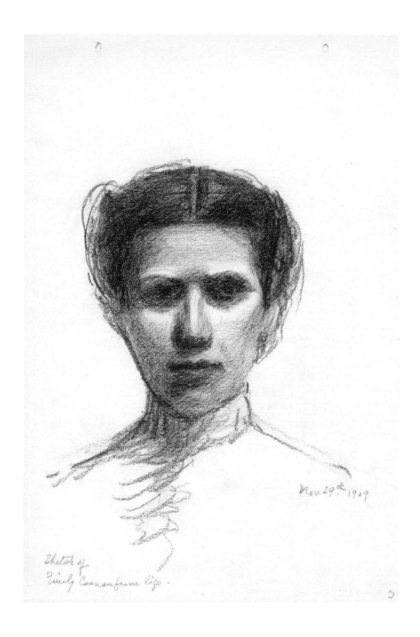

Nina M. Owens, *Sketch of Emily Coonan*, lead pencil on paper,
29 November 1909.
Courtesy of Margaret N. Owens.

Nina M. Owens, *Miss May*, lead pencil on paper,
6 March 1911.
Courtesy of Margaret N. Owens.

friendships among her fellow students. But it is hard to say how much her isolation was due to class difference and how much to her personality. According to Lilias Torrance Newton, Emily Coonan was "a very odd, shy, strange person … a real loner."[14]

The AAM school provided the women with a rigorous training in drawing, which Brymner considered "the foundation of all the graphic and plastic arts."[15] Students in the Elementary classes learned to draw simple three-dimensional shapes (cubes, spheres, cylinders) before tackling the human form. "The day the class got a plaster cast of a human ear was a day of great excitement," according to Marian Dale Scott, who was at the school in about 1918.[16] Students in the Antique class drew from casts of Greek sculpture, finally progresssing to the Life class, where they drew from a live model.

Many European art schools, including the Slade and the Académie Julian, provided separate Life classes for women. But the Life classes at the AAM do not appear to have been segregated, probably because there were so few male students. Instead, a semi-nude model was provided. Mabel May's "Académie," which won the Scholarship in 1911, shows a standing man wearing briefs. The students also worked from a "draped figure" (usually a woman) in the Afternoon Painting class. The question of women painting the female nude was bound up with attitudes towards class and propriety; models who posed in the nude were associated with promiscuity and thus not fit company for ladies.[17]

The curriculum of the AAM included composition, portrait study, and outdoor sketching. The emphasis in the Composition class was on idea and arrangement rather than execution. Once a week, the students practiced quick portrait sketches, using each other as models. The sketch books of Nina May Owens contain charcoal drawings of Emily Coonan, Mabel May, and Mabel Lockerby.[18] Anne Savage's oil sketch of William Brymner (1919), with bushy mustache and monocle, may also have been done in this class.

Brymner's method of teaching was through verbal analysis. Anne Savage describes the master walking past the students' work, displayed

on a ledge, and commenting on each painting: "Drawing's pretty good there, the values aren't very good there. I think you could build better." She remembers an occasion when Brymner remarked on her fine sense of colour. She replied in a cheeky sort of way, "That's a good thing." And he said, "You ought to thank the Lord on your knees for that. That's given to you. Nothing to do with you."[19]

Brymner was a demanding teacher. "The 'nearly right' he would not condone," according to Robert Pilot (1897-1967), a fellow pupil. Pilot claimed that many former students would recall being "stymied" by an academy drawing and hearing Brymner's voice behind them say two words: "Start another."[20]

Brymner believed that the artist must work directly from nature. Marian Scott remembers Brymner criticizing her interpretation of the Garden of Eden because she had painted the animals from imagination, instead of using models.[21] Merely copying nature, however, was not enough; as Brymner explained: "The real artist makes us see even the simplest things in a new light. Thus an artist when he initiates or reproduces the external forms of nature, must bring the light of his own thought upon it."[22]

The early 20th century was a period of great experimentation in painting, with new movements rising rapidly: the Post-Impressionists, the Fauves, the Cubists. Brymner kept in touch with these movements by visiting Europe in the summer and managed to communicate the excitement of the new developments to his students.

From Brymner, the Beaver Hall women acquired a desire to push on and discover things for themselves. As Anne Savage observed: "He possessed that rare gift in a teacher—never to impose his way on his pupils. 'Work out your own salvation in fear and trembling,' he would admonish us and leave us to struggle on."[23]

Most of the Beaver Hall women also studied with landscape painter Maurice Cullen, who taught at the AAM school from 1911 to 1923. Born in St. John's, Newfoundland, Cullen (1866-1934) attended the Académie Julian, and while in Paris absorbed the influence of the

William Brymner and sketching class at Calumet, Quebec, June 1918. Front row: William Brymner and Regina Seiden; third row, right: Nora Collyer; back, right: Anne Savage in dark hat.

Courtesy of Jane Wandell.

Impressionists. Works like *Logging in Winter, Beaupré* (1896) were among the first to apply the theories of Impressionism to the Canadian landscape.[24]

Anne Savage was influenced by Cullen's personality—his love of the outdoor world and his sensitive response to weather and atmosphere. She described Cullen as more emotional than Brymner and less articulate. Instead of explaining something, Cullen would just grab the student's brush and do it. Anne Savage believed that Cullen taught them more about painting than Brymner, who never touched a student's work. Cullen showed them that "painting is a language in itself. It isn't a language of words. It's a language of material and medium and the feeling of the whole context. That is the art, and he showed us that."[25]

Every spring Cullen took a group of students on a sketching trip. There was a camaraderie between teacher and students; they stayed at the same boarding house, ate together, and shared painting experiences. At eighty-one, Kathleen Morris spoke of the "fun" she had had in Carillon, Quebec, in 1914, recalling that the group included Prudence Heward and Cullen's stepsons, Bob and Jack Pilot.[26] The habit of sketching together stayed with the Beaver Hall women, and long after they left the AAM, they continued to enjoy their painting picnics.

Ethel Seath may have made her first contact with the Beaver Hall women on sketching trips with Brymner and Cullen. An information form she completed in 1913 for the Art Museum of Toronto mentions three years with Edmond Dyonnet (at the Conseil) and "a few lessons from W. Brymner and Maurice Cullen." The fact that Seath showed sketches of Phillipsburg and Beaupré at the AAM Spring Exhibitions of 1911 and 1912 suggests that she was in Brymner's class at Phillipsburg in 1910 and at Beaupré with Cullen the next summer.[27]

According to Anne Savage, Ethel Seath was a "self-taught artist."[28] Although this description is somewhat exaggerated, Ethel Seath acquired much of her training in the art departments of Montreal newspapers. At sixteen, she started work at the Montreal *Witness*, transferring in 1901 to the *Montreal Star*. Her mentors were A.G. Racey, head of the art

department at the *Witness*, and later, the cartoonist Henri Julien, whom Seath described as supportive and helpful "with his splendid knowledge and talents."[29] Unlike the students at the AAM, who were encouraged by their female friends, Ethel Seath served her "apprenticeship" in the workplace among male colleagues. Not content to be an illustrator, she spent her lunch hour sketching in churches or around the dockyards. She began contributing to the AAM Spring Exhibitions in 1905, showing mainly etchings and watercolours until 1910, when she exhibited oil paintings of St. Patrick's Church and Christ Church Cathedral.

The outbreak of the First World War in August 1914 affected the lives of all Canadians. Women were temporarily welcomed into the labour force as replacements for the thousands of men who enlisted. By 1917, over 35,000 women were working in the munitions factories of Quebec and Ontario.[30] Others had jobs in the steel industry, ship yards, and agriculture. But the biggest influx was in clerical work; even the banks (previously a male enclave) were forced to train female clerks and tellers. Besides salaried work, women performed many unpaid jobs, raising funds, knitting for the soldiers, and running canteens in munitions factories. Much of this work was coordinated by women's organizations like the National Council of Women, the YWCA, and the Women's Institutes, which all expanded dramatically.

The Beaver Hall painters contributed to the war effort in various ways. Mabel Lockerby worked as a volunteer for the YMCA and received a certificate of thanks in 1920 for her "self-sacrificing and untiring" service. Emily Coonan and Mabel May donated paintings to the Patriotic Fund Exhibition, organized by the RCA to get artists involved in the war. The exhibition was a great success, visiting nine Canadian cities in 1915, and raising over $10,000 through sales and entrance fees.[31]

Mabel May was later engaged by the Canadian War Memorial Fund (CWMF) to paint women in munitions factories. Directed by Lord Beaverbrook in London and the National Gallery in Ottawa, the CWMF was launched in November 1916 to create a "magnificent and lasting

artistic record" of Canada at war.[32] It commissioned British and Canadian artists to paint the battlefields, and Canadians, including four women, to represent the home front.[33]

Mabel May began sketching munitions workers at Montreal's Northern Electric plant in September 1918. According to her, the work was "desperately interesting" and the "remuneration" ($250 a month) "princely."[34] By March 1919, she had completed a large canvas, six feet high by seven feet wide.

Women Making Shells depicts a crowded factory floor with women working alongside men, tugging at pulleys and bending over machines. During the war, a whole mythology was spun around the female munitions worker, who became an emblem of heroic self-sacrifice. Women's willingness to work in industry was ascribed to patriotic, rather than economic, motives and to women's devotion to their warrior sons and husbands. The smiling woman in the foreground of May's painting (absent from the sketches) can be associated with the spirit of cheerful self-sacrifice attributed to female war workers.[35]

The war disrupted the studies of several Beaver Hall painters. Prudence Heward and Lilias Torrance Newton left the AAM school in 1916 and spent two years working for the Red Cross in England. Both young women were accompanying their mothers, who wanted to be near sons serving overseas. Lilias Torrance Newton continued to paint, taking classes twice weekly with British artist Alfred Wolmark (1877-1961).[36] Prudence Heward was unable to paint at this time. We know little about her life in England, but her cousin, Montreal designer Mary Hervey, may have introduced her to the aesthetics of Roger Fry and to his Omega Workshops, which designed fabrics with bold abstract motifs.[37]

Emily Coonan's painting career was also affected by the war. Although she won the National Gallery's travelling scholarship in 1914, she could not leave for Europe until 1920.

The Beaver Hall women suffered the pain that all women face during war, the departure of their loved ones and the stress of waiting for news. As Nellie McClung protested in 1915: "Up to the present time women

Sarah Robertson, at right, and an unidentified
student at the Art Association of Montreal.
Courtesy of Alison Rolland.

Mabel Lockerby, holding dog, and other volunteers,
in Red Cross uniforms, c. 1918.
Courtesy of Gwen Floud.

have had nothing to say about war, except pay the price of war—this privilege has always been theirs."[38] Although conscription was not implemented until early 1918, thousands of Canadian men volunteered. In January 1916, Prime Minister Robert Borden pledged half a million soldiers from a Canadian population of barely eight million.[39] Commitment to the war was strongest among Canadians of British origin, and all the Beaver Hall women, except Emily Coonan, were of English or Scottish extraction.

Seven of the Beaver Hall women had brothers serving overseas. Sarah Robertson's fiancé and Mable Lockerby's cousin and lifelong friend, Ernest McNown, also volunteered. Not all families were united, however, in their support of the war. Emily Coonan's Irish Catholic father was surprised that a son of his would fight for the English.[40] Kathleen Morris's family was divided: her eldest brother, Jim, served in the Black Watch, while Harold, the youngest, became a pacifist.

Casualties in the Canadian Expeditionary Force (CEF) were severe, due to poor training and the appalling conditions of trench warfare. By the war's end, the CEF had suffered 60,661 deaths. Thousands more were wounded, physically or psychologically.[41]

Three of Lilias Torrance Newton's brothers served in the war, and only one returned. Prudence Heward's two brothers survived, but Jim, to whom she was closest, was permanently impaired by chlorine gas. Sarah Robertson's only brother, Louis, a sergeant, was killed at Ypres on 19 July 1916. Anne Savage's twin, Donaldson, a second lieutenant, was killed on the Somme on 15 November 1916. Her sister, Queenie MacDermot, remembers Anne standing at the cottage window at Lake Wonish shortly after Don died, painting the bare trees with tears in her eyes.[42]

Don Savage was killed in Anne's third year at the AAM. As adolescents, the twins had shared their ambitions: she was going to be an artist, Don an engineer. When he died, at 21, she determined to succeed for them both:

"I was left with this feeling of trying to do something to make up for

that loss.... It was a sort of challenge, you see, that came at a very critical time, right at the right minute. It fired me to go on, and I know perfectly well that that really was the basis of what I was doing."[43]

The effects of the war were felt in the AAM school. Male students had always been in the minority, but the disparity widened until by spring 1918, there were only ten men in the classes, compared to seventy women.[44] Maurice Cullen, who was commissioned as a war artist, left for the front in 1918. William Brymner had a stroke in the spring of 1917. Although he recovered enough to resume his classes by autumn, he was visibly weaker and walked with a cane. In the mornings, as Robert Pilot recalls, the sound of Brymner's cane and trailing leg outside the main studio "galvanized the students into life."[45]

The devastating influenza epidemic of 1918 also affected the school. When registration finally picked up the next autumn, only three of the Beaver Hall women were still at the school. Anne Savage had left in May 1919, to work as a medical artist in the military hospital of Ste-Anne-de-Bellevue. Prudence Heward, who had returned from England in 1918, resumed her place in Brymner's class along side Sarah Robertson and Nora Collyer. In May 1921, the sixty-five-year-old Brymner retired, ceding the directorship of the school to his former pupil, Randolph Hewton. Nora Collyer, who had been at the school for nine years, left when Brymner retired. Prudence Heward and Sarah Robertson stayed on. Three years later, however, the AAM suspended the Advanced classes, due to competition from the provincially-funded École des Beaux-Arts, which opened in 1923.

Anne Savage, Sarah Robertson, Mabel Lockerby, Kathleen Morris, and Nora Collyer received virtually all their professional training at the AAM school. Anne Savage visited France and England in the summer of 1924, but as a tourist rather than a student. Mabel May and Emily Coonan went to Paris to study in 1912, encouraged by Brymner who believed in the superiority of the French academies. Little is known about their trip, but they may have worked on their own rather than at a school. While in Europe, Mable May became interested in the representation of light and

atmosphere. The small sketch *Yacht Racing* (1914; plate 1) shows the influence of the Impressionists in its subject matter, a well-dressed crowd enjoying a summer day, and its treatment of light.

Lilias Torrance Newton and Prudence Heward completed their training in Paris. Newton enrolled at the Académie Colarossi in 1924, but soon left to study with Alexandre Jacovleff, a Russian emigré and a fine draughtsman. Under his tutelage, she worked on large chalk drawings to give her figures greater solidity.[46] In 1925, Prudence Heward spent several months in Paris, studying painting at the Académie Colarossi under Charles Guérin, and drawing at the École des Beaux Arts under Bernard Naudin. On her second visit in 1929, she went to the Scandinavian Academy, where she may have been influenced by the expressionist figure paintings of Swedish artist Per Krohg, one of the instructors.[47]

Brymner continued to support the Beaver Hall women after they left the AAM school. It may have been due to him that Emily Coonan won the National Gallery travelling scholarship in 1914, since he was on the RCA committee that chose the winning candidate. Through Brymner, a man of wide cultural interests, the Beaver Hall women gained an awareness of what it meant to be an artist. As Anne Savage said, he made them feel "the terrific importance" of being connected to the world of art.[48] This was reassuring to students who lived in a community that valued art chiefly for its decorative function. To put art at the centre of their lives, as the Beaver Hall women did, they needed to know that painting was more than a private indulgence or frill.

Nevertheless, the atmosphere at the AAM school was not ideal for women. While learning about the importance of art, they must have wondered privately about their status as female painters. The school mirrored the structure of the patriarchal family, with Brymner at the top of the pyramid, Alberta Cleland, his former pupil, as his subordinate, and the students at the base. While male students could imagine themselves succeeding to Brymner's roles as painter, director of a school, and president of the RCA, what aspirations could the female students realistically embrace?

Brymner sometimes gave short talks to his class on the different schools of painting, an approach that focussed largely on the artistic accomplishments of men. The AAM library contained catalogues of the great European and American galleries and works on various school of art, most of which had little to say about women artists.[49] For information on women painters, the students would have had to consult books like Clara Clement's *Women in the Fine Arts* (Boston, 1904), which the AAM may or may not have owned. The tendency of art historians to treat women's work as a separate and distinct class reinforced the perception of women's art as lacking creativity, and undermined women's confidence in their own talents.

Leah Sherman, a former student of Anne Savage's, remembers hearing Savage say that the women in Brymner's class had a greater sense of vocation during the war, because they believed that they were carrying on for the men.[50] But while this idea of "carrying on" may have had a liberating effect in the short term, was it not ultimately limiting? Did it not imply that women could fill in while the men were overseas, but were expected to step aside when the "real" artists returned?

The company of other talented female students helped the Beaver Hall women to believe in themselves as artists. They watched one another's progress with interest. Even after Mabel May and Emily Coonan left the school in 1912, their presence was felt at the Spring Exhibitions, where their paintings won several awards. The younger women were inspired by the success of the older ones, and by the time they left the AAM school all had exhibited at the Spring Exhibitions and many at the RCA. The desire to paint came from an inner vision, but the will to exhibit was stimulated by their friendly rivalry and the hope of sales.

Chapter Three

≋

The Beaver Hall Women's "Gang"

IN THE AFTERMATH of the First World War, Canadian artists founded two new associations: the Group of Seven in Toronto and the Beaver Hall Group in Montreal. The former was an all-male group, the latter a mixed group that included Mabel May, Lilias Torrance Newton, Anne Savage, Mabel Lockerby, and Sarah Robertson.

The impulse behind the creation of these groups was economic, political, and aesthetic. Artists had had a difficult time during the war, owing to a decline in markets and patronage. Although some found work with the Canadian War Memorial Fund in the last years of the war, by 1920 the Fund had run out of money.[1] With little hope of further commissions, artists were forced to consider new ways of creating a demand for their work.

Art institutions, with the exception of the National Gallery, gave little support to Canadian painters. In 1913, the AAM owned a mere thirty-three works by Canadians artists (all but nine of them gifts), while the Art Gallery of Toronto did not buy a work by a living Canadian artist until 1926.[2] Private galleries catered to the taste of their clients, who believed that Canadian art was inferior to European. An exception was W. Scott & Sons of Montreal (founded in 1860), who handled a few Canadian painters, notably James Wilson Morrice. According to William R. Watson, who opened his Montreal gallery in 1921, "no dealer could live on the sale of Canadian art alone."[3]

Kathleen Morris in her early twenties.
Courtesy of Greta Stethem.

The Group of Seven and their Montreal colleagues faced particular difficulties because they were working in a modernist style before that style was generally appreciated in Canada. The brilliant colours and simplified forms favoured by the modernists led some critics to label their work crude or inept. Other critics claimed that the barren landscapes painted by the Group of Seven were poor advertisements for Canada; some even linked the distortions of modernist painting to the breakdown of moral and spiritual values.[4]

The artists hoped that by forming associations they could create a market for their work and educate the public about modernism. The Group of Seven and some of their Montreal colleagues had a further aim, to foster a distinctly Canadian expression in painting.

The idea that Canada needed to develop its own culture and institutions was shared by many English-speaking intellectuals in the 1920s. Politically and economically, Canada was loosening its ties with Britain. Before the war, Canada had been largely dependent on Britain for investment and markets, but by 1920 it was being integrated into the North American economy.[5] English-speaking intellectuals, many of whom had served overseas, were proud of Canada's role in the war and her status as an independent member of the newly-formed League of Nations. They wanted Canadians to shed their colonial mentality and show confidence in Canadian-made goods and culture. To promote these ideas, they formed or revived organizations like the Canadian Clubs (revitalized in 1925), the Canadian Authors' Association (founded in 1921), and the Canadian League (organized in 1925).[6]

In its first issue, October 1920, the *Canadian Forum*, mouthpiece of the new nationalism, declared its intention to support what was "distinctly Canadian" in arts and letters: "Real independence is not the product of tariffs and treaties. It is a spiritual thing. No country has reached its full stature, which makes its goods at home, but not its faith and its philosophy."[7]

Earlier that year, the Group of Seven held its first exhibition. The message in the catalogue was similar to that of the *Canadian Forum*: "an

Art must grow and flower in the land before the country will be a real home for its people."[8] The members of the Group were J.E.H. MacDonald (1873-1932), Lawren Harris (1885-1970), A.Y. Jackson (1882-1974), Arthur Lismer (1885-1969), Fred Varley (1881-1969), Frank Johnston (1888-1949), and Frank Carmichael (1890-1945). They had been exhibiting together since before the war and shared a common aesthetic. Emphasizing that art must be Canadian in form and content, they turned from an inherited culture to nature.[9] For them the landscape of Northern Ontario, unmarked by European settlement, was an appropriate vehicle for expressing the Canadian identity. Lawren Harris, a theosophist, associated the North with loneliness, cleansing, and spiritual replenishment. A.Y. Jackson saw the rugged mountains, clear colours, and vast scale of the northern landscape as symbolic of Canada's youth and virility.

The Montreal artists were also organizing, as Jackson reported on 28 May 1920: "Just last week the Montreal artists formed a new association and elected me president while I was up at Mongoose Lake."[10] The Montrealers were motivated by the example of the Group of Seven, and by the need to find cheap studios. Four of Brymner's former students—Mabel May, Lilias Newton, Randolph Hewton, and Edwin Holgate—found a suitable house, 305 Beaver Hall Hill, and asked friends to share the studios and the rent. Among those invited were Mabel Lockerby, who acted as secretary to the Montreal group, and Anne Savage.[11] The artists called themselves the Beaver Hall Group.

The area around Beaver Hall Square had long been a favourite haunt of artists. The architects Edward and W.S. Maxwell and painters G. Horne Russell and the Des Clayes sisters had studios on Beaver Hall Square in the early 1920s. Number 305 Beaver Hall Hill was just a few doors below the square, on the east side of the street. From their studios, Anne Savage and her friends looked out on the "hidden garden and green fountain" of St. Patrick's Church.[12]

In January 1921, the Beaver Hall Group held its "first annual exhibition." The names of the members, all of whom were represented in the show, appeared in the *Gazette* (18 January 1921) and in *La Presse*

Cover, *Chansons of Old French Canada*, 1920,
arranged by Margaret Gascoigne.
Illustrated by Ethel Seath.

(20 January 1921). They were Jeanne de Crèvecoeur, James Crockhart, Adrien Hébert, Henri Hébert, Randolph Hewton, Edwin Holgate, Alex Jackson, John Johnstone, Mabel Lockerby, Mabel May, Darrell Morrissey, Lilias Torrance Newton, Hal Ross Perrigard, Robert Pilot, Sybil Robertson, Anne Savage, Adam Sheriff Scott, Regina Seiden, and Thurstan Topham.[13]

The exhibition caused quite a stir, prompting long articles in the *Gazette* and *La Presse*. Jackson, who spoke at the private view (15 January 1921), mentioned the possibility of striking a "distinctively national note," but emphasized that the Group's first concern was painting. Its purpose was "to give the artist the assurance that he can paint what he feels, with utter disregard for what has hitherto been considered requisite to the acceptance of work at the recognized art exhibitions in Canadian centres. 'Schools and isms' do not trouble us; individual expression is our chief concern."[14]

The Montreal artists, unlike the Group of Seven, did not have a common aesthetic. They were an eclectic bunch, mostly former students of William Brymner, who came together for exhibitions and social gatherings. Jackson provided a link between the two groups. He visited Montreal regularly, kept the painters informed about one another's activities, and invited the Montrealers to exhibit with the Group of Seven. "He was simply magnificent," according to Anne Savage, "because he was a teacher. He came down and inspired other people. . . . His whole idea was to create a Canadian art for Canada."[15]

Anne Savage shared Jackson's enthusiasm about creating an art for Canada. In 1967, she looked back on the twenties as a period when the artists were not painting purely out of personal ambition, but to enrich their country. "The whole idea of painting has changed. It's supposed to be a personal evolution of your own reactions, this, that, and the other thing. It was completely different in our case. Ours was, who can find the best motif to represent Canada."[16]

While Anne Savage agreed with the Group of Seven's ideas, she interpreted the nationalist project in her own way. A descendant of one of the

Fathers of Confederation (Sir Alexander Galt), she took pride in her country's past as well as its physical beauty. As a teacher, she used history and nature to stimulate her students' imagination; as a painter, she drew inspiration from the Quebec landscape, a landscape already marked by European civilization. In *Ploughed Field* (c. 1923), the rhythmic furrows in the foreground and the wooden fences direct the viewer's eye to a white farmhouse, the focal point of the composition. Dabs of aquamarine on the lake, the roof, the furrows, and the distant hills integrate the composition and suggest the intimate relationship between the land and the people who work it.

Several of Sarah Robertson's early paintings focus on the people and culture of rural Quebec. *Le Repos* (c.1926) depicts a large family seated under the trees, with a sunlit field and farm house in the middle distance. Although the painting is not explicitly narrative, the title, the formal arrangement, and the costumes (the girls' white dresses, the men's suits) all suggest that the family are resting after Sunday mass.

In *Joseph and Marie-Louise* (c. 1930; plate 2), a farmer and his wife are standing beside a wayside cross. The subject, reinforced by the biblical echo in the title, evokes the traditional values of Quebec: the land, the family, and the Catholic faith. Streaks of white light in the sky contribute to the overall pattern and intensify the spiritual atmosphere of the work.

Kathleen Morris and Ethel Seath also painted canvases in the 1920s that evoke the religious and social rituals of Quebec. Kathleen Morris's *After Grand Mass, Berthier-en-Haut* (1927) has a static quality (the people arrested in conversation, the sleigh-horses waiting), which suggests the unchanging life of the habitant; the massive façade of the village church symbolizes the power of the Catholic Church. Touches of red in the horses' blankets, women's hats, and gabled roofs unify the composition and lend it a festive note. Ethel Seath's *The Gardener's House* (c. 1930) is both a particular scene, the view from The Study art room, and—with its elements of traditional grey stone house, snow, and black-robed nuns— an icon of Quebec.

These paintings would seem to have much in common with the work

63

of Quebec artists like Clarence Gagnon and Marc-Aurèle Fortin, who were involved in the conservation of ancestral values. These painters of the "terroir" linked the survival of the French-Canadian identity ("la survivance") to the rural way of life, the Catholic faith, and the French language.[17] But why would English Protestants be interested in these values? It could be that they recognized that this way of life was already changing and wanted to record it for posterity. To an English Canadian of the 1920s, there was nothing paradoxical in celebrating Quebec culture as part of Canada's cultural heritage.

The Women's Art Society of Montreal had been involved in the exhibition and sale of Quebec's traditional arts and crafts since 1900.[18] But these crafts were endangered, as ethnologist Marius Barbeau recognized, by industrialization and the break-up of rural communities. From 1911 until the 1960s, Barbeau worked to preserve the traditional cultures of Quebec and the aboriginal peoples.[19] He appreciated these cultures for their beauty and as a source of inspiration for living artists, an idea shared by Anne Savage, Ethel Seath, and the Group of Seven.

Ethel Seath illustrated a small book of songs, *Chansons of Old French Canada*, arranged by her friend Margaret Gascoigne.[20] Seath's woodcuts include Quebec motifs such as the voyageurs' canoe and European décors appropriate to songs like "Sur le Pont d'Avignon," which originated in France.

Anne Savage and other artists were involved in Barbeau's projects to conserve aboriginal culture in British Columbia. At his suggestion, she and Florence Wyle visited the Skeena River in 1927. While her sculptor friend made models of the endangered totem poles, Anne Savage sketched the village, once the site of Temlaham, a legendary "Paradise Lost."[21] Her sketches and canvas *Temlaham, Upper Skeena River* were included in the travelling exhibition *Canadian West Coast Art, Native and Modern* (1927-28), organized by Barbeau. In the catalogue, Barbeau stressed that art was not a luxury for the native peoples, but "fulfilled an all-essential function in their everyday life."[22] The association with aboriginal culture may well have deepened Anne Savage's understanding of the intimate

relationship between art and life, a leitmotif of the nationalist project.

The original Beaver Hall Group survived for less than two years. Randolph Hewton attributes its collapse to financial problems. Writing to Eric Brown of the NGC, Hewton claims the Group held four exhibitions during its "short existence": canvases by members of the Group (January, 1921), compositions by students of the art gallery (AAM) and decorative designs by the children of Anne Savage's class, an exhibition by Adrien Hébert, and a sketch exhibition by members of the Group.[23] At least one other show was held in the Group's "club rooms," from 22 November to 4 December, 1920.[24]

According to *Lovell's Montreal Directory*, the Beaver Hall Group occupied number 305 until the year 1923-24. Apart from Randolph Hewton, who "camped" in an upstairs room, the artists who frequented the studios were women. Lilias Newton and Mabel May shared the largest studio and taught a women's class on Saturday mornings. Emily Coonan rented one of the smaller studios but, according to Lilias Newton, did not mix with the other painters. Sarah Robertson joined the Group in December 1921 and contributed to the 1922 exhibition. Nora Collyer, who left the AAM school in May 1921, shared a studio with Anne Savage. Writing to Nora Collyer from the South of France, William Brymner remarked wryly: "I'm sorry I can't go to see you in your studio but it's too far to go."[25]

The little house on Beaver Hall Hill provided much more than a space to work. The artists looked on it as a club, a place to meet and exchange ideas. There was, as Edwin Holgate remarked, a feeling of "bonhomie" that spread through the building.[26] Fortunately, this energy did not dissipate in 1924 when the artists could no longer afford the studios. The surviving women members—Mabel May, Lilias Newton, Mabel Lockerby, Anne Savage, Sarah Robertson, and Nora Collyer— formed a network, which expanded to include Prudence Heward, Kathleen Morris, and Ethel Seath. As Savage observed: "There was a remarkable spirit. We telephoned one another. 'Have you got anything?

What are you doing? Can I come up and see it? Could you come down?'
We had a swell time, actually."[27]

Sarah Robertson was at the centre of the network. She was "a bureau
of information for her friends, who would come to her for help and
discussion ... concerning their work."[28] Prudence Heward, in particular,
relied on Sarah Robertson for criticism and advice. A.Y. Jackson, who
recognized Robertson's role in the group, frequently consulted her about
her friends' work. "Stir all your gang on, Sarah," he urged in 1928.[29] And
she did.

The women's "gang" had no constitution, no officers and, until 1966,
when Norah McCullough of the National Gallery organized an exhibition,
no name. Anne Savage referred to it as "our little group"; Jackson as the
"Montreal Group," or simply, in letters to Sarah Robertson, as "your
gang." Why then did Norah McCullough call her exhibition of ten women
painters—half of whom had not belonged to the original Beaver Hall
Group—by the name of that long defunct association?

When asked, Norah McCullough replied that, as National Gallery
liaison officer for Western Canada, she wanted to introduce the work of
Quebec women to audiences in the West.[30] She consulted A.Y. Jackson
and Anne Savage, who told her about the original Beaver Hall Group.
Somehow, the name of the association got confused with the street and
McCullough's exhibition became *The Beaver Hall Hill Group* (a variation
that most writers ignore).[31] The one painter included who did not belong
to Sarah Robertson's "gang" was Emily Coonan. Norah McCullough
cannot now recall who suggested Emily Coonan, but thinks that it might
have been Anne Savage.

In her catalogue, Norah McCullough provided a brief introduction
to the work of the Beaver Hall women. Unfortunately, she suggested
that these painters were "by no means careerists but rather talented
gentlefolk." This description diminishes the Beaver Hall painters by
associating them with upper-class dilettantism. Women painters had
struggled at the turn of the century to avoid the stigma of amateurism by
gaining access to professional schools and associations. To say that the

Beaver Hall women "painted for pleasure," as McCullough does, creates the impression that they did not care about exhibitions and sales, when the reverse is true. Their impressive exhibition lists and the time they devoted to the business side of their profession (correspondence, serving on hanging committees) suggest that selling was important. Sales confirmed their identity as artists; and although they did not depend on their art for a living, they needed the money for art materials, studios, and trips to art shows outside Montreal.

The Beaver Hall Hill Group, which included twenty-six paintings, was shown at the Arts and Letters Club in Toronto in September 1966, and at small galleries in Ontario and Western Canada. The exhibition celebrated the work of women artists at a time when the feminist movement was gathering momentum. Although McCullough did not recognize the professional status of the Beaver Hall women, by giving the group a name she helped to focus attention on them and to ensure that even the lesser talents among them would not be forgotten.

Chapter Four

≋

Professional Beginnings

IN THE 1920S, the Beaver Hall women began to play a significant role in the Canadian art world. They shared the success of Canadian artists at the British Empire Exhibition at Wembley, London (1924-25), and participated in the ensuing debate over the selection of paintings for international exhibitions. The Wembley controversy, as it is called, was a power struggle between the Royal Canadian Academy and the National Gallery, as well as a rearguard action by the older academicians against the modernists.[1] The Beaver Hall women showed their commitment to modernism in their painting and in their support for the National Gallery and its beleaguered director.

The modernism of the Beaver Hall painters and the Group of Seven was restrained when compared to European art of the 1920s.[2] It was essentially a form of Post-Impressionism, characterized by bright, clear colours, brushwork that called attention to the surface of the work, simplification of the subject, and an emphasis on design. In Emily Coonan's *Girl in a Dotted Dress* (c. 1923), for example, the figure is silhouetted against a freely-brushed background, the face is simplified and all accessories have been eliminated. The viewer's attention is held as much by the formal elements of the painting (triangular shapes and patterned fabric) as by the quiet concentration of the model.

For nearly twenty years, the Group of Seven and their modernist colleagues were attacked by conservative critics like Hector Charlesworth

of *Saturday Night* and Samuel Morgan-Powell of the *Montreal Star*. Paintings by the Group of Seven were described as "hot mush," "freak pictures," or "gruesome hallucinations."[3] After Emily Coonan returned from Europe in 1913, Morgan-Powell dismissed her contributions to the annual RCA Exhibition as "imitations of the grotesque," adding that "her 'studies' [were] not likely to encourage anyone else to follow suit."[4] Emily Coonan, Kathleen Morris, Sarah Robertson, Anne Savage and others were berated by the same writer in 1926 for showing works "marred by crudity of colouring, harsh tones, and neglect of drawing."[5]

Other Montreal critics were more appreciative of the Beaver Hall women. In 1922, Albert Laberge of *La Presse* praised Sarah Robertson's bright, decorative works and ranked Mabel May among Canada's five or six best artists. The same year, he declared that the boldest, most brilliant works at the AAM Spring Exhibition were by women, including Nora Collyer, Mabel Lockerby, and Mabel May.[6]

Eric Brown, Director of the National Gallery from 1913 until 1939, was a powerful supporter of the Group of Seven and the Beaver Hall women. After languishing for 33 years, the NGC was revitalized in 1913 by an act of parliament, which consigned its administration and control to a board of trustees.[7] Between 1913 and 1924, the NGC bought four works by Mabel May, two each by Emily Coonan and Lilias Torrance Newton, and one by Kathleen Morris. Brown and his wife, Maud, were particularly close to Kathleen Morris, who lived in Ottawa from 1923-29, Mabel May, and Lilias Torrance Newton. According to Morris's friend Louisa Chapman, "Eric was marvellous to all the young people. He and his wife, Maude [sic], invited groups of us to their place and very often Eric would read poetry (beautifully)."[8]

Brown was largely responsible for the success of the Canadian artists at Wembley, in 1924. By arranging for the National Gallery, and not the RCA, to select the jury, he ensured that the modernists would be well represented. Thirty women were invited to take part in the exhibition, including Coonan, Lockerby, May, Morris, Newton, Robertson, and Savage.[9]

Nora Collyer in the garden at Hill Crest, Foster, Quebec, 1932.
Courtesy of Jane Wandell.

In *Breaking Barriers*, Maud Brown, who accompanied her husband to Wembley, described the excitement of opening day. The critics, bored with the work of the other dominions, drifted into the Canadian gallery. Then came "gasps of surprise . . . a buzz of conversation. Here was something new!"[10] The reviews were "overwhelmingly enthusiastic," claiming that Canada has an "indigenous and vigorous school of painting." And while many praised the Group of Seven, a few also acknowledged the women's contribution. "Some of the Groups are strong in clever women painters like Miss Kathleen Morris and Miss H. Mabel May."[11]

The next year, a second selection of Canadian work was sent to Wembley. This time all the Beaver Hall women were included except Emily Coonan and Nora Collyer. The British critics agreed that the landscapes were superior to the figure painting, but the prestigious *Sunday Times* singled out Prudence Heward's portrait, *Miss Lockerby* (c.1924), as "very promising."[12]

The positive reviews of the Wembley exhibitions, which were republished by the NGC, raised the prestige of Canadian painters at home. Nevertheless, some members of the RCA objected to the inclusion of so many modern works, and claimed that the selection of the jury should have been left to the RCA.[13] When, in 1926, the conservatives tried to have Brown removed as director of the National Gallery, Lilias Newton, Mabel May, and Kathleen Morris were among the artists who signed letters of support. Although the malcontents renewed their attack in 1932 with a petition signed by 118 artists, the campaign against Brown was losing strength. Sculptors Frances Loring and Elizabeth Wynn Wood launched a counter-petition signed by 282 artists, including the ten Beaver Hall women.[14] Brown survived, but responsibility for the Canadian collection passed to H.O. McCurry, and the Annual Exhibitions of Canadian Art were discontinued.

The exhibitions, introduced by Brown in 1926, provided a showcase for Canadian art. Between 1926 and 1933, the NGC made all its purchases of Canadian art from these shows. The Beaver Hall women sold sixteen works from the Annual Exhibitions to the NGC, including portraits by

Lilias Newton, cityscapes by Kathleen Morris and Mabel Lockerby, landscapes, and works that combined figures and landscape.

Prudence Heward's paintings *Girl on a Hill* (1928) and *Rollande* (1929) are monumental portraits of women in pastoral settings.[15] In *Girl on a Hill*, the model, a well-known modern dancer, is sitting, barefoot and bare-armed, under a stylized arch of trees. Her naked limbs, and loose dress, are appropriate for her profession, and suggestive of the greater freedom women were enjoying. In *Rollande*, the model in her high-necked black dress and pink pinafore could be a schoolgirl or a servant. She confronts the viewer boldly, her arms akimbo, and her back turned to the farm, but her defiant stance is somewhat diminished by her costume. These paintings invite us to reflect on the changes to women's political and social position in the 1920s. As Quebec became increasingly industrialized, young women were leaving the farms to work in factories or as domestics. More *single* middle-class women were also taking jobs. But most were obliged to stop working when they married, since school boards, government offices, and many private firms did not employ married women. Although marriage was still considered the "real" career for middle-class women, working before marriage was justified on the grounds that it would help them become more competent wives and mothers.[16]

Politically, women's status was improving. The federal government granted them the vote in 1918 and the next year admitted them to the House of Commons.[17] In 1929, women were legally recognized as "persons" and thus eligible for appointment to the Senate. They had little real power, but their enfranchisement and a token presence in Parliament increased their status and self-confidence.

The mass circulation magazines of the 1920s claimed that women had more opportunities than ever before. The magazines popularized an image of the Modern Woman, with short skirts and short hair, who danced, played sports, and worked at interesting jobs. But many women may have had been confused, as feminist Anne Anderson Perry suggested in 1928, "between old ideals of shrinking, dependent femininity, and the

more modern conception of woman as an independent entity with a destiny of her own, both political and economic."[18]

The symbolism of *Girl on a Hill* and *Rollande* evokes the ambiguities in women's situation. The dancer—whose profession links her to the city, modernism, and art—is shown sitting alone on a hill. Her bare feet can be read as an allusion to her profession (modern dance was based on natural movements) and as a reference to a rural past. The fence in *Rollande* can be seen as cutting the girl off from her past and/or closing her within herself. Taken together, the paintings offer a pertinent commentary on the predicament of women in the 1920s—caught between the traditional values of domesticity and rural stability (symbolized by the apron and the farm) and the prospect of independence and self-fulfilment suggested by the successful dancer.

In other works of this period, *At the Café* (c. 1928) and *At the Theatre* (1928; plate 4), Heward shows women enjoying the social and cultural life of the city. In the late 19th century when modern-life painting became a popular genre, public spaces were divided by class and gender. The Impressionists Mary Cassatt and Berthe Morisot represented middle-class women in Parisian parks and theatres, but not in cafés, which were associated with mistresses and courtesans.[19] By depicting a woman painter, Mabel Lockerby, sitting alone at a café table, Heward draws attention to the increased independence of middle-class women. The shadowy male figures in the background reinforce the impression of strength in the solidly-painted woman, while simultaneously reminding the viewer that the world in which the artist moves is still dominated by men. *At the Theatre* portrays women in evening dress, half-turned towards the stage. Light ripples over the shoulders of the central pair, creating a warm, intimate feeling. While Mary Cassatt's *At the Opera* (1879) draws attention to women's vulnerability by showing a man training his binoculars on a female spectator, Heward's image suggests that women are autonomous beings (the viewers, not the viewed) with the artistic taste and means to support the arts.[20]

Lilias Newton's *Self-Portrait* (c. 1929; plate 5) raises interesting

questions about the public perception of professional women. As a married woman and a mother, Newton's position was somewhat anomalous in a period when wives were expected to devote themselves to their families. In the portrait she presents herself as an elegantly-dressed woman, staring confidently at the viewer. Her profession is suggested by the outline of a palette at lower right and a picture frame at the top of the canvas. Newton's attention to fashion details (the bobbed hair, bright lipstick, and gold choker) suggest that she may have been concerned (consciously or unconsciously) to show that her profession had not undermined her "femininity." Although Newton was not the first woman to represent herself as a painter, this self-portrait has a particular resonance in a period when the Group of Seven was forging an image of the painter as a virile, outdoors man.[21]

Emily Coonan eliminates all inessential details in her unsentimental portraits of young girls, such as *The Arabian Nights* (c. 1929). Unlike Mary Bell Eastlake's *Fairy Tales* (1916), which focusses on the affection between the little readers, Coonan's painting presents reading as something that is valued for itself. The book is placed at the centre of the composition; the viewer's eye is directed to it by the girl's downward gaze, and the diagonal lines of her arms. The title's exotic connotations can be read as an ironic comment on the girl's everyday world, or as an allusion to the transforming power of the imagination.

In *The Blue Armchair* (c. 1930; plate 6), Coonan explores approaching womanhood, a theme favoured by the female Impressionists.[22] The model sits, ankles together, holding her hat, an emblem of her new status. The closed book lying on the floor suggests an end to childhood and make-believe. Emily Coonan, who had been a tomboy, may have been remembering her own adolescence in this portrait of her niece.[23] The textures—the hot plush upholstery and itchy stockings—and the girl's self-conscious pose contribute to the image of adolescent unease.

Mabel May's early work included crowd scenes like *Immigrants, Bonaventure Station* (1914) and portraits. In *The Three Sisters* (c. 1915; plate 7), the young girls are grouped under a tree listening to a story. The

painting, with its effect of dappled light, evokes the atmosphere of a dreamy summer's day. After 1920, however, Mabel May concentrated mainly on unpeopled landscapes and cityscapes. Her painting, *From My Studio Window* (c. 1928), is a view of snow-capped roofs, framed by a window sill. Like Newton's *Self-Portrait*, May's painting reinforces the idea of the female painter as a professional with her own studio.

The city with its modern buildings, port, and bridges was a subject that appealed to many Montreal painters, including Ernest Aubin, Adrien Hébert, and the Beaver Hall women.[24] Mabel May's *On the Docks* (1917) and Ethel Seath's watercolour *The Docks* (1898) suggest that women painters recognized the pictorial possibilities of the Montreal harbour before the 1920s, when it became a favourite subject of Adrien Hébert's.[25]

Ethel Seath's cityscapes, *St. James's Cathedral from La Gauchetière Street* (c. 1925; plate 8) and *The Canal, Montreal* (c. 1924; plate 10), show the city beneath a romantic blanket of snow. In *The Canal*, the pale colours and a scattering of large fluffy snowflakes soften the image of warehouses and sheds. By contrast, Mabel Lockerby's *Early Winter* (1927) emphasizes the bleakness of the urban scene. The grey-green canal (or river) sweeps across the canvas, framed by a railing in the foreground and boxlike buildings in the background.

In *Beaver Hall Square* (c. 1923; plate 9), with its links to the art community, Anne Savage found a subject rich in historical, cultural, and personal associations. The rural past is suggested by the snow and horse-drawn sleighs in the foreground, an older Montreal by the row of grey-stone houses on the left, and the city's future by the skyscraper in the background. A stylized tree on the right and telephone pole on the left are a framing device.

The city is seen as a backdrop for human activity in Kathleen Morris's paintings of Ottawa. Works like *Market Day, Ottawa* (c. 1924; plate 11), *At the Hay Market*, and *The Fruit Shop, Ottawa* (c. 1926) focus on the life of the streets: fashionably-dressed men and women mingle with farmers in flat caps and market women in pinafores.

The Beaver Hall women also liked to paint the Quebec countryside,

Prudence Heward with fur collar.
Courtesy of Ross Heward.

particularly the Eastern Townships, the Laurentian mountains, and the western part of Montreal Island. Like many Quebec artists, the women humanized the landscape by focussing on houses, barns, bridges, and churches.[26] In Anne Savage's *The Red House, Dorval* (c. 1928; plate 12) the dark boughs arch over the house as though to protect it from the encroaching snow. The feeling of intimacy conveyed by the image may be due to childhood memories the house evoked for Savage.[27]

The Beaver Hall women maintained their links with the Group of Seven throughout the 1920s. The alliance benefited both groups. The male painters had greater prestige than the Beaver Hall women, and more influence with art institutions. Nevertheless, the women painters were not "followers," but collaborators with their own artistic vision. Emily Coonan and Lilias Newton took part in a Group exhibition that toured the United States in 1923-24.[28] Mabel May, Prudence Heward, Mabel Lockerby, and Sarah Robertson contributed to the Group of Seven's 1928 show in Toronto. "You and your gang show up very well," Jackson told Robertson. "Your *Autumn Storm* looks much better than it did at the RCA, we borrowed your *Blue Sleigh* too, it looks *très distingué*. Prue's two canvases fine in colour and lots of vitality and Mabel Lockerby's fine too."[29]

A.Y. Jackson, who served on many exhibition juries, gave the women practical help. He promoted their work to collectors and curators, and occasionally offered technical advice. But his attitude to women painters seems to have been ambivalent. He was sometimes patronizing. For example, he addressed Sarah Robertson as his "little niece," and dismissed Anne Savage's professional problems as "your little troubles at the school."[30] In his *Autobiography* (1958), he spoke of the women's contribution to the Canadian Group of Painters, saying: "The distaff side of the new group was never overawed by the male members."[31] To present-day readers, this language stereotypes and belittles women; but the response of the Beaver Hall women may have been more complex. Brought up in a patriarchal society, they may not have consciously

recognized some of its attitudes towards women artists.

In a lecture entitled "Women Painters of Canada," Anne Savage uses Jackson's cliché "the distaff side" to refer to her subjects. She speaks of the "charm and joyous grace" women painters have contributed to Canadian art and their "concern with trivial incidents."[32] Her use of words like "charm and grace" to describe women's art, and "trivial" to depict its subject matter, suggests that she has internalized some aspects of the feminine stereotype. But in the same lecture, she challenges that stereotype by calling Prudence Heward a genius, a word traditionally reserved for male artists.[33]

The Beaver Hall painters formed ties with other women artists. They exhibited at the Women's Art Association in Toronto, and several of them became friends of Frances Loring (1887-1968), president of the Women's Art Association, and her lifelong companion, Florence Wyle (1881-1968). Anne Savage, who visited Wyle and Loring at their farm, admired their dedication to art and their generous hospitality to fellow artists. Anne Savage, Mabel May, and Sarah Robertson met the western painter Emily Carr, who visited Montreal in 1927.[34]

The Beaver Hall women had little contact with French-speaking women painters. This is not surprising, since French and English artists seldom associated until John Lyman brought the two groups together in the late 1930s.[35]

By 1929, art critics were beginning to acknowledge the significant contribution of women painters. Frederick Housser's article in *The Yearbook of the Arts in Canada* (1929) mentions fourteen women painters, including Heward, May, Newton, Robertson, and Savage. He concludes: "Much distinctive modern work is being done in the country by women." In 1930, an exhibition at the Women's Art Association in Toronto prompted a critic to say: "some of the very interesting things in Canadian art are being done by women." The writer was particularly impressed by the work of Anne Savage, Prudence Heward, and Sarah Robertson. American critics also singled out Prudence Heward, when the exhibition *Paintings by Contemporary Canadian Artists* toured the United Sates in 1930. According

to a Chicago writer, Heward's *Rollande* and *Girl on a Hill* were "stunning sober portraits of women, distinguished, almost classical in their serene self-assurance."[36]

The Beaver Hall women gained further prominence by their success in the Willingdon Arts Competitions. Organized by the NGC, and sponsored by the Governor General, Lord Willingdon, these competitions were aimed at promoting public interest in the arts. In 1929, Prudence Heward was recognized as one of Canada's most original painters, when her canvas *Girl on a Hill* won first prize ($200) in the initial Willingdon Competition. She shared her triumph with her friends Mabel May and Mabel Lockerby, whose *Melting Snow* (1925) and *Marie et Minou* (c. 1928) were among nine paintings to receive honourable mention.

"I was simply delighted over Prue winning the Willingdon prize & think she thoroughly deserves it," Kathleen Morris wrote to H.O. McCurry, Assistant Director of the NGC. Referring to the artists who won honourable mention, Morris adds, "Naturally I wish that Sarah & I were among them, too."[37] The next year, Kathleen Morris's wish was fulfilled when her painting *Nuns, Quebec* (c. 1926) was awarded an honourable mention in the second Willingdon Arts Competition.

By 1930, all the Beaver Hall woman had established themselves as professional artists. Their success was reflected in increased sales and in the substantial prices they received for their work. In 1930, the National Gallery paid $600 for Heward's *Rollande* and $500 for Newton's *Self-Portrait*.[38] Nevertheless, none of the women could have survived without some other means of support. In this respect they did not differ greatly from their male colleagues. With the exception of Jackson and a few older or more conservative painters, few Canadian artists in the 1920s managed to support themselves on the proceeds of their art.[39]

Chapter Five

≈

Family Ties

NINE OF THE BEAVER HALL women were spinsters—whether by choice or circumstance is hard to say. Some may have chosen to stay single, while others may have rejected a particular offer at a particular time without feeling any particular commitment to spinsterhood. Mabel Lockerby, who had a deep attachment to a man, probably felt that marriage was too great a risk, given his personality and situation.

As career opportunities for women opened up in the 19th century, spinsterhood—formerly associated with poverty and dependence—became an acceptable option. By the turn of the century, a different model for women had emerged in Britain and North America. The "New Woman", as she was called, was a young middle-class woman who supported herself and often lived alone or with chosen companions.[1] Although admired by feminists for her independence and moral superiority, the New Woman was derided by middle-class men who felt threatened by women's access to the professions. The British magazine *Punch* ridiculed the New Woman as prudish and man-hating, while sexologists like Havelock Ellis claimed that motherhood was woman's "natural" function and that non-use of the female reproductive system could lead to madness.[2]

Although some women chose spinsterhood, others may have remained single due to family circumstances or social conditions. After the First World War, for example, there was an imbalance in the population

due to the deaths of thousands of young men.

Most middle-class women were forced to choose between a career and marriage, since institutions were reluctant to employ married women. Being self-employed, women painters had more freedom of choice. Canadian painters Elizabeth Armstrong Forbes and Mary Hiester Reid married fellow artists, but other women painters may have feared, as Emily Carr did, that marriage would interfere with their profession.[3]

The Beaver Hall women were brought up to consider marriage a full-time commitment. They had a vocation, a purpose in life, and may well have felt that the responsibilities of marriage would jeopardize their professional careers. At thirty-seven years of age, Prudence Heward confided to a friend that she was wondering what she would do with herself if she didn't paint. "Marry some poor unfortunate & make him unhappy for the rest of his life as well as myself? Perhaps."[4] For Prudence Heward, marriage was clearly an alternative to painting—an alternative that she occasionally looked back on with whimsical curiosity.

The nine single painters lived with their parents and siblings for most of their lives. Some had little choice, since their art did not provide them with a livelihood, but most were also influenced by family loyalty. Society expected unmarried daughters to care for their parents. Anne Savage and Ethel Seath, who had full-time teaching jobs, contributed to the family income. Nora Collyer, whose mother died suddenly, gave up her job teaching art at Trafalgar School to supervise the household for her wealthy father.

Living with their families gave the Beaver Hall women some economic security, but it entailed a loss of personal freedom. Sarah Robertson was obliged to cater to the caprices of a wilful mother. Prudence Heward had to conform to her family's conservative standards of dress and behaviour. But the real problem for these creative women was caused less by external circumstances than by the patriarchal image of woman as nurturer, which they had internalized. Virginia Woolf, who labelled this image the "angel in the house," warned that women would have to destroy this aspect of themselves to succeed as artists.[5]

Woolf also recognized the importance of a physical space for the creative woman. A studio, preferably outside the home, provides privacy and strenthens a woman's artistic identity. But after the first exhilarating years on Beaver Hall Hill, few of these painters could afford the luxury of a studio.

Sarah Robertson's life was overshadowed by a dominating mother. Jessie Robertson was devastated by the death of her only son, Louis, who was killed at Ypres in July 1916. Sarah's cousin, who used to visit the painter's family in the 1940s, remembers the dark apartment, presided over by the mother in a long black dress and black choker.[6] Thirty years after Louis's death, his mother was still in mourning.

Jessie Robertson's excessive grief affected the lives of her three daughters. Sarah was obliged to give up her fiancé. The alleged reason was that he was not good enough for her, but Jessie's opposition may have been reinforced by her resentment that Sarah's fiancé had survived the war when Louis had not. Anecdotal evidence suggests that Sarah's fiancé was Lieutenant Orin Rexford, Louis's best friend.[7]

Why did Sarah Robertson agree to break her engagement? She may have felt that she had no choice. Although she was at least twenty-five when the rupture occurred, she was still living at home and dependent on her parents. As an exhibiting artist, she may also have worried about what would happen to her career if she married. Most of Sarah Robertson's adult life was spent in genteel poverty, owing to the decline in her father's business. In 1922, the family was forced to sell their house at Chambly, which must have been devastating for Sarah, who loved the country. She had few opportunities to travel, except for visits to friends. When a Van Gogh exhibition came to Toronto in 1936, Jackson offered to pay her fare, urging her to "come along and see the marvels of Toronto with your own eyes and not just depend on Prue to tell you about it."[8]

All three of the Robertson sisters had to struggle to win a measure of independence. Marion (1894-1978), who was treated as an invalid by her mother, painted watercolours and contributed to the AAM Spring Exhibitions from 1911 to 1939; Elizabeth (1897-1978) trained as a nurse,

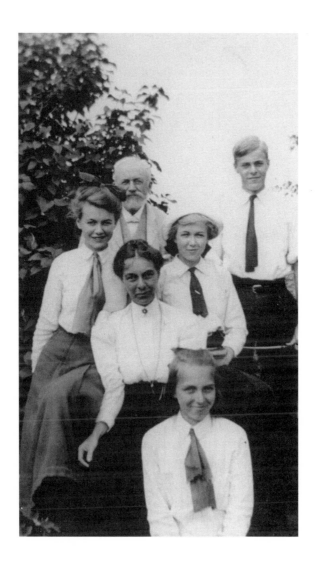

Robertson family.
Back row, from left: John and Louis;
second row: Marion and Sarah;
third row: Jessie; front: Elizabeth.
Courtesy of Alison Rolland.

From left: Ernest McNown, Mabel Lockerby,
Jean McNown, and Florence Lockerby Mullan.
Courtesy of Margaret Pope.

despite parental objections, and worked at the CNR's Turcot yards. Sarah, who had a warm relationship with her sisters, introduced them to her painting friends and included them in many of the friends' activities.

Natural high spirits and a sense of humour helped Sarah overcome the constraints of her daily life. Naomi Jackson Groves spoke of the "effervescence" Sarah revealed in her work—a quality that seemed out of keeping with her "mousey" appearance. "We always said that Sarah was the size of a mouse and had the courage of a lion."[9]

Anne Savage compared Sarah, with "her widely set blue eyes and fair hair," to a Botticelli angel, "playing and constantly singing hymns of praise."[10] As Anne recognized, her friend had the capacity to take pleasure in simple things. "One day in the country to Sarah was a tremendous event." And if she could not get to the country, she would paint the view from her window, or the Virginia creeper she saw on her daily walk. The Sulpician Seminary at the top of her street was a subject to which she often returned, painting it from various angles in all seasons.

Outwardly, Mabel Lockerby's circumstances resembled Sarah Robertson's: a household of women, dwindling finances, and few opportunities for travel. Mabel Irene, the second daughter of Barbara Cox (1848-1939) and Alexander Linton Lockerby (1848-1915), lived with her widowed mother and sisters Eva and Hazel. But Mabel enjoyed more independence than Sarah, since it was she who took over responsibility for the family after the death of Alexander Lockerby.

Unlike Sarah, Mabel found a way of accommodating both her creative drive and her sexuality. She had a relationship with her cousin Ernest McNown that began when they were teenagers and lasted all their lives.[11] McNown, who was exactly her age, served as a private in the First World War. Although there may have been some kind of contract between them (McNown claimed that they were secretly married before he went overseas), they never lived together. Parental disapproval of marriage between cousins may have deterred the couple from marrying in their youth, but the mature Lockerby probably had her own reasons for preferring the status quo. McNown was a travelling salesman with no

fixed home and a weakness for alcohol. By staying single, Mabel Lockerby was assured of a roof over her head and the freedom to paint. In the evenings she visited McNown, who boarded with his sister or niece when not "on the road."

This comfortable arrangement was disrupted in 1950, when McNown moved to Toronto with his niece's family. After the move, Mabel rarely saw Ernest, but she continued to write, beginning each letter "Dear old love," until a few weeks before her death.

Mabel Lockerby found a way of life that satisfied her and allowed her the freedom to paint. According to a relative, she was comfortable with her sexuality and outspoken about the female body. Unconventional and unsentimental, Mabel Lockerby had her own opinions on everything from politics to hockey.

A love of animals formed a special bond among Mabel Lockerby, Prudence Heward, and Kathleen Morris, all of whom adored their dogs. The Lockerby menagerie included a parrot (dubbed vicious by outsiders), a dog, and two cats, some of whom appear in her paintings. Kathleen Morris supported the S.P.C.A. and fought against cruelty to animals, on one occasion chastising a cabdriver for beating his horse.[12] Animals feature prominently in her work, from the ubiquitous sleigh-horses to delicate images of sparrows on a telephone wire.

Kathleen Moir Morris was the fourth child and only daughter of Eliza Howard Bell (1862-1949) and Montague John Morris (1848-1914). Kathleen suffered from a congenital nervous ailment which impaired her speech and co-ordination. She seldom seemed embarrassed by her disability, according to a friend who attributed Kathleen's self-confidence to "the intelligent support and boundless love given her by her mother and brothers. Mrs. Morris devoted her life to her."[13]

Eliza, a strong woman with feminist opinions, was determined to give her daughter every opportunity. Since Kathleen loved to draw, Eliza arranged piano lessons for her to improve her co-ordination.[14] Soon Kathleen could control her pencil sufficiently to enrol at the AAM school.

From late 1923 to 1929, Kathleen and Eliza lived in Ottawa, where

the painter was encouraged by the National Gallery's Eric Brown. On returning to Montreal, the women found an apartment near St. Joseph's Oratory. Kathleen enjoyed the area, painting the Oratory, old houses on Queen Mary Road, and the birds that flocked to their balcony in winter. Her youngest brother, Harold, an amateur naturalist, moved in with them.

In the summer, Kathleen and her mother went to Marshall's Bay, near Arnprior, Ontario, staying at a simple cottage belonging to Eliza's parents. There was no running water and no electricity until 1950. But Kathleen loved it, swimming and fishing as a child, and later, sketching the cows at the neighbouring farm. Her nephew, Angus Morris, remarked that Kathleen considered herself a "winter" painter, and sketched at Marshall's Bay purely for her own enjoyment.[15]

In winter, Kathleen went on sketching trips to Quebec City, the Laurentians, and Berthierville. The sketch for her well-known painting, *After Grand Mass, Berthier-en-Haut,* was made in 1923, although the canvas itself was not completed until 1927. Many years later, Kathleen Morris described the thrill of seeing the horses, sometimes as many as 300, all with different coloured blankets, waiting outside the old church.[16] She had to work quickly before the people dispersed, catching the essential groupings of horses and people, then putting in the snow and background later. Reminiscing about those trips, Kathleen said: "I had a wonderful mother. She would take me off on sketching trips and sit beside me while I painted." But on the coldest days, Kathleen went alone. She was dropped off by sleigh, and painted standing in the sleigh tracks, wearing an apron over an old fur coat. She did two sketches, one in the morning and another in the afternoon, and "never fiddled with them" afterwards.[17] The spontaneity and joy in these sketches reflect her exhilaration at recognizing a subject and being able to put it down in paint.

Like Kathleen Morris, Prudence Heward lived with her widowed mother. Efa Heward, the mother of eight children, had artistic skills, and encouraged her daughters' talents, but she had rigid standards on matters of dress, manners, and morals. Prudence chewed gum in her studio, but never in the drawing room.

In 1930 Prudence and her mother moved into a large house, 3467 Peel Street. The downstairs was presided over by Efa, who served tea, a daily ritual, to the extended family including her eldest son Chilion, the surrogate patriarch of the family.[18] Prudence had a large studio on the top floor and a bedroom filled with art deco furniture that she had painted herself. Her brother Jim, who lived on this floor until his marriage, shared Prudence's love of music and ironic sense of humour. In Prudence's portrait *Jim* (1928), her only painting of an adult man, the frontal pose and the tightly wrapped scarf suggest a certain rigidity in the subject which is qualified by the inward expression of the eyes.

Prudence, who was naturally shy, drew poise and self-confidence from her social background. Family money enabled her to travel and study abroad. She had a car, a studio, and no domestic responsibilities. But for all this, she paid a price. According to her niece, Ann Johansson, Prudence suffered physically and emotionally from the stress of belonging to a large, hypercritical family.[19] Her social life was "filtered through the family." Her painting friends were scrutinized at the tea table and on their visits to Fernbank, the Hewards' summer home. Although Prudence enjoyed the sketching picnics with her friends, she may have found summers at Fernbank somewhat claustrophobic.

Prudence was delicate as a child, and later developed asthma. Her condition may have been aggravated by conflicts in her personality: on one side, the well-mannered lady; on the other, the free-thinking artist. When she visited Paris, she stayed in an expensive hotel on the Right Bank, isolated, as painter André Biéler observed, from the Bohemian life of her fellow artists.[20] Lacking the temperament of the rebel, she remained caught between two worlds, not entirely comfortable in either.

Another source of stress may have been her repressed sexuality. Prudence's nephew, John Heward, believes that she had a great fear of, and longing for, "the dominating male figure"—an archetype she may have recognized in her handsome cousin Frank Heward.[21] Frank, a marine engineer, was married—but living apart from his wife—when he and Prudence became close. Whether marriage was ever discussed is not

known. Divorce was considered scandalous in the 1930s, and for Frank, whose wife was Roman Catholic, it would have been extremely difficult.

Prudence Heward's complex, ambivalent attitude towards sexuality is reflected in many of her paintings of women. An image like *Autumn* (or *Girl with Apple*, 1942; cover and plate 23) unsettles the viewer because of the heroic scale of the female figure and the sexual tension suggested by the unconventional pose.

Like Prudence Heward, Anne Savage was encircled by a large, affectionate family. Her father John George had seven children by his first wife and four by his second wife Helen (or Lella) Lizars Galt. Annie Douglas Savage was Lella's second daughter, named after an aunt. As an adult she rejected the diminutive form of her name, feeling a tremendous sense of liberation when she first signed herself "Anne."[22]

John Savage's second family—Helen, Anne, Don, and Queenie— grew up on his experimental farm at Dorval. They spent their summers at Lake Wonish, an isolated estate in the Laurentians that became a sacred place for Anne. Later she found in Wonish a retreat where she could paint and a centre for relaxation and the renewal of family ties.

Anne Savage's position within her family was different from Prudence Heward's, because Anne earned her own living. Her job as art teacher, and later Art Supervisor for the Montreal Protestant School Board, gave her financial independence and status within the family. She had the means to travel, to visit Europe, and to build a studio at Wonish in 1933. Her painting and her opinions commanded the respect of her highly successful brothers-in-law: liberal politician Brooke Claxton (who married Helen) and Terry MacDermot (Queenie's husband), an educator and diplomat.[23] Anne Savage valued her independence, claiming "the mercy and the blessing to have to earn your living in some way is one of the best things that can happen to you."[24]

Although Anne trained to be a painter, she knew that she would have to find a way to make her art pay. After experimenting with medical drawing and commercial art, she found her vocation as art educator, teaching for 28 years at Baron Byng High School.

For most of her adult life, Anne lived with her mother in a modest house on Highland Avenue. The two women had great affection for each other and shared a love of music and reading. Lella took care of the housekeeping, with the help of the family's former nanny, Margaret English (Gee-Gee), while Anne managed the accounts. When John Savage died in 1922, the family business, Albert Soaps, was in decline. Although it continued to provide some revenue, Anne's salary was essential to the household.

According to her nieces, Anne had many men friends in her youth and at least one opportunity to marry. "I find weddings most upsetting affairs—but great fun," she wrote to A.Y. Jackson on the occasion of her sister Helen's wedding.[25] Anne's anxiety is understandable. The wedding must have forced her to reflect on her age (twenty-eight), and the added responsibility that she, as the only unmarried daughter, would bear.

The deepest emotional experience in Anne Savage's life was probably her love for A.Y. Jackson, as Anne McDougall suggested in her memoir, *Anne Savage: The Story of a Canadian Painter*. Both Anne Savage and Alex Jackson had difficulty expressing their feelings, finding it easier to write than to speak. He often resorted to describing nature when he wanted to express his tenderness for her. She occasionally used the same stratagem, writing: "The dearest little breeze has just sprung up—the air is full of a strange ecstasy—I think if you were here I might be able to talk to you—but then if you were no doubt I would remain dumb."[26]

Anne Savage wrote those words in June 1933, the year their relationship reached a climax. Jackson, who had turned fifty the previous October, became increasingly aware of his own mortality following an unpleasant tonsillectomy and a prolonged depression. In response to his urgent request, Anne visited Georgian Bay in July, camping out with Jackson and his cousins on the Western Islands. Two months later, Jackson wrote proposing marriage but in terms that conveyed his own hesitation. "What do you want me to do Anne? You are the dearest and sweetest soul I know, and if you will be my wife I will try so much to make you happy."[27] Her reply is not extant, but Jackson's letter of 8 October 1933 suggests

that responsibility for her mother was the reason alleged for her refusal. There were other reasons. Jackson's letters following the camping trip reflect Anne's anxiety about his friendships with other women and his itinerant way of life. Marriage to Jackson, who lived in Toronto, would have meant giving up her work at Baron Byng High School. Anne Savage may also have feared, whether consciously or not, that proximity to an artist of Jackson's stature might threaten her own development as a painter.

Jackson was obviously relieved by her decision. After 1933, his letters gradually lose their emotional urgency. Her letters to Jackson continue until at least 1967, giving a running commentary on her life, with only an occasional hint of deeper feelings. One letter stands apart from the rest. On 18 June 1944, nearly two years after her mother's death, Anne wrote suggesting that perhaps they could make a life together: "To seek one's own personal happiness is hopeless but to be able to help someone else would be well worthwhile."[28]

It must have taken courage for a woman of forty-eight to contemplate such a radical change in her life, and Anne may have felt relief as well as disappointment when Jackson drew back. As she herself acknowledged five years later to Jackson's niece Geneva Jackson Baird, "it would never have worked."[29]

In making her offer, Anne may have been motivated by her deep-rooted need to serve as well as by romantic love. After retirement in 1953, she took on new duties as art educator, while continuing her role as "angel in the house." She had already nursed her mother, with the help of Margaret English, and when the latter fell ill, Anne nursed her to the end. In doing so, she neglected her own health. Three weeks after Margaret English's death, Anne was operated on for breast cancer.[30]

Anne Savage's story suggests how difficult it is for a woman to destroy the internalized image of the "angel in the house." As a child, Anne was influenced by the Christian values of her father, an elder of Knox-Crescent Church, and by images of woman as nurturer in the Bible and in school texts. The accepted professions for women in her family were the "caring"

ones of teaching and nursing. The stereotype of woman as nurturer lies behind many of the tasks she undertook, for example, sharing her house with an evacuee family during the war. Despite her success as artist and educator, Anne continued to play the role of the self-sacrificing woman that she had learned as a child.

Henrietta Mabel May also had a strong sense of family responsibility. The fifth of ten children born to Evelyn Henrietta Walker (1843-1930) and Edward May (1840-1916), Mabel took up painting in her teens, but postponed her professional training until her mid-twenties to help with the younger children. Lively and energetic, Mabel (or "Henry") was a "source of strength for the whole family."[31]

After completing her art studies with a trip to Europe (1912-13), Mabel returned to Montreal, where she rented a studio at 745 St. Catherine Street West (later the site of the York Theatre). She continued to live at 434 Elm Avenue with her parents, sister Lillian, brother Stanley, and Stanley's son Jack (b. 1919). In summer, she painted at Hudson Heights, where the family had a country cottage, and occasionally joined Lillian in a game of golf.

During the Depression when property values fell, the Mays were forced to sell their cottage and take in boarders. Mabel May gave up her studio and, while continuing to paint, turned to teaching to support herself.

At the age of fifty-nine, May embarked on a new career, becoming art mistress at Elmwood School in Ottawa. She later said that her ten years in Ottawa were "some of [her] happiest years."[32] Family bonds were still strong, however, and in 1950, Mabel and Lillian moved to Vancouver—home of their sister, Queenie White. Before leaving for the West, Mabel May had an exhibition at the Dominion Gallery, her first solo exhibition in her native city.

Lilias Torrance Newton was the only one of the Beaver Hall painters to marry. While in England during the war, she met Frederick Gilbert Newton, a lieutenant in the Canadian army. On 1 June 1921, Lilias and Fred were married in Lachine, Quebec. Anecdotal evidence suggests

that Lilias Newton only agreed to marry on condition that she could spend six months of the year studying in Paris.[33]

Women painters who marry frequently experience conflicts between their domestic and their professional responsibilities. In an effort to resolve the conflict, some painters change the direction of their career; others paint less, or stop exhibiting and paint only for self-fulfilment. Montreal painter Marian Dale Scott (1906-93) limited her painting for several years after the birth of her son. Later, she juggled her work schedule to suit the convenience of her husband, Frank Scott, poet, lawyer, and academic.[34] Regina Seiden (1897-1991), who studied at the AAM with the Beaver Hall women, married European painter Eric Goldberg. For forty years she devoted herself to furthering her husband's career rather than her own, because she feared that competition would destroy her marriage.[35]

Lilias Newton's marriage lasted ten years. During that period she contributed to international exhibitions, sold three paintings to the National Gallery, and was elected an Associate of the RCA. She visited Paris twice, in 1923, when she studied drawing and composition with Alexander Jacovleff, and in 1929, accompanied by her son and his nanny. Francis Forbes Newton was born on 16 April 1926. Lilias's maternal duties may have temporarily reduced her artistic output, since she did not exhibit at the AAM Spring Exhibition or the RCA in 1926. But the following year, she showed three portraits at the RCA and, like other new mothers, sketched her child.

A long article in *Saturday Night*, in 1927, portrayed the 31-year-old Newton as a kind of "superwoman."[36] The article neglected to mention that to succeed in her triple role (wife, mother, painter) Newton needed a studio, domestic help, and financial support. All these things, which she took for granted in 1927, were jeopardized in October 1929, when her stockbroker husband suffered heavy financial losses.

Lilias and Fred Newton may have been temperamentally unsuited, as Fred's brother suggested.[37] In any case, the couple's relationship deteriorated after the stockmarket crash when Fred Newton began to

Lilias Torrance Newton with her son Francis Forbes, c. 1929.
Newton Papers, National Gallery of Canada Archives.

drink heavily. In May 1931, he left Montreal and never saw his family again. Two years later, Lilias Newton obtained a divorce by parliamentary decree on the grounds of her husband's adultery. The Divorce Law of 1925 had given women the right to divorce on the same grounds as men—simple adultery. The ideology of the period maintained, however, that it was the wife's duty to preserve the marriage for the benefit of the family and the nation.[38] Lilias Newton's career does not seem to have been damaged by her divorce, probably because she was perceived as the wronged party.

Faced with the problem of supporting herself and her son, Lilias Newton taught students in her studio, while building a clientele for her portraits. Her portrait of Frances McCall (c. 1931; plate 14), a large-scale figure set against a Laurentian landscape, was probably commissioned at this time. The sitter's husband, Ronald McCall, was a supporter of modern art and a friend of the Beaver Hall women. Eric Brown of the National Gallery also helped Newton, by commissioning a portrait of himself and recommending her to other clients. "I don't know what I would do without you as a refuge & a support," she wrote Brown in 1938.[39]

The portrait of Brown, followed by paintings of Vincent and Alice Massey, launched Lilias Newton's career as a commercial portrait painter. Her success was due to her social background, which helped her feel at ease in upper-class circles, and to the genuine interest she took in people. She claimed to be "obsessed by people," and when not painting, she observed them "in the street, on the bus, in the shops." While painting, she liked to chat to draw her subjects out. "The impact of the sitter's personality on mine is what I paint," she said. "There must be sympathy between the subject and the artist for the portrait to be good."[40] Many of Newton's sitters became her friends.

Lilias Newton's success as a portrait painter came at a cost to herself and her son. Since she travelled a lot, she sent Forbes to boarding-school. According to Forbes, he and his mother were never close. Lilias was impatient and did not like children very much. Nevertheless, she

obviously cared deeply about her son and suffered the usual maternal anxieties when he was away at school.[41]

After Forbes grew up, Lilias enjoyed more independence than any of the other Beaver Hall women. She travelled across Canada, fulfilling commissions for boardrooms and council chambers. A brilliant conversationalist, Lilias was stimulated by company and travel. There was a dark side to her personality, however, that few suspected: she suffered from bouts of depression. She had always enjoyed a scotch, but in her later years began to drink more heavily, possibly to alter her mood.[42]

Lilias Newton's depressions suggest a split between the public persona of successful artist and the private woman. Lilias suffered many losses in her personal life. Her father died before she was born. In 1925, she lost her mother, to whom she was very close. Two of her brothers were killed in the First World War and the third, Stewart Torrance, died in 1942, ten years after a paralytic stroke.[43] These deaths, in addition to the break-up of her marriage, must have left Lilias feeling very much alone. Despite her strings of friends and admirers, Lilias Newton may have been a lonely woman, craving the intimacy that she was unable to achieve, even with her son.

As we have seen, several of the Beaver Hall women had difficulty reconciling their personal and professional aspirations. Some of the problems they faced are common to all artists, male and female. Women painters who live with their "birth families" are often perceived to have an advantage over male artists who have to support themselves and their families. It is true these women were economically privileged (particularly when compared to working-class women), but living with their parents entailed certain responsibilities and loss of freedom. There was no medicare or subsidized help for the elderly at this time. Society expected unmarried women to care for family members, even at the expense of their own health and careers.[44]

Nevertheless, the Beaver Hall women led rich, fulfilling lives. Anne Savage summed up the situation in her lecture on Canadian women

painters: "It is a brave story," she said. "We all know the problem—the struggle to meet the home demands and over and above to find time for the expression of creative ideas."[45]

Chapter Six

Friendships

UNTIL RECENTLY, friendship between women has been a neglected topic. Writers have celebrated the bonds between men (Achilles and Patroclos, Oliver and Rolland), but have found little to say about female friendships. In the last thirty years, however, feminist historians have discovered the important role friendship has played in women's domestic and professional lives. For example, British writers Vera Brittain and Winifred Holtby, who met as students in the 1920s, were sustained by an enduring friendship. This bond, as Carolyn Heilbrun notes, enabled them to withstand the risks and pains of public life.[1]

Traditionally, art historians have emphasized the role that male mentors have played in the careers of women painters from Judith Leyster to Georgia O'Keeffe. The help that women received from other women was largely overlooked. But recently, feminist historians like Deborah Cherry and Janice Helland have focussed attention on networks of women artists in 19th-century Manchester and Glasgow.[2]

The Beaver Hall women received support from their teacher, William Brymner, and from A.Y. Jackson, but the help and encouragement they gave one another was even more crucial to their professional careers. They studied together, got to know each other's families, understood and sympathized with each other's problems as women and as artists. Just as living in Toronto created a certain physical distance between Jackson and the Beaver Hall "gang," so his position as an older, established,

male painter created a psychological distance between him and the women.

The Beaver Hall women's network was not a rigid structure with leaders and followers, but a cluster of overlapping friendships. They thought of one another as friends. "Her painting friends meant a lot to her," Sarah Robertson said of Prudence Heward, and the same was true of them all.[3]

Shared interests and goals, mutual admiration, a desire for companionship or intimacy—any one or more of these may be the basis of a friendship. But there is often another element, hard to define, that corresponds to the magnetism in sexual love. Friends, like lovers, are often attracted to each other because of the perceived differences between them. Prudence Heward and Sarah Robertson complemented each other both physically and temperamentally: the former, tall, dark, and serious, the latter short, fair, and effervescent.

Friendships are "relationships of equality," according to sociologist Pat O'Connor, and usually occur between women of the same ethnic background, class, marital status, and age group.[4] The Beaver Hall women (except Emily Coonan) belonged to the same class and ethnic group, and all, except Lilias Newton, were single. Although there was a difference of 21 years between the youngest and the eldest, the disparity was overcome by their shared interests and goals as exhibiting artists.

In 19th-century America, as Carroll Smith-Rosenberg concludes, female friendships were often part of highly integrated networks.[5] These networks sustained women during the main events of their lives— marriage, childbirth, and death. In some ways, the alliance between the Beaver Hall women resembled these 19th-century groups. The painters supported each other during periods of illness or domestic crisis; Anne Savage made regular visits to the ailing Sarah Robertson. Individual friendships like that between Prudence Heward and Sarah Robertson were part of a larger group that included the mothers and sisters of some of the painters. Thus Sarah Robertson's sisters continued to visit the Heward family long after the deaths of Prudence and Sarah.

But the Beaver Hall "gang," unlike the 19th-century networks, was an alliance of professional painters competing in the public world for recognition, exhibition space, and sales. For the painters, as for Brittain and Holtby, friendship meant more than intimacy (important as that was); it meant what Caroline Heilbrun called the "enabling bond."

Male artists, like other professionals, have their clubs and informal meeting places. Many of the men who had studied with the Beaver Hall women joined the Pen and Pencil Club, an informal group which met to discuss the arts for nearly seventy years, 1890-1959. As noted by the Club's historian, women were "rigidly excluded."[6] The Arts Club, founded in 1912, was a larger, more formal institution with its own clubhouse on Victoria Street. Women, including Lilias Newton and Kathleen Morris, were sometimes invited to exhibit, but no women were admitted as members until the 1960s.[7]

Women were also excluded from many public spaces where men gathered to talk and drink. Kaufman's Tavern near Beaver Hall Square and the Oxford Pub on University Street were favourite meeting places for artists and writers. The painter André Biéler remembers the wine, bonhomie, and impassioned discussions of art at Kaufman's Tavern. Shut out from this world, the Beaver Hall women formed their own club— "a nucleus of interest and conversation," as Anne Savage described it.[8]

After they gave up their studios on Beaver Hall Hill, most of the women painted at home. To offset the solitary hours in the studio, they had teas, sketching picnics, and weekends in the country. The Heward house on Peel Street, the Savage home on Highland Avenue, and the Morris apartment on Avenue de l'Oratoire were popular meeting places. Informal gatherings gave the friends an opportunity to exchange news of the art world and see each other's work. "Kay Morris came back & we all gathered at tea to see the results of her trip," Anne Savage remarked. "She had some very good sketches of Quebec street scenes—very solidly painted."[9]

When visiting one another's country houses, the women would often sketch together. Sarah Robertson, Ethel Seath, and Anne Savage were

frequent visitors to the Collyer farm at Foster. "It was just perfect," Anne Savage remarked after one such visit. "Nora is one of the loveliest people imaginable, so unpretentious, so apparently listless and apathetic and so full of fun and constant chatter, thoughtful and planning for everyone." Lilias Newton found sketching at Lake Wonish a welcome change from portraiture. "It was a joy to see Lilias so happy," Anne Savage noted after Newton's visit in 1937.[10]

Prudence Heward made Fernbank into a centre of painting activity. She invited her women friends, a neighbouring family called Eliot, and A.Y. Jackson. Together, the painters explored the old settlements around Brockville, picnicked under the trees, and sketched the barns, ragged fences, and ripening fields.

Visiting exhibitions was another activity that brought the women together. Kathleen Morris and Prudence Heward went to Ottawa to see the J.E.H. MacDonald Memorial Exhibition, which Morris described as a "knockout." They attended each other's *vernissages* and supported Anne Savage by visiting her students' shows at Baron Byng High School.[11]

Occasionally the women modelled for each other, as they had done in Brymner's class. The two portraits that Prudence Heward did of Mabel Lockerby in the 1920s attest to the bond that existed between the painters at that time. Lilias Newton's canvas *Prudence Heward* (c.1926) is the only portrait of her painting friends to survive.[12] But she also painted Mabel May's young nephew, Jack, and Anne Savage's sisters and mother. *Mrs. John Savage* (c.1924) is a particularly fine portrait of an older woman, whose well-modelled face expresses humour and compassion.

The painters sometimes shared models. The little girl who posed for Prudence Heward's *Farmhouse Window* also sat for Mabel Lockerby.[13] They may have taken life classes together. Anne Savage, who painted few portraits after she left art school, writes: "Have just come in from the class at the Gallery & we had the most lovely dark girl—Prue got her she was a delight."[14]

They bought each other's sketches and encouraged their families to do likewise. Works by Robertson, Morris, Seath, and Lockerby are still

in the collections of Heward's nieces and nephews. The painters discreetly promoted each other's careers. Lilias Newton tried to get a travelling scholarship for Anne Savage in 1935, and Sarah Robertson wrote to the director of the National Gallery, praising a 1944 exhibition by Heward, Newton, Savage, and Seath. When Kathleen Morris was up for election as an associate member of the Royal Canadian Academy in 1929, Mabel May and Lilias Newton, who were non-voting associates, attended the RCA annual meeting for the first time to support their friend.[15]

There were few opportunities for solo exhibitions when the Beaver Hall women began their careers. By banding together, they presented a strong alliance to art curators and collectors. The painters encouraged one another to exhibit at the annual shows and international exhibitions. When possible, they organized their own shows, like the 1930 *Group of Contemporary Montreal Artists* at the AAM. Their paintings showed well together, as they treated similar themes. After seeing a four-woman show (Heward, Robertson, Seath, and Savage) at the Art Gallery of Toronto, Jackson remarked: "All very individual, but a feeling of unity, a common outlook."[16]

All artists have periods of doubt when they lose confidence in their work; but for women painters in the early 20th century such doubts were particularly acute as they had few female models to inspire them. Sarah Robertson agonized over her three-woman exhibition at Hart House, afraid that she did not have enough good paintings. Prudence Heward told Eric Brown that she was very nervous before her first solo exhibition, "[I] wake up at night & think everything will look awful." And Kathleen Morris felt that an exhibition of Jackson's was so good that "it almost discourages anyone like myself from even thinking of having one."[17]

Sometimes the Beaver Hall women show a kind of diffidence towards their work, an attitude that reflects their early training in feminine deportment. A young girl was considered boastful and unladylike if she appeared to promote her own work. "My sketches are not very much, in fact I was just thinking how awful they were," Sarah Robertson wrote to a prospective client.[18] In this context, the painter's remark does not sound

Prudence Heward, left, and Isabel McLaughlin,
with sketching materials.
Courtesy of Isabel McLaughlin.

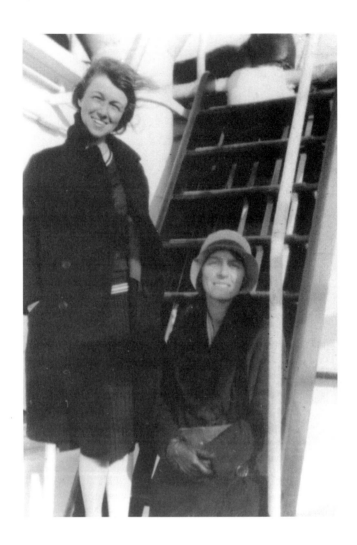

Sarah Robertson, left, and Nora Collyer
on a Bermuda cruise, c. 1929.
Courtesy of Helen Hendry.

like genuine self-criticism, but rather like the self-depreciation she had learned in childhood.

Anne Savage also disparaged her own work, as Jackson recognized. When he wanted one of her paintings for the Corcoran exhibition in 1930, he asked Sarah Robertson to choose it, saying: "You take control of her Sarah, she underestimates all her work."[19] Prudence Heward found it difficult to cope with the applause at a luncheon honouring her as winner of the Willingdon prize. She was almost frightened, according to Jackson, to be the centre of attention.[20] Prudence Heward's fear is easy to understand. Nothing in her upbringing had prepared her for professional success. Being part of a group of women, all struggling to establish themselves as professional artists, helped the painters to cope with periods of self-doubt and their own ambivalence towards success and failure.

Several of the Beaver Hall women had close relationships with women outside the group. These friends were, like the painters themselves, single professional women. Prudence Heward and Toronto painter Isabel McLaughlin met in 1929 at the suggestion of their mutual friend, A.Y. Jackson. Isabel McLaughlin was born in 1903, in Oshawa, Ontario, the third daughter of Robert Samuel McLaughlin, president of General Motors, Canada. She studied at the Ontario College of Art under Arthur Lismer and the Toronto Art Students' League.[21]

Prudence Heward and Isabel McLaughlin began their long friendship over tea at the Ritz Hotel in Paris. It must have been wonderful for Prudence Heward to meet a woman from her own social class who shared her passion for painting. The women visited the art galleries together and took classes at the Scandinavian Academy in Paris. Later they went on a sketching holiday in Normandy with the Montreal painter Clarence Gagnon and his wife.

The friends kept in touch after their return to Canada through letters and frequent visits. "It seems ages & ages since you were here," Prudence Heward wrote in 1934. "I simply loved having you, & everyone who met

you reiterates how charming you are etc. etc. . . . I tell you as one needs these little things to remember in our dark moments."[22]

Prudence Heward joined Isabel McLaughlin, Audrey Taylor, and Yvonne McKague Housser in 1936 for a trip to Bermuda, staying at the McLaughlin family villa. While there, Prudence produced several sketches, one of which served as the background to her 1938 portrait *Clytie*. These sketching trips with Isabel McLaughlin—in Bermuda, the Laurentians (1933), and elsewhere—may have been the happiest days of Prudence Heward's life. A snapshot of the friends, both carrying sketching boxes, shows Prudence relaxed and self-confident, radiating joy.[23]

At Christmas 1933, she begged Isabel McLaughlin to come to Montreal: "You'd have to choose between having a gay time or having me paint you & being quiet," she wrote. "I'd love to paint your funny face & I'd love to see it too."[24] Despite the teasing tone, Prudence Heward was thinking seriously about the portrait. "I have been planning just how I will paint you," she admitted. This forethought is typical of a painter who selected backgrounds and accessory details for symbolic as well as pictorial values. Isabel McLaughlin decided not to pose, fearing that it would be too much for her hostess—a decision she now regrets.[25] All who admire Heward's art must share this regret. The portrait would have been a wonderful tribute to the friendship between two women painters.

Ethel Seath's life was transformed by her friendship with Margaret Gascoigne, founder of The Study. Ethel Seath had been a newspaper illustrator for over twenty years when she met Margaret Gascoigne. "I thought no more of teaching than flying," Seath said, "until I met a fine person who was starting a school. . . . She had seen one of my little things in the Museum, and asked me to join her."[26] So began a partnership that enriched the lives of both women. Seath found a new creative outlet in teaching, and Gascoigne found a confidant with whom she could build her school.

Margaret Gascoigne (1876-1934) was born in Nottingham, England, and attended Lady Margaret Hall, Oxford, at a time before Oxford

granted degrees to women.[27] Arriving in Montreal in 1912, she taught at Miss Edgar's and Miss Cramp's before founding her own school. In September, 1917, when Ethel Seath joined The Study, the school had fifty-six pupils and a staff of five.

The two friends, although different in temperament (Gascoigne, impulsive and somewhat eccentric; Seath, reserved and more conservative) shared a passion for music and art. Both believed that education involved stimulating children to excel by exposing them to the best in art, literature, and music. They encouraged spontaneity and distrusted structures. The first students of The Study remember the excitement they felt when invited to the Headmistress's apartment for an evening of music. Margaret Gascoigne, who had studied to be a concert pianist, would play from her classical repertoire while her friend gazed into the fire.

Ethel Seath lived with her mother and sister, but often spent holidays with Margaret. Guthrie Gascoigne recalls the summer of 1932 when his aunt and Ethel Seath were staying in a cottage near Knowlton. It was not a happy time. Montreal was in the midst of the Depression and every day a letter would arrive announcing the withdrawal of another pupil.[28]

Anxiety about the school may have affected Margaret Gascoigne's health. She was operated on for cancer in January 1934, and died ten months later. In her will, she said that Ethel Seath had done as much for the school as she had herself.

For Ethel Seath the loss was devastating. She buried her friend in the Seath family plot and returned to the art room that had become her second home. She taught at The Study for another 28 years, a memorial to her friend.

Nora Collyer had a gift for friendship. Too shy and reserved to shine in public, she revealed her warmth and sense of fun among her chosen companions. She kept up relationships that had begun at Trafalgar School, but her closest friend was Margaret Reid (1900-79). Tall, well-groomed, and self-assured, Margaret Reid worked as an executive secretary for Dominion Oilcloth (Domco). The two women complemented each other

Charcoal drawing from Nora Collyer's sketchbook for
her unpublished children's story, "Toby's Tale."
Courtesy of Jane Wandell.

perfectly, Margaret supplying the social ease that her friend lacked.[29]

After the death of Alfred Collyer in 1946, Nora took an apartment at 3400 Ridgewood where she was later joined by Margaret Reid. In July 1950, the women bought a lot overlooking Lake Memphremagog. From that date, if not earlier, they shared their resources and their lives. Strawberry Hill, the summer cottage that they built, was a joy to them both. Nora Collyer spent the summer sketching and creating a beautiful garden. Margaret Reid joined her for the weekends. The two women shared a love of children, and considered a neighbour's daughter their adopted niece.[30]

Although Nora Collyer and Margaret Reid spent much time together, each kept her own friends and interests. When they moved to a duplex in Westmount, around 1953, each woman had a bedroom and sitting room. Nora Collyer used her sitting room as a studio, spreading a tarpaulin over the rug when she gave her classes.

In 1967, the friends sold Strawberry Hill, because the upkeep had become too much for them. Margaret Reid, whose mother had suffered from Alzheimer's disease, began to show symptoms herself. Nora Collyer took care of her friend as long as she could, but finally had to put her in a nursing home. According to a neighbour, "Margaret's illness was gradual . . . but of course it was an increasingly great worry for Nora. . . . It was acutely painful to see such a dear witty, kind and intelligent friend deteriorate so."[31] Nora Collyer continued to live in the duplex on Elm Avenue until she died, on 11 June 1979, just twelve days after her friend.

Emily Coonan did not have any intimate relationships outside her own family. For over eighty years, she lived in the family house on Farm Street in Point St. Charles. She attended mass regularly and copied an icon for the church sacristy, but took little part in the social life of the parish. She told her niece Pat Coonan that she had never been to a party—an extraordinary admission considering the gregarious customs of the tightly-knit Irish community.[32]

Introverted and self-sufficient, Emily Coonan was absolutely dedicated to her work. For most of her life, she painted at home, in the

house she shared with her father, sister Eva, brother Frank, and Frank's son Frankie (b.1930). Emily and Eva, a piano teacher, did the housework and took care of Frankie.

The painter's closest relationship may have been with her brother Thomas, her childhood playmate. Thomas, who became a lawyer and later a judge, moved away from the Point, but visited his family every week, bringing his daughter Pat. On these occasions Emily would discuss politics with Thomas and her father, leaving her sister Eva to entertain the children.

Emily Coonan found women uninteresting, according to her niece Pat, because they did not engage with ideas. The painter believed that if a woman had a talent she should develop it, otherwise she should marry or join a convent. She once asked Pat, a spinster, why she had not become a nun. Pat replied, "Because I don't like women," and felt that her aunt agreed.

This perception of women as intellectually limited probably originated in Coonan's childhood. Growing up in a working-class area, she had few models of professional women, other than nuns. She believed in her own talent, but to sustain this belief she may have set herself apart from other women. This negative opinion of women may have been partly responsible for her failure to make lasting friendships with the other Beaver Hall painters.

Emily Coonan's exhibiting career was short. Between 1908 and 1924, she contributed to many of the annual exhibitions at the AAM and the RCA and to a few international exhibitions. After 1925, she exhibited less frequently. In 1933, she showed a portrait of a young girl, *The Chinese Kimono* (c. 1933; plate 15) at the AAM Spring Exhibition. It was the last time she exhibited.

Many people have speculated on the reasons for her early retirement.[33] Pat Coonan blamed it on Samuel Morgan-Powell, music and art critic for the *Montreal Star*. But Morgan-Powell's attacks on Coonan's flamboyant style and poor drawing began in 1913 and continued into the 1920s. In the late 1920s and 1930s, he and other *Montreal Star*

reviewers simply ignored her.[34] Emily Coonan may have been hurt by this neglect. She may also have been discouraged by the death of William Brymner, her mentor, in 1925. In any case, she lost the will to exhibit. Faced with critical indifference, and lacking the inspiration and support of a group, she followed her own inclination for privacy and withdrew from the Montreal art world.

Emily Coonan continued to paint until the end of her life. But her later works, mostly landscapes, are rather conventional. This is not surprising, since painters, like other artists, need the stimulation of dialogue.

Her early retirement has affected her place in art history. While the reputations of the Beaver Hall women grew during the 1930s and 1940s, Coonan's name was forgotten. In 1955, a request for information about one of her paintings was addressed to her sister Eva. "I suppose people think I am dead," Emily Coonan replied, "as I haven't exhibited my work for a long time."[35]

Emily Coonan's story reminds us of the vulnerability of women artists. The other Beaver Hall women had the advantage of continual contact with one another. They lived in the same neighbourhood and visited one another frequently. They gave and received criticism, discussed new art trends, and stimulated one another to produce. A kind of momentum was built up that compelled them to exhibit because their friends were exhibiting. There was rivalry and, on Anne Savage's part, for example, some envy of Prudence Heward, the most acclaimed of the group. But the envy was unimportant compared to the love and reassurance they gave one another.

Chapter Seven

⬅

Surviving as Painters in the Great Depression

THE COLLAPSE of the New York stock market in October 1929 set off an economic crisis that affected all Canadians. In the next four years, factories closed, prices fell drastically, and farmers lost their farms to mortgage companies. At the peak of the Great Depression, 30% of the labour force was unemployed. Montreal, with a population of around 818,000, had 62,000 unemployed in 1934, and 242,000 on municipal assistance.[1] Hugh MacLennan evokes the atmosphere of the period in his novel *The Watch that Ends the Night*, describing the unemployed flowing "in two rivers along St. Catherine Street, and . . . stopping in front of shop windows to stare at the goods they could not buy."[2]

The Depression was particularly hard on women, who not only experienced wage cuts and a deterioration in working conditions, but also saw their right to work seriously challenged.[3] Women in business and the professions were accused of stealing men's jobs, and many were forced to postpone marriage, or keep their relationship secret, to retain their jobs. Married men with families got some relief from local authorities, but municipalities were reluctant to help single women, some of whom turned to prostitution to survive. Many married women were temporarily abandoned by husbands who "rode the rails" in search of work, or left permanently rather than face the shame of being "on the dole."

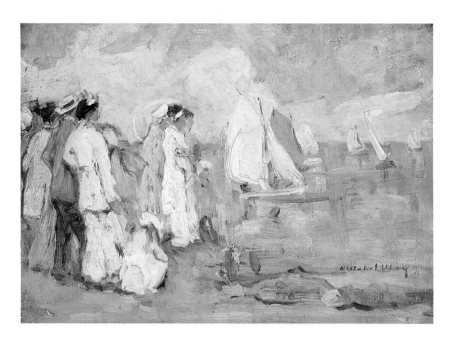

PLATE I
Henrietta Mabel May, *Yacht Racing*, 1914.
Oil on panel, 22.2 x 26.7 cm.
Leonard and Bina Ellen Art Gallery, Concordia University, Montreal.

PLATE 2
Sarah Robertson, *Joseph and Marie-Louise*, c. 1930.
Oil on canvas, 61.6 x 66.2 cm.
National Gallery of Canada, Ottawa.
Vincent Massey Bequest, 1968.

PLATE 3
Sarah Robertson, *The Red Sleigh*, c. 1924.
Oil on panel, 38.5 x 46.1 cm.
Private collection.

PLATE 4
Prudence Heward, *At the Theatre*, 1928.
Oil on canvas, 101.6 x 101.6 cm.
Montreal Museum of Fine Arts. Horsley and Annie Townsend bequest, 1964.
(Photo: Brian Merrett).

PLATE 7
Mabel May, *The Three Sisters*, c. 1915.
Oil on canvas, 77.2 x 67.3.
Beaverbrook Art Gallery, Fredericton, N.B. Gift of Lord Beaverbrook.

PLATE 8
Ethel Seath, *St. James's Cathedral from La Gauchetière Street*
(renamed Mary Queen of the World Cathedral), c. 1925.
Oil on panel, 41.0 x 30.8 cm. Private collection.

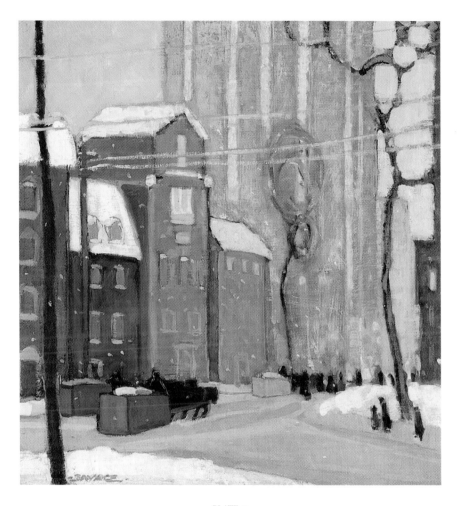

PLATE 9
Anne Savage, *Beaver Hall Square*, c. 1923.
Oil on canvas, 71.8 x 66.7.
Private collection.

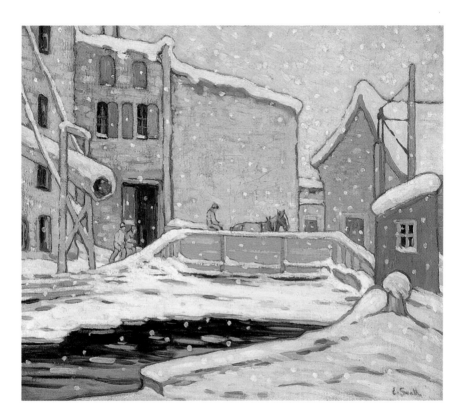

PLATE 10
Ethel Seath, *The Canal, Montreal*, c. 1924.
Oil on canvas, 66.7 x 76.9 cm.
Private collection.

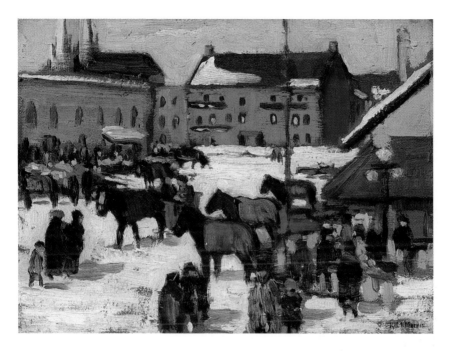

PLATE 11
Kathleen Morris, *Market Day, Ottawa*, c. 1924.
Oil on panel, 26.9 x 35.9 cm.
Private collection.

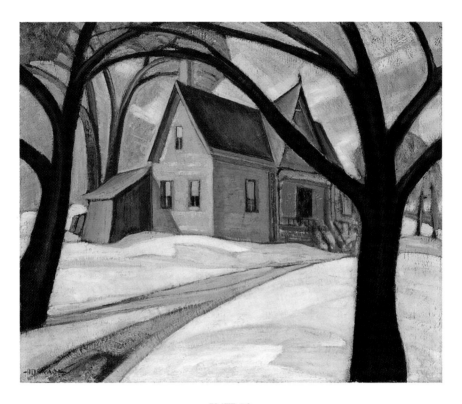

PLATE 12
Anne Savage, *The Red House, Dorval*, c. 1928.
Oil on canvas, 51.0 x 61.7 cm.
Musée du Québec. (Photo: Jean-Guy Kérouac, Musée du Québec).

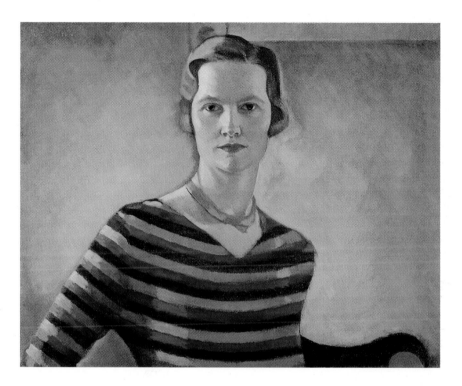

PLATE 5
Lilias Torrance Newton, *Self-Portrait*, c. 1929.
Oil on canvas, 61.5 x 76.6 cm.
National Gallery of Canada, Ottawa. Purchased, 1930.

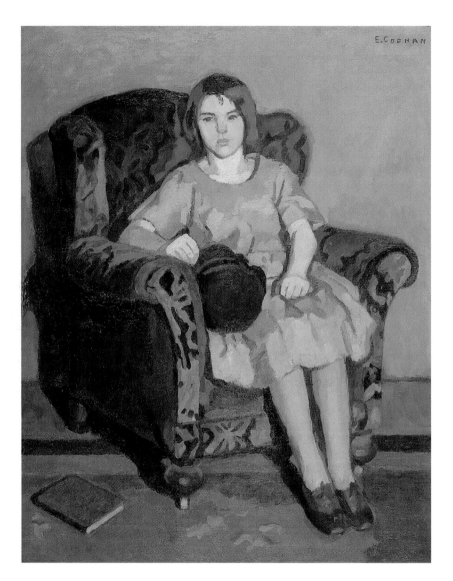

PLATE 6
Emily Coonan, *The Blue Armchair*, c. 1930.
Oil on canvas. 77.2 x 61.3.
Musée du Québec. (Photo: Patrick Altman, Musée du Québec).

PLATE 13
Kathleen Morris, *Queen Mary and Côte des Neiges Road*, n.d.
Oil on canvas, 45.7 x 61.0 cm.
Private collection.

PLATE 14
Lilias Torrance Newton, *Frances McCall*, c. 1931.
Oil on canvas, 81.3 x 66.0 cm.
Private collection.

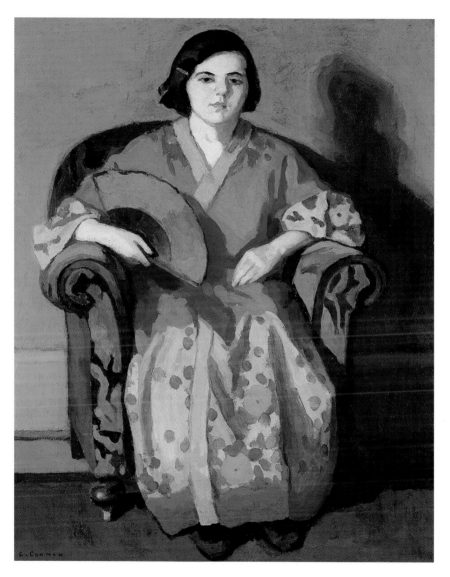

PLATE 15
Emily Coonan, *The Chinese Kimono*, c. 1933.
Oil on canvas, 76.0 x 61.0 cm.
Private collection.

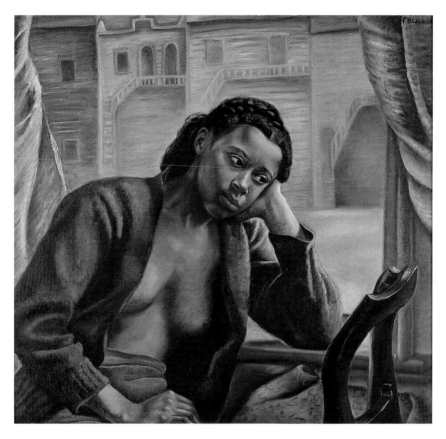

PLATE 16
Prudence Heward, *Girl in theWindow*, 1941.
Oil on canvas, 86.4 x 91.5 cm.
Art Gallery of Windsor.
Given in memory of the artist and her sister by the estate
of Gladys S. Nares, 1981.

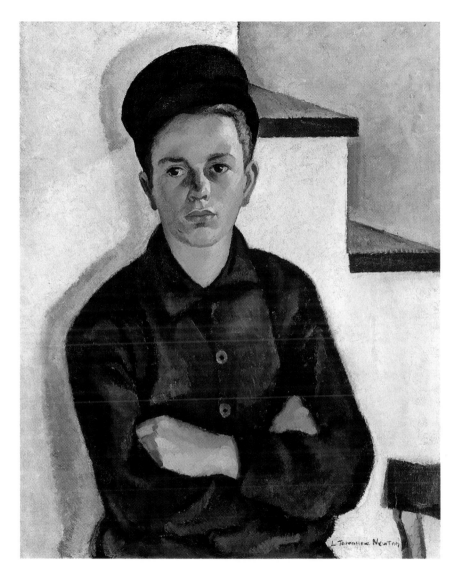

PLATE 17
Lilias Torrance Newton, *Maurice*, 1939.
Oil on canvas, 76.8 x 61.6 cm.
Hart House Permanent Collection, University of Toronto.
Purchased by the Art Committee with the income from the Harold
and Murray Wrong Memorial Fund, 1939.

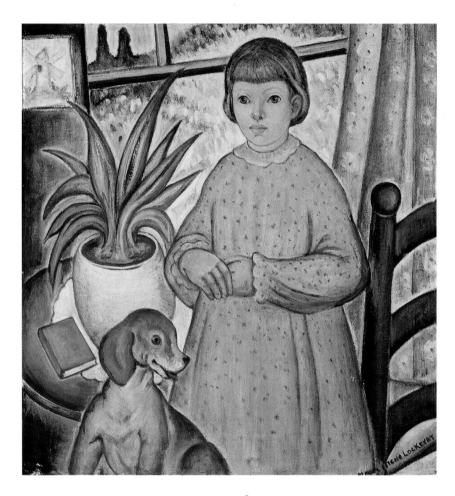

PLATE 18
Mabel Lockerby, *Lucille et Fifi*, c. 1939.
Oil on canvas, 79.8 x 75.5 cm.
Private collection.

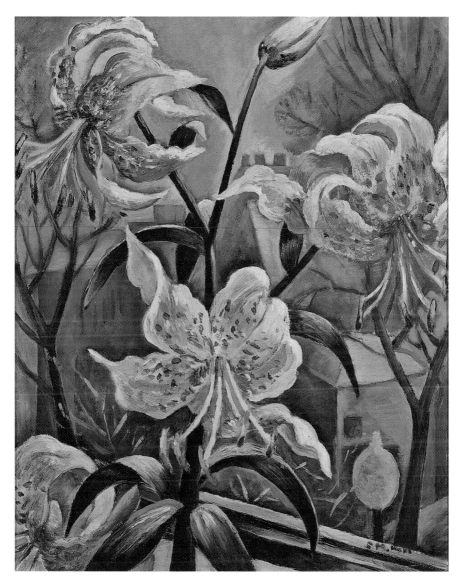

PLATE 19
Sarah Robertson, *Lilies*, c.1938.
Oil on panel, 51.3 x 42.3 cm.
Private collection.

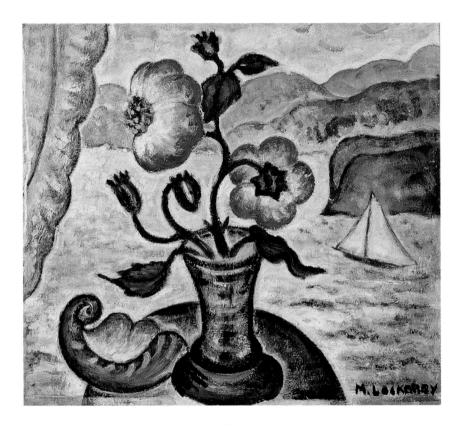

PLATE 20
Mabel Lockerby, *The Dahlia*, c. 1940.
Oil on panel, 39.8 x 45.0 cm.
Private collection.

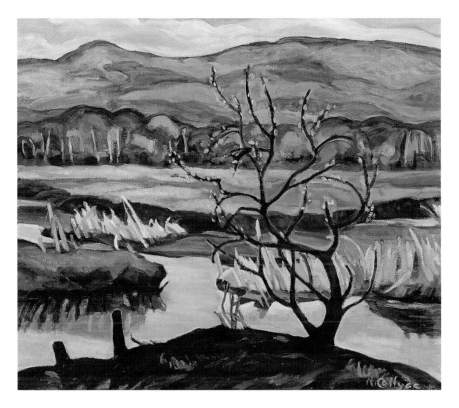

PLATE 2 I
Nora Collyer, *Spring Creek, Foster, Quebec* c. 1935.
Oil on canvas, 61.5 x 71.8 cm.
Private collection.

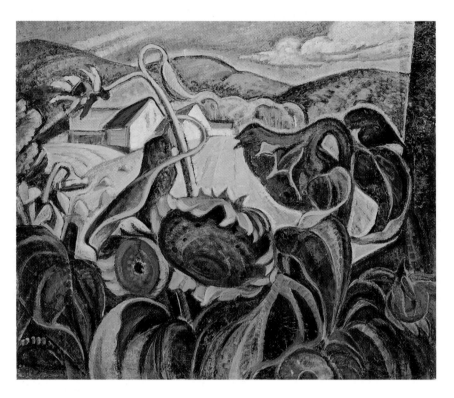

PLATE 22
Anne Savage, *Autumn, Eastern Townships (or Autumn),* c. 1935.
Oil on canvas, 64.0 x 76.6 cm.
Private collection.

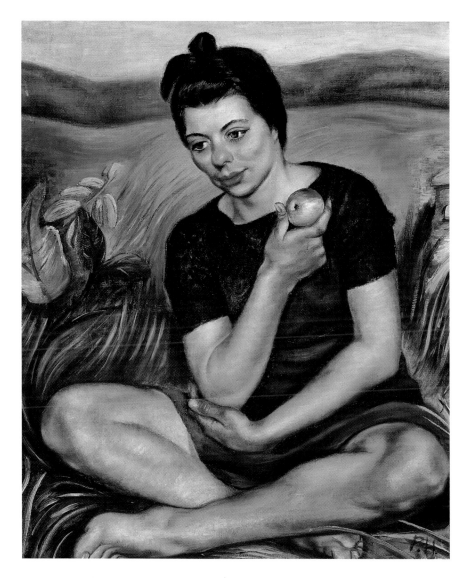

PLATE 2 3
Prudence Heward, *Autumn (or Girl with Apple)*, 1942.
Oil on canvas, 76.2 x 63.5
Private collection.

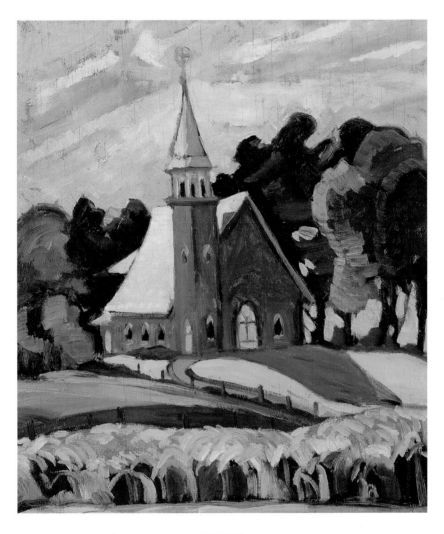

PLATE 24
Nora Collyer, *Village Church in Summer,* n. d.
Oil on panel, 46.1 x 41.0 cm.
Private collection.

In such a climate, public support for the arts declined rapidly. The National Gallery had its budget slashed from $130,000 in 1929 to $25,000 in 1934, and between 1932 and 1936, it bought only two contemporary Canadian paintings.[4] The Ontario Society of Artists, one of the oldest art associations in Canada, did not sell a single painting from its 1932 annual exhibition. A few private collectors like Vincent Massey and H.S. Southam bought Canadian paintings in the 1930s, but many people were reluctant to spend money on art in a time of social crisis.

Canadian artists received little help from the federal government, unlike their American colleagues who benefited from programmes set up by the Works Progress Administration (WPA) as part of Roosevelt's New Deal. In the United States, the Federal Arts Project (WPA/FAP) employed thousands of artists to decorate public buildings, while other programmes hired artists to teach in the new Community Art Centres.[5]

By contrast, Canadian painters, unable to support themselves by their art, were forced to look for ways to supplement their income. Some, like Jack Humphrey of St. John, tried teaching, while others turned to commercial work. Pegi Nicol MacLeod, Paraskeva Clark, Charles Comfort, and Carl Schaefer worked on projects for the T. Eaton Company in Toronto. Emily Carr took up writing, opened a gallery in her house, and exhausted herself catering to her tenants and boarders.[6]

In Montreal, Fritz Brandtner, Edwin Holgate, and Will Ogilvie, turned to teaching. André Biéler designed advertisements for Canadian Celanese and collaborated with his wife, Jeanette Meunier, on designs for modern furniture and fabrics. Louis Muhlstock delivered groceries for the family business, while Aleksandre Bercovitch, already evicted and threatened with the confiscation of his paintings, was rescued by gallery-owner Sidney Carter, who offered the painter an exhibition.[7]

The Beaver Hall women fared better than some Montreal artists, since they had their families to fall back on. Sarah Robertson, Mabel Lockerby, and Mabel May were living on income from the estates of their deceased fathers, and these incomes were drastically reduced during

the Depression. Sarah Robertson found occasional work, painting murals in private homes. "Sarah is working away at the Hall Decoration for the Cottinghams & I believe it is going very well," Anne Savage wrote Jackson (9 April 1935).

Robertson, Morris, Lockerby, Savage, and Seath designed Christmas cards for the Canadian Artists Series, issued by Rous & Mann. A.Y. Jackson, who had organized the venture, felt that the pay was inadequate and wrote to Sarah Robertson (6 January 1928), saying, "This cent a card business is a joke." In 1931, he negotiated a contract with Coutts, suggesting a fee of $20 per design.[8] Anne Savage and Ethel Seath designed cards for the new series, but how much they received is not known.

Lilias Torrance Newton and Mabel May took up teaching. The former had a class in her studio in the University Tower Building. Speaking of the Depression, she remarked: "I don't suppose any of us would have made a living if it hadn't been for teaching."[9] Mabel May, who could no longer afford a studio, organized outdoor sketching classes and may have taught in her home. Writing to Jackson (9 April 1935), Anne Savage said: "Henry [May] is gathering a sketch class together—& she is still looking for a good boarding house in the Townships."

Anne Savage and Ethel Seath, who were already teaching, probably experienced some insecurity, since schools, like other firms, were cutting salaries. Ethel Seath worried about the survival of The Study, which was in financial trouble, and her own future. Having taken a 10% cut in salary in 1932 and another 10% the next year, she was uncharacteristically harsh with a new colleague, Geneva Jackson Baird, who was using drawing to teach arithmetic.[10] The fifty-six-year-old Seath may have felt threatened by A.Y. Jackson's young niece who had naively confided that she hoped one day to teach art herself.

In the 1930s, when the Beaver Hall women were reaching their prime as artists, there were few places in Montreal where they could exhibit. The AAM continued its Annual Spring Exhibitions and sometimes showed contemporary work in the Print Room. The Beaver Hall women and their friends exhibited there in December 1930, and Kathleen Morris

Christmas card designed by Anne Savage.
Collection of the author.

Christmas card designed by Mabel Lockerby.
Courtesy of Gwen Floud.

and Lilias Newton had back-to-back shows in 1939. The Arts Club occasionally offered exhibition space. Lilias Newton showed her drawings there in 1932, and in 1937 Prudence Heward, Sarah Robertson, and Mabel Lockerby participated in a show with Marian Scott, Fritz Brandtner, and other Modernists.

Montreal's commercial galleries were struggling during the Depression, and few were willing to take a risk on contemporary Canadian painters. Eaton's Fine Art Galleries held annual exhibitions of Canadian work for a few years, and in 1933 they organized a show of Canadian women painters, which included Kathleen Morris, Sarah Robertson, and Mabel May.[11] W. Scott & Sons, the gallery most associated with Modernism, gave Prudence Heward her first solo exhibition in April 1932.

The exhibition included three landscapes and a still life, but the main focus was on the figure. In *Sisters of Rural Quebec* (originally *Rollande and Pierrette*; 1930), Heward explores the relationship between sisters. The dreamy Pierrette leans against the older girl, who sits straight-backed and self-confident. The contrast is reinforced by the symbolism of the sunflowers in the lower left-hand corner—one strong and upright, the other drooping.[12]

Girl Under a Tree (1931), a large painting of a reclining nude, may be a self-portrait, as the sharp angular features show a strong resemblance to Heward's own. The latent sexuality of the taut figure and the large, staring eyes produce a disturbing effect, which is heightened by the diversity of styles. Painter John Lyman objected to the disruption between the fully modelled nude in the foreground and the flattened background, dismissing the work as a "Bougereau [sic] nude against Cezannian background."[13] The theme of a nude in a landscape is a familiar one in European art, but instead of a mythological, idealized figure, Heward presents a 20th-century woman with a somewhat androgynous body and a recognizable face. The painting can be read as an attempt by the artist to liberate woman's body from stereotypical male fantasies and to present it as the vehicle for her own desires and creativity.

Two years later, Prudence Heward exhibited at Scott's with Isabel McLaughlin and Sarah Robertson. The exhibition, which had originated in Toronto's Hart House, opened in Montreal on 5 May 1934. Heward was delighted with the success of the *vernissage*, which attracted over 100 people, and with the general effect of the show. As she told Isabel McLaughlin (11 May 1934), "The impression you get when you first go into the room is a warm glow of colour." Arthur Lismer reviewed the show for the *Montreal Star*, at the request of the painters, who wanted a piece "by someone who knew something." Beginning with a tribute to Canada's women painters, Lismer went on to praise Heward and Robertson for the strength of their designs and the ability to "create landscapes, and not copy them literally."[14] Financially, the exhibition was less successful, except for Robertson who sold two canvases and a sketch. After expenses and the 30% commission were deducted, Robertson made $158.13 and McLaughlin $39.14, while Heward, who sold one sketch, owed $9.86.[15]

The low volume of sales may have deterred Scott's from mounting further exhibitions for Prudence Heward and her friends. In 1939, Scott's, which had been dealing in art for 79 years, closed—probably influenced by the continuing economic crisis. [16]

The Depression convinced many artists of the need for social reform. A few, like Fred Taylor, were attracted to communism. Many more were involved with the League for Social Reconstruction (LSR), founded in 1932 by Frank Scott of the McGill Law Faculty and Frank Underhill of the University of Toronto. Although intended primarily as a research group, the LSR issued a manifesto declaring its dissatisfaction with capitalism and its intention to work for a new social order.[17] The core of this document was embodied in the so-called Regina manifesto of the new Cooperative Commonwealth Party (CCF), adopted in July 1933. The CCF brought together a wide range of people—workers, farmers, and intellectuals—who wanted to see socialism established by democratic means. Many artists, including Marian Dale Scott, Jori Smith, Jean Palardy,

and Pegi Nicol MacLeod supported the CCF. Fritz Brandtner, Louis Muhlstock, and others contributed drawings and cartoons to *New Frontier*, a Marxist journal, and *The Canadian Forum*, which became the mouthpiece of the LSR and the CCF.[18]

The ideas of Frank Scott and the LSR were anathema to many establishment leaders, particularly in Quebec. In an article entitled "The Fascist Province," published anonymously in *The Canadian Forum* in 1934, Frank Scott denounced the "provincial trinity" (i.e. the Roman Catholic Church, the ruling Liberal Party, and Montreal's business class) for their opposition to social reform during the Depression.[19] After Maurice Duplessis was elected premier in 1937, the atmosphere became even more repressive. His notorious "Padlock Act," adopted in 1937, was used to ban the meetings of left-wing activists and harass groups like the Jehovah's Witnesses. The restriction of civil liberties and the rise of Adrien Arcand's National Social Christian Party, which mirrored the fascism and anti-semitism of Hitler's Nazis, were profoundly disturbing to Montreal's artists and intellectuals.

Marian Dale Scott explained how she coped during this stressful period, saying: "The inner necessity to paint was there, in spite of the times, in spite of the misery, the growing fear of fascism and war. I found that I could not (or should not) 'use' my painting directly, but I could use some of myself, some of my time."[20] The attitude of the Beaver Hall women may have been similar to Marian Dale Scott's. They devoted time and talent to causes they believed in. Kathleen Morris was a passionate supporter of the Loyalists during the Spanish Civil War. She, Heward, Savage, Newton, and others donated paintings to the Sale Aid to Spanish Democracy, held in Montreal, in December 1938.[21]

The Beaver Hall women's social concerns may have been expressed indirectly in their painting. Prudence Heward's *Farmer's Daughter* (1938) and her portraits of black women show an empathy with women of a different class and/or race. Her black nude *Hester* (1937) is strikingly different from the eroticized images produced by Dorothy Stevens and others. In a recent thesis, Charmaine Nelson associates Stevens' *Coloured*

Nude (1932) with the Eurocentric perception of black women as licentious, aggressive, and deviant.[22] Unlike *Coloured Nude*, in which the model's face is half-hidden by her arm, *Hester* is a portrait of a recognizable black woman.

While Heward's contemporaries praised *Coloured Nude*, they were confused and antagonized by *Hester*. "Why, oh, why," a critic complained, "take the trouble to paint and paint well—a hideous, fat, naked negress, with thighs like a prize fighter and a loose lipped leering face?"[23] The critic perceives Hester as fat and ugly merely because she does not conform to ideal standards of female beauty. Furthermore, by describing her as "loose lipped" and "leering," he projects onto her the colonial stereotype of the black woman as "licentious" and sexually "deviant." Hester's expression is withdrawn and sad, and her body, far from inviting sexual attention, is slumped awkwardly against a tree. By setting the naked Hester in a rugged Canadian landscape, Heward suggests the vulnerability and isolation of the subject. The drooping branches reinforce the melancholy in Hester's bowed head and downward gaze.

Girl in the Window (1941; plate 16), the last of Heward's portraits of black women, places the subject in an urban setting. Her expression and pose (head supported by bent arm) suggest weariness and resignation. The row-houses in the background, apparently seen from the rear, link the woman to domestic service, the most common occupation for black women at this time.[24] The wall of houses cuts off the viewer's sight lines, suggesting the narrow prospects before the subject who, as a working-class black woman, is three times disadvantaged. Heward's image can be read as symbolizing the black woman's response to discrimination and/or patriarchy, or even the capitalist system, but the impression of an individual personality is so strong that the subject cannot be reduced to a mere symbol or stereotype.

Heward did not like interviewing models, as she told Isabel McLaughlin (5 January 1945). Possibly she felt embarrassed by an awareness of the social hierarchy and the power invested in her as a potential employer. Women's wages were pitifully low in the 1930s. The

minimum wage laws, enacted in Quebec in 1927, set the minimum for the most experience female workers at $12.50 a week and for the least experienced at $8.00. Many employers ignored the laws with impunity, particularly during the Depression. Women who were paid by the piece were even worse off, as the rates were continually cut. The T. Eaton Company paid its workers $5.00 for sewing a dozen dresses in 1929 and only $1.35 in 1934.[25]

An artist's model in the 1930s earned from .75 to $1.00 an hour, according to Madeleine Rocheleau Boyer.[26] Boyer, who posed for Lilias Newton and other artists, averaged $34.00 a week, compared to the $7.50 a week that she had made as a bookkeeper. She confirmed that there were black women in the profession at that time; so, Heward's black models, except for the little girl who posed for *Clytie*, may have been professionals. Although being an artist's model involved certain risks, the pay was good and the women enjoyed more personal freedom than their sisters in domestic service.

Unlike Prudence Heward, Lilias Newton seldom had the luxury of choosing her own subjects. As a single parent dependent on commissions for a livelihood, she painted wealthy men like H.S. Southam, chairman of the board of the NGC. But she preferred to portray women or adolescents. In *Maurice* (1939; plate 17), painted while she was on holiday at St. Adolphe de Howard, Newton captures the tension and self-absorption of youth.[27] The steps in the background serve both a formal function— echoing the line of the head and shoulders—and a symbolic purpose, suggesting the unfinished quality of adolescence. The staircase motif may have been suggested by Prudence Heward's portrait of a young boy, *Rosaire* (1935), which was shown at the AAM Spring Exhibition in 1939. *My Son* (1941), Newton's painting of Forbes seated on the same staircase, shows a sensitive, somewhat withdrawn teenager. After Newton had sold the portrait to the Art Gallery of Toronto, she asked for a photograph, saying: "My maternal heart demands that much record."[28]

Among Lilias Newton's most successful works are her portraits of fellow artists, A.Y. Jackson (1936), Edwin Holgate (c. 1937), Louis

Muhlstock (1937), and Frances Loring (c. 1942). In the portrait of Jackson, the broad shoulders, "bull-dog" chin, and direct gaze suggest the sitter's energy and determination. The background of snow-covered hills, which Jackson "drew in" himself, reinforces his image as a virile outdoor painter. [29]

Painting a woman was a rare treat for Newton, as she explained: "There is more colour to work with, and I feel I can paint a more imaginative portrait of a woman, because of her clothes, through which she expresses herself." [30] Newton seized the opportunity to play with colour in the portrait of her sculptor friend Frances Loring, who wears a bright red stole draped over a yellow bodice. There is a monumental quality in the handling of the drapery, and in the modelling of the face and neck, while the eyes gazing into the distance suggest the inner strength and vision of this unconventional woman.

In 1937, Lilias Newton was elected to full membership in the Royal Canadian Academy—only the third woman to be so honoured by that patriarchal association. While recognizing that her election would increase her status with clients, Newton dismissed the RCA as a "queer mixed-up sort of society." [31] The portrait of Louis Muhlstock, which she presented as her diploma piece, is a skilful composition of triangles. The arched eyebrows, bent elbows and splayed fingers echo the triangular shape of the face. [32] Muhlstock's unusual pose—seated backward on a chair, with hands gripping the frame—and the downward thrust of his eyes, suggest the artist's impetuosity and intensity.

The political and economic uncertainties of the thirties led many intellectuals to reflect on the role of art in society. Critic Graham McInnes, who wrote for *The Canadian Forum* and *Saturday Night*, believed that art should play a vital role in the community and be accessible to all. [33] He rejected the extreme forms of abstract art, but also deplored the use of art for propaganda purposes. The *Daily Clarion*, mouthpiece of the Communist Party of Canada, supported art that promoted social change or flaunted an anti-fascist message, but few Canadian artists or critics

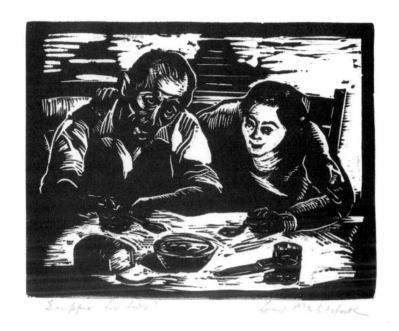

Louis Muhlstock, *Supper for Two*, c. 1935.
Linograph on paper.
Collection of the artist.

supported this extreme position.

Unlike Graham McInnes, Bertram Brooker believed that the purpose of art was purely aesthetic. His 1936 essay, "Art and Society," which defended this position, prompted a lively discussion among artists and critics.[34] Writing in *The Canadian Forum* (December 1936), Frank Underhill referred to the rise of fascism and suggested that many European artists are deciding that "in our troubled generation the artist must be red or dead." To which Elizabeth Wynn Wood replied, dissociating Canadian artists from European politics and recommending that they take their inspiration from the northern pre-Cambrian shield. This attitude was denounced as the "exaltation of the individual" by Paraskeva Clark, who believed that artists should support the social struggle of their fellow men.[35]

Anne Savage's attitude to art was closer to that of Elizabeth Wynn Wood than to the other participants in the debate. For Savage, art was the highest endeavour of the human spirit. As she wrote in her autobiographical notes: "To me, Art as a revealer of the human spirit is veiled in mystery—it is one of the facets through which we approach the inner life."[36]

What did she mean by "inner life"? Probably something closer to the Christian idea of the soul than to Freud's unconscious. She often criticized the artists of the fifties, alleging that for them art was merely self-expression. For her, art was larger than that. She saw the formal beauty created by the artist as a shadow of the divine spirit manifested in nature. But that beauty could not be created merely by technical means. As she explained to Jackson: ". . . without the driving force of a devotion to an inspired cause it [art] flattens out to a pattern, or technique." She had difficulty in accepting works that were critical, nihilistic, or ugly, remarking of Picasso: "What a brute he was. He has saved everyone the trouble of trying to express violent agony and horror." She admired Van Gogh, claiming that he never painted anything ugly or sad. "It was all radiant and today the morose and cynical are the vogue. It may be politics but surely not art."[37]

Anne Savage came into daily contact with Montreal's poor and unemployed. She saw the effects of the Depression on her working-class students, and she devoted time and energy to helping them. Her paintings, however, focus on the natural world, particularly the landscapes of the Laurentians and the Eastern Townships. She found the Laurentians a challenge because, unlike a fishing village, there were no obvious motifs. "But if you're faced with a forest that you have to unravel a bit and you have to search around and find your plains and your hills, and model it up that way, it takes a lot more looking."[38]

Green Shores, Laurentians (c. 1935), with its clump of sunlit trees and sparkling water, creates a feeling of serenity. The lake, cut off by the curved shoreline in the foreground and the gently rounded hills behind, appears safe and friendly. A critic who saw the painting in 1936 declared it a "relief from the relentless virility of the earlier Group of Seven."[39] In *Dark Pool, Georgian Bay* (1933), the perspective is intimate but the expanse of water, broken only by rocks, suggests a feeling of emptiness. The canvas was painted from a sketch Savage made while visiting Jackson in Georgian Bay and may reflect her ambivalent feelings about their relationship.

Anne Savage showed *The Plough* at the 1931 Group of Seven Exhibition, but continued to work on it at Jackson's suggestion. "I'm glad you thought *The Plough* was better," she wrote Jackson, "I am at the stage of not knowing how to push a thing without making it look mulled over & rubbery."[40] The image of a plough soaring over fertile fields could be read as a symbol of hope in the Depression, when farms were failing and so many people were starving. The colours—muted greens, browns, and ambers—bring together nature (earth and sky) and technology (the plough). The painting has a spiritual quality, partly due to the treatment of the sky with its streak of violet cloud hinting at a rainbow.

In *The Canoe* (c. 1935), an empty boat with one paddle propped against the gunwale floats in a secluded bay. The personal feeling in this image comes from its association with Savage's twin brother, killed on the Somme in 1916. Savage's niece, Anne McDougall, who spent her childhood summers at Wonish, describes Don's canoe still resting on the

rafters of his log cabin. "So lasting is his memory," McDougall writes, "that for his sisters, and his twin in particular, time almost stopped at Lake Wonish when he was killed."[41]

Like Anne Savage, Sarah Robertson imbued her work with love of the natural world. In *Storm Como* (c. 1937), the bending trees and dramatically streaked sky suggest the exhilaration of a bright autumn day. Many of Robertson's works are small panels painted on sketching trips with her friends. *Back of Brockville, Ontario* (c. 1935) captures the radiance of summer in a composition that includes golden haystacks and humped green fields, framed by a sagging wooden fence. Her love of flowers is reflected in works like *Decoration* (c. 1933) and *Campanula* (c. 1933) and in her watercolours.

Robertson's urban scenes usually include some reference to nature. In *Coronation* (1937), the swirling trees that half conceal the buildings and the brightly-coloured flags create a mood of celebration. Graham McInnes, reviewing an exhibition in 1937, praised this work (and one of Emily Carr's) as "sensitive personal reactions to Canadian life."[42] To Robertson, as a British Canadian, the coronation of George VI may have represented a symbol of hope, but to Montreal's thousands of unemployed (particularly the French) it must have seemed irrelevant.

Several of the Beaver Hall painters experimented with combining still life and landscape—possibly influenced by the New Zealand artist Frances Hodgkins, whose work was shown in Montreal in the 1930s. Robertson's *Petunias* (1938) may have been inspired by Hodgkins' *Still Life with Landscape*, which was owned by Prudence Heward.[43] But unlike Hodgkins, who uses a terrace wall to integrate the flowerpots and the landscape, Robertson sets her vase of petunias in a meadow, relying on colour and form to unify her composition.

Mabel Lockerby showed humour and a touch of fantasy in the way she combined still life and landscape. Pink curtains are used as a framing device in the 1935 painting *In an Open Window*, which depicts a blue-green vase of sunflowers against a background of buildings and green hills. In *The Dahlia* (c. 1940; plate 20), the room disappears and the table

is projected into the landscape, making the flowers appear to soar over the lake and touch the mountains in the background.

Like Anne Savage, Lockerby had a special fondness for trees. In works like *Old Forts* (1940) and *Haunted Pond* (c. 1948), the branches take on an anthropomorphic quality. In *Red Apples* (c.1938), the boughs, heavy with fruit, curve across a sunlit lake. As Marian Dale Scott suggested, *Red Apples* is the work of a "fulfilled woman."[44] Lockerby uses the image of ripe fruit that Gauguin and others have associated with woman's fertility to express her own fulfilment, which came not from motherhood, but from painting and her relationship with her cousin.

Nora Collyer's subjects are primarily the farms, orchards, and fields of the Eastern Townships, where she had her summer home. In *Spring Creek, Foster, Quebec* (c. 1939; plate 21), the sunlit water and the branches tinged with new growth convey a quiet joy. Collyer composes her image carefully, creating an interplay between the diagonals of the flowering tree, the triangular masses of land, and the horizontal bands of blue river, brown trees and mauve-blue hills. Although she seldom includes figures, she often makes a church or a barn the focal point of the composition, as in *Village Church in Summer* (n.d.; plate 24). Reviewing her solo exhibition in 1964, Robert Ayre remarked: "She loves ripeness, the fatness of the land, the snugness of the villages in the hills, and celebrates them in full-bodied colour and easy, comfortable rhythms."[45]

Although Nora Collyer was aware of social problems and did volunteer work in hospitals, these concerns are not reflected in her painting. Her Montreal canvases tend to focus on picturesque subjects such as Mount Royal mountain or the old Martello Towers. Like Marian Scott, Collyer may have felt unable, or unwilling, to use her painting directly as a vehicle for social commentary.

Kathleen Morris also liked to paint Montreal cityscapes. But unlike Louis Muhlstock, whose images of back lanes and empty doorways evoke the desolation of the Depression, Morris focussed on the more traditional and decorative elements of a scene. A comparison of her canvas *Maison Calvet, St. Paul Street* with the original sketch shows how she charged the

image with greater intimacy, even a touch of nostalgia, by adding a horse-drawn sleigh and several figures.[46] Although sleighs were occasionally used for deliveries (or tourists), cars were far more numerous than sleighs by the 1930s. In works like *Queen Mary and Côte des Neiges Road* (n.d.; plate 13), Morris creates a harmonious blending of old and new—between the sleighs and old gabled houses in the foreground and the towering buildings behind. The traditional elements in these works evoke memories or fantasies of a simpler rural life. This "timeless" quality was reassuring for viewers unsettled by the Depression and the threat of another world war.

Twenty-eight artists from across Canada, many isolated by the Depression, came together in 1933 to form the Canadian Group of Painters (CGP). The new society was both a response to the economic crisis and an attempt to revitalize the Group of Seven, which had lost its momentum and needed to expand.[47] Nine of the founding members were women, including Prudence Heward, Sarah Robertson, Anne Savage, Mabel May, and Lilias Newton.

The CGP held its first meeting on 17 February 1933. Prudence Heward, who was in Toronto for the opening of Isabel McLaughlin's exhibition, attended. As Jackson reported to Savage (20 February 1933), "It went off very happily, no pomposity or solemnity, but we put everything through." Lawren Harris was elected president, with A.Y. Jackson and Prudence Heward as vice-presidents. The predominance of the Group of Seven on the executive meant that the Group's strong nationalist bias continued in the CGP.

As second vice-president, Prudence Heward represented the Montreal painters on juries and hanging committees. The only woman on the executive, she owed her election partly to the perception that she could afford to attend meetings in Toronto, as she did not have a full-time job.

All the Beaver Hall women, except Emily Coonan, contributed to the CGP show at the Art Gallery of Toronto, in November, 1933.[48]

Prudence Heward was on the selection committee with Lawren Harris and Will Ogilvie. A controversy erupted over a nude by Lilias Newton. Writing to Sarah Robertson (1 November 1933), Jackson said: "The saddest thing I have to relate is that Lil's big nude is not hung, politics." The Gallery's trustees were afraid that *Nude in a Studio* (1933) might be considered "offensive," and jeopardize their annual grant from the city. Their objections focused on the model's fashionable shoes, which disrupt the concept of an idealized female beauty existing outside of time. Prudence Heward wanted to cancel the exhibition unless the nude was included, but was finally persuaded that such a gesture would be futile.

Lilias Newton, who had worked on the painting all summer, was bitterly disappointed. But her dismay turned to relief when Alice and Vincent Massey decided to buy the nude. Commenting on the sale, Jackson said: "If it had been hung it is not likely the Masseys would have bought it. The idea that she was not getting a fair deal was what probably moved them to some extent."[49] Jackson's remark seems rather petty; the Masseys were discerning collectors and may well have bought the portrait on its merit.

Prudence Heward's painting *The Bather* (or *Femme au bord de la mer*, 1930) displeased several critics. Augustus Bridle denounced it as a "joyless exposure of stylized rocks and a gloomy flesh figure."[50] His remark betrays the bewilderment of the male critic accustomed to images that display the female body as an object of male desire (joy). Heward's portrait depicts a monumental figure in a sagging bathing suit who sits awkwardly, knees splayed outward, immersed in her thoughts. A stylized plant springing out of the rock can be read as a symbolic reinforcement of the bather's vitality and latent sexuality.

Kenneth Wells, whose caricatures of the show appeared in the Toronto *Evening Telegram*, focussed on Heward's plant, saying: "Even *The Bather* made the artist hungry. He thought it was a cook watching a salad sprout with forks, spoons and all!"[51] Wells also caricatured Sarah Robertson's *Decoration*, transforming her image of foxgloves into a pair of frilly panties with the caption: "'Flowers' they call this, but the art critic is sure they

don't call them that in smart women's magazines!" Devastated by this cruel joke, Sarah Robertson tore the painting off its stretcher and threw it on the floor.[52]

Another of Robertson's works, *In the Nuns' Garden* (c. 1933), was one of three paintings bought from the exhibition by the Art Gallery of Toronto (AGT). According to Jackson, *In the Nuns' Garden* created a "commotion" in Toronto, as both Hart House and the AGT wanted to buy it.[53] The painting is remarkable for its bold use of colour—the black habits of the nuns against the bright autumn foliage and orange pumpkins. But it may have been the subject as much as the formal qualities that appealed to the AGT committee. The image, with its suggestion of traditional values and its promise of plenty, must have been particularly meaningful in the Depression.

The CGP exhibition transferred to the AAM in January 1934. As president of the Montreal branch, Prudence Heward made the arrangements and helped with the hanging. "It was nice having Lawren [Harris] here & Will Ogilvie," she wrote to Isabel McLaughlin, "only they stayed a very short time, I didn't begin to have time to show them the things I would have liked to down here."[54] Heward enjoyed her new position, particularly the trips to Toronto, which provided opportunities to meet younger painters like Yvonne McKague. There was a dinner party at Isabel McLaughlin's before the opening of the 1933 CGP show and a party of seventy people at Lawren Harris's afterwards. Heward also attended a CGP executive meeting at a Toronto restaurant, which Jackson described to Savage as "not very businesslike but good fun."[55] He added that Heward was very much liked in Toronto. "She doesn't take people by storm but she has her little ways."

The CGP exhibition of 1939 was heralded as significant by critics Graham McInnes and Robert Ayre. The former claimed that "the long expected upswing in contemporary painting has at last begun"; while the latter welcomed a new generation of Canadian painters that "wants to come to grips with life . . . wants more humanity in its work . . . wants to come to grips with painting and is not satisfied with bold decorations."[56]

Eight of the Beaver Hall painters contributed to this exhibition. Heward's portraits of little girls (*Clytie* and *Farmhouse Window*) drew praise from both critics, but the other Beaver Hall women were overlooked or merely mentioned in passing.

Heward's portraits of children are remarkable for the extraordinary presence with which she invests her young sitters. The model for *Clytie* (1938) was a black child who acted as flower girl at the wedding of one of the Hewards' maids. The background was developed from a sketch the painter made while visiting Isabel McLaughlin in Bermuda. The small girl, standing with folded hands in front of a rough wall, epitomizes the action of waiting. Childhood is full of waiting—for parents, for birthdays, for adulthood—and Heward evokes that feeling again in *Farmhouse Window* (c. 1938). There is a haunting quality to this little girl's face, which stares at us from between the parted curtains.

Anne Savage had four strong paintings in this CGP exhibition, including *Strawberry Pickers, Cap à l'Aigle* (c. 1939), one of her few works to include figures. The three little girls form a triangular group in front of an old wooden house—the wavy lines of their sunbonnets echoed in the contours of the roof and the hills behind. In Mabel Lockerby's *Lucille et Fifi* (c. 1939; plate 18), the child in her pink frock, the little dog in the foreground, and the potted plant on the table, are all treated with equal interest, like elements in a still life. The image has a naive quality, emphasized by the background which juxtaposes the view from the open window and a framed picture of a windmill.

In June 1939, Isabel McLaughlin was elected president of the CGP, with Anne Savage as first vice-president. Although this might look like a female take-over, Isabel's election was due largely to her much-needed status as daughter of Sam McLaughlin, President of General Motors of Canada. According to Jackson, "If she [Isabel] calls a meeting they will all turn up, every blinking one of them."[57]

Anne Savage shared Jackson's belief in the importance of the CGP as a counterweight to the conservative RCA. Her organizational abilities and natural tact made her a successful leader, and she served several

separate terms as head of the Montreal branch. In November 1939, Kathleen Morris, Mabel Lockerby, and Ethel Seath, who had all contributed regularly to CGP shows, were elected members.

The CGP brought the Beaver Hall women into contact with painters from across Canada, raised their prestige among fellow artists, and gave them experience in organizing and hanging exhibitions. For example, Robertson and Savage helped Heward hang the 1938 CGP exhibition at the AAM. By serving on hanging committees and juries, the women were able to influence the public's perception of art.

The Beaver Hall painters were also associated with Montreal artist John Lyman, and may have attended his salons in the early 1930s.[58] Lyman, who had studied in Paris, believed that Canadian painters should be more aware of Modernist French art and less concerned with the nationalist theme. As he later wrote in *The Montrealer* (1 February 1938), "The talk of the Canadian scene has gone sour. The real Canadian scene is in the consciousness of Canadian painters, whatever the object of their thought."

In November 1931, John Lyman, architect Hazen Sise, and others, set up the Atelier as a school of modern art. Heward, Robertson, Newton, May, and Savage were on the twelve-member executive committee. Although not part of the teaching staff, the women probably took part in the discussions on modern art that preceded the school's opening. The prospectus, in which their names appear, emphasizes the Atelier's commitment to the study of form, saying: "The essential qualities of a work of art lie in the relationships of form to form, and of colour to colour. From these the eye, and especially the trained eye, derives its pleasure and all artistic emotion must find its expression through these means."[59] The Atelier also provided a studio and an opportunity for artists to work from the model. Involvement with the school strengthened links between the Beaver Hall women and Montreal's more progressive artists. Unfortunately, the Atelier survived only two years, another casualty of the Depression.

John Lyman continued his efforts on behalf of the younger artists, founding the Eastern Group of Painters in 1938 and bringing French

"An Artist Draws his Impressions of Expressionist Art,"
Toronto *Evening Telegram* 25 November 1933.
The works caricatured are upper row: George Pepper,
Sea and Rocks, Nova Scotia; Lawren Harris, *Mountains
in Snow;* and Sarah Robertson, *Decoration;*
lower row: Prudence Heward, *The Bather;*
Lawren Harris, *Island, Georgian Bay;* and
F. Forester (?) *Cul-de-sac.*

and English artists together to form the Contemporary Arts Society (CAS), in January 1939. Lyman later described the CAS as an "anti-academy," which emphasized imagination, intuition, and spontaneity and regarded "membership in an academy as merely a consolation for having died during one's own lifetime."[60]

A.Y. Jackson, alarmed that the CGP might become a "group of mild liberals between the conservatives and the radicals," tried to effect a merger between the CGP and the CAS. "Isabel is going down to see Prue this weekend," he wrote Anne Savage. "So you can send her into the lion's den. She can go and see Lyman. It may work."[61] Lyman declined the merger but promised to co-operate, which meant that artists were free to belong to both societies if they so chose.

Heward, Savage, Lockerby, and Seath joined the CAS in 1939. Heward attended the Society's debate on Abstract Art, which she described to Isabel McLaughlin (17 January 1940) as "lots of fun." She also participated in five CAS exhibitions between 1939 and 1946 and served on the jury for the 1942 exhibition. Women had less influence in the CAS than in the CGP. There were no women on the Society's executive, and in 1945 only two, Marian Scott and Jori Smith, were included in the CAS annual show in Toronto.[62] In November 1948, the CAS disbanded due to internal squabbles.

The Beaver Hall painters took part in several international exhibitions during the 1930s, including the 1936 show that circulated in the Southern Dominions of the British Empire. Prudence Heward's *Rollande* attracted comment throughout the tour, and in Perth, Australia, a newspaper poll selected it as one of the six best paintings in the show.[63] All the Beaver Hall women (except Coonan) contributed to the so-called Coronation exhibition in London, in 1937, which brought together artists from the dominions. The British art critic W.G. Constable praised some of the younger members of the CGP for their "largeness of conception and treatment, which gives everyday things new significance." As examples, he cited Anne Savage's *Wheelbarrow* and *Autumn* (or *Autumn Eastern Townships*, c. 1935; plate 22) and Sarah Robertson's *Ontario Farm in September*. He

also remarked that Prudence Heward in her portraits *Rosaire* and *Barbara* "achieves architectural quality, without losing the grace and charm of childhood."[64]

The next year, eight of the Beaver Hall women contributed to an exhibition at London's Tate Gallery, but this time the reviews were less favourable. Herbert Read compared the Canadian paintings to the Scandinavian school: "the same raw radiance . . . the same absence of atmosphere; a certain objectivity and (in the portraits) a certain inhumanity. . . . No single artist stands out, as Munch does in Norway." The Canadian critic Northrop Frye sprang to the artists' defence, declaring, "There is life and buoyancy in Canadian painting, of a kind not often found outside France, and fading there."[65]

During the 1930s, the Beaver Hall women (with the exception of Emily Coonan) received increasing recognition from critics in Canada and abroad. But despite the painters' critical success, only three had solo exhibitions during the decade. Lilias Torrance Newton (1932 and 1939), Prudence Heward (1933), and Kathleen Morris (1939) had shows in Montreal, while Mabel May had one in Ottawa (1939).

The continuing Depression reduced the painters' sales and forced some of them to look for alternative work. Lilias Newton turned to commissioned portraits, and both she and Mabel May took up teaching. Anne Savage and Ethel Seath, who taught full time, found that the additional stress of the Depression left them little time for painting. Writing to Jackson (12 August 1938), Savage explained: "The holidays have [been] and still are wonderful but how little I have done, it makes me value more and more the enormousness of the work of a good painter. How difficult it is and how easily that something can be snapped which is necessary to produce a good job."

Chapter Eight

⁓

The Beaver Hall Women
as Art Educators

WOMEN PAINTERS have made substantial contributions to art education in Canada. In the late 19th century, they held classes in their studios and taught in private girls' schools. Several of the Beaver Hall women carried on this tradition, teaching part time to supplement their earnings as painters. But for Anne Savage and Ethel Seath, teaching was a second career, as important as painting. They developed a new child-centred approach to teaching, similar to that used by Arthur Lismer at the Art Gallery of Toronto. Savage and Seath pioneered the new art education in Montreal.[1]

Before the introduction of the new pedagogy, Canadian public schools took a utilitarian approach to teaching art. This is hardly surprising since these schools were intended primarily to prepare workers for industry. Gender as well as class bias characterized 19th-century art education. Working-class pupils in state schools were taught industrial drawing and design, while middle-class girls in private schools studied botanical drawing and watercolour painting.[2]

In the 1880s, many public schools adopted a programme designed by Walter Smith, who taught at the Massachusettes Normal Art School.[3] Smith's programme, packaged as a series of texts and teachers' guides, included freehand drawing, industrial drawing, and elementary design. His texts were the first in a long line of drawing books used in Canadian

schools. Art educator Donald Soucy compares these texts to penmanship books. "Both types of books provided models to be copied accurately, both were believed to require the same mental and psychomotor skills, and both were used to keep one group of students busy while the teacher worked with another group."[4]

The impetus for change came from outside the school system. In the late 19th century, educators and psychologists began to take an interest in children's art. In 1897, the painter Franz Cizek opened the Juvenile Art Class in Vienna as a centre where children could work from their own imagination and experience. Several art institutions in North America were already running children's Saturday classes, notably the Victoria School of Art and Design in Halifax. But Cizek's approach was different because he recognized the role art plays in the child's development. As he said: "There is an art that children create for themselves. The child makes pictures and drawings, not for grownups, but to make real his own desires, inclinations, and dreams."[5]

Arthur Lismer was the leading proponent of Cizek's ideas in Canada. As principal of the Victoria School of Art and Design in Halifax, he set up a Saturday morning art class for children in 1917. When he was hired by the Art Gallery of Toronto in 1927, he organized an exhibition of work by Cizek's children's class. The success of this exhibition persuaded him to launch his Saturday morning children's class at the Art Gallery of Toronto. For the next forty years, Lismer developed his ideas on child art, lecturing on art education in Canada and abroad.

In the 1930s and 1940s, art galleries across North America set up children's classes based on Lismer's theories. But public schools were slow to change their teaching methods. In 1950, the *official* art programme of Quebec's elementary schools was still based on drawing books, *The School Art Series* (Renouff of Montreal).[6] Although an imaginative teacher could introduce her own programme, few had the necessary training. Art was taught by classroom teachers in the elementary schools and in high schools by "specialists"—i.e. teachers with a particular interest in art. Anne Savage's background—five years of art school—was unusual,

if not unique.

Neither Anne Savage nor Ethel Seath had planned to be teachers. Savage was working at Ronalds Press in 1921, when she was contacted by Dr. H.J. Silver, head of the Montreal Protestant School Board. Many years later, the mature Anne Savage ridiculed her early ambition to be a designer, saying: "I thought I was going to move the world, I really thought I was heading for New York to be a great big commercial artist. I had no soul at all. I was only thinking how I could make my work practical." [7]

Anne Savage began teaching at the Commercial and Technical High School in January 1921. She had gained some teaching experience in her student days, when she ran an art class in Griffin Town, for "little toughs off the street," as she called them. [8] (A grateful pupil was still sending her Christmas cards in 1967.) But Savage had no idea how to plan a course, and at first she just struggled through one class at a time. Her principal must have been satisfied, however, because when he moved to the new Baron Byng High School in 1922, he took Savage with him.

It is difficult to say how much Anne Savage and Ethel Seath were influenced by Cizek and other proponents of the child-centred approach. Both women appear to have developed their own teaching methods based on their belief in the inherent creativity of children. Ethel Seath began teaching at The Study in 1917. Her pedagogy was developed in consultation with Margaret Gascoigne, who believed in encouraging children's imagination and spontaneity. Seath gave her pupils models (gourds, shells, wooden animals) to work from and introduced them to a variety of media, including coloured chalk, clay, finger paint, and lino blocks. [9] She also encouraged group projects, such as building sets for school plays, and decorating the ugly concrete passage between the school buildings. Everything she did was based on her belief in art as a powerful vehicle in the development of the child's personality. As she explained:

> The aim of art education is to help children to see, to feel and
> to express beauty with clear, spontaneous feeling and to give
> them the ability to use the experiences of everyday life creatively

in order that they may gain increased intelligence through the skill of the hands. . . . Nearly all children have something to say through drawing, and training in Art results in refinement of thought, eye and hand.[10]

As a novice teacher, Anne Savage drew inspiration from visiting Seath's Art room at The Study. Savage was also grateful to Arthur Lismer, who wrote to her in 1922 after seeing some of her students' work, saying: "Any class that can produce such work proves the ability & enthusiasm of the instructress."[11] Later, she visited his Saturday morning class at the Art Gallery of Toronto. Recalling that visit, she said: "I'll never forget the impression, going into that Gallery, and seeing it just filled with children with the most extraordinary feeling of enthusiasm going right through the group."[12]

Leah Sherman, who has studied Savage's development as a teacher, mentions various educators whose work Savage consulted, but concludes that "Savage was selective in her adoption of ideas and theories. Examples of her students' work and her pedagogical notes indicate that she evolved a successful method of teaching and then found the theories to support it."[13]

Leah Sherman and Alfred Pinsky, art educators and former pupils, have difficulty separating Anne Savage's pedagogy from Anne Savage, the person. As Pinsky remarked: "It didn't emanate from a learned technique, it emanated from a total personality who was totally convinced, totally imbued, and totally in love. Totally desirous of handing on this awareness."[14]

Anne Savage saw herself as an enabler, telling stories or suggesting themes from Canadian history to stimulate her students' imagination. But it was not so much the subjects that motivated her students, as personal contact while they were working. According to Pinsky, Savage would come over and "make some suggestions, praise, criticize all at once, leaving a residue of desire to continue and make wonderful things."[15]

Ethel Seath and Anne Savage taught in very different environments.

The Study was a private girls' school catering to the Anglo-Protestant elite. Ethel Seath had the advantage of working with small classes and of guiding her pupils from the age of six to seventeen. Baron Byng, mythologized in the stories of Mordecai Richler, stood on St. Urbain Street, the heart of Montreal's Jewish community. During Savage's tenure, 90% of the students were Jews—the children of immigrants who had fled the European ghettos. How did an Anglo-Protestant Canadian respond to this meeting with other cultures?

According to her niece, Anne Savage was stimulated by the atmosphere on the east side of Mount Royal: the ethnic shops smelling of salami and garlic, the crowds swarming down the Main, so different from the quiet residential area of Highland Avenue.[16] Savage spoke enthusiastically about her Jewish pupils: "I was very fortunate in working with a group of very sensitive, very artistically minded people like the Jews are. I think the Anglo-Saxons haven't got anything like the emotional drive that the Jewish people do."[17]

This emotional energy might have been labelled "brash" or "common" by many of Savage's Anglo-Protestant peers. Quebec in the 1930s and 1940s was an openly anti-semitic society, where Jews were excluded from many private clubs and resort hotels; access to the professions was also restricted (for example, the McGill Medical school had a quota for Jews). Anne Savage recognized that life was more difficult for her students because they were Jewish, and she continued to help Leah Sherman and others, even after they graduated.

Until the 1940s Anne Savage taught mainly girls. (The curriculum stipulated Manual Training for the boys.) Savage represented someone exciting and different to the girls, who saw it was possible to be a well-dressed, single woman with a fulfilling job. As Leah Sherman observed, Miss Savage looked different from the other teachers, not because her clothes were expensive but because she had an eye for style and colour.[18] According to Sherman, the art room at Baron Byng was "a very particular kind of place." It was partly the atmosphere, the focus on colour and texture, and partly the realization that this was a place where the students'

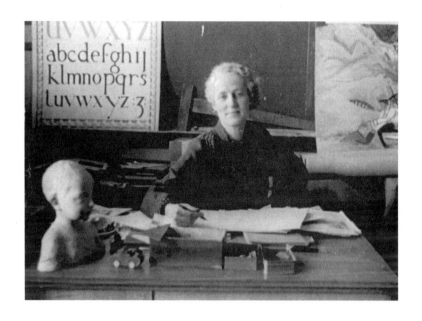

Anne Savage at her desk in the art room at
Baron Byng High School.
Anne Savage Fonds, Concordia University Archives.

"own potentialities as individuals were emphasized." Inspired by Savage's example, many of the girls became teachers, designers, and professional artists.

Anne Savage could always see something to praise in a child's work. Alfred Pinsky, one of the first boys to join Miss Savage's class, remembers her generosity as a teacher. She stayed in the art room during lunch so that students could work on their projects, and she paid for special materials for Pinsky from her own pocket.

Savage was fortunate in having a supportive principal, Dr. John Astbury, who encouraged her efforts to bring more art to Baron Byng. When her pupils wanted to buy an A.Y. Jackson for the school, Savage conducted the negotiations. She also helped the students to decorate the walls with friezes and murals—until, as Pinsky said, the whole school was "infected" with art. [19]

In 1948, when her career at Baron Byng was coming to an end, Savage spoke nostalgically about her colleagues:

> Never shall I experience the joy and the excitement of real creative teaching as I did at Byng—when the staff was at its peak—when Dr. Astbury was Principal and six other good friends were there—they have gone and the joy seems to be waning— so maybe it is better that I slip out. . . . [20]

As Assistant Art Supervisor for the Montreal Protestant School Board (1948 to 1950) and Supervisor (1950 to 1953), Anne Savage influenced the way art was taught in all the Board's schools. She started classes for elementary school teachers at Baron Byng, and she wrote a book *Art in the Elementary Grades* (1951) and several booklets of "Design Activities." For Savage, the purpose of the art class was to give an opportunity for personal expression and to make students aware of the visual world.

Anne Savage's influence on art education continued even after her retirement as Art Supervisor in June 1953. She taught a course on Art Methods in the Education Faculty of McGill University from 1955-59,

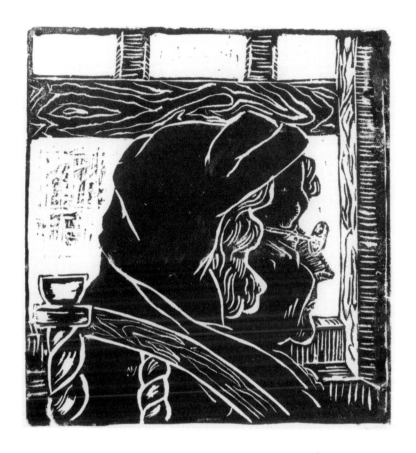

Linograph by one of Anne Savage's students.
Collection of Anne Hirsh.

Gouache on paper by one of Anne Savage's students.
Collection of Anne Hirsh.

and she helped set up the Child Art Council (CAC). Founded in 1955, the CAC brought together anglophone and francophone teachers and promoted new ideas in art education through the publication of a bilingual bulletin. According to Leah Sherman, it was only when the art teachers began to form professional organizations (and the CAC was the first) that the new art education took hold in Quebec schools.[21]

In 1937, Anne Savage set up the children's Saturday morning art class at the AAM. Every week, a hundred children gathered in the Sherbrooke Street gallery to draw, paint, and model in clay. Ethel Seath taught the modelling class. After spending five days in the classroom, the two women gave up their Saturday mornings to encourage children's creativity. The programme proved so popular that volunteers, including Alfred Pinsky, were recruited to assist the instructors. Sarah Robertson and Nora Collyer taught a drawing class in 1940, but whether as volunteers or paid instructors is not clear. In 1941 Arthur Lismer, who was hired to expand the educational programme, took over responsibility for the Saturday class, but Savage continued to teach the older children for two more years.[22]

Anne Savage and Ethel Seath kept up with new trends in art education by attending conferences and exhibitions of child art. On a trip to England in 1935, Seath met Marion Richardson, the educator who reformed the teaching of art in London County Council Schools. Anne Savage attended the 1946 Eastern Arts Convention in New York, a meeting of 500 art specialists. As teachers and painters, these women were always learning. Savage "taught in a way which didn't separate learning and teaching," Sherman said. "There was always this partnership. The feeling that she was getting something from this experience at the same time that you were."[23]

As interest in child art expanded in the 1930s, Savage and Seath were invited to send samples of their students' work to exhibitions in Canada and abroad. Paying tribute to Seath in 1934, Margaret Gascoigne said: "It is our Art work which has won the greatest reputation for the School, not only in Canada, but in England, Europe and South Africa."[24]

Gascoigne added that the aim of the art programme was not so much to turn out artists as to develop the creative imagination, observation, and memory of all children.

The proudest day in Ethel Seath's life may have been 22 November 1955, when the exhibition and sale *Art from the Study* was held at the Montreal Museum of Fine Arts (formerly the AAM). Ethel Seath, 44 Old Girls, and 23 pupils contributed works in a variety of media to raise money for The Study Retirement Fund.[25]

Many of Ethel Seath's students have become professional artists— including Elizabeth Imrie, Jill Crossen Sargent, Katherine Mackenzie, and my late sister, Shirley Wales. Many more continue to paint and study art for their own enjoyment. As Anne Savage noted, by educating the daughters of Montreal's English-speaking elite, Ethel Seath created an informed audience for art and a nucleus of art patrons.[26]

Alfred Pinsky has remarked on Savage's ability to incorporate the two aims of art education within one class: to stimulate the visual imagination of all students and to extend the particularly talented one.[27] As a former pupil of Ethel Seath, I can confirm that she too had this ability. Both my sister and I were enriched by our hours with Miss Seath. I remember the sensuous pleasure of working with clay and the pride with which I carried home my model of a mauve-pink bird on a brown nest.

Among Anne Savage's notes for student teachers is the passage: "The outstanding quality that a teacher must have is absolute belief in the power of the child to find his own way . . . no doubts—no fears—no mistakes are possible—no criticism, only appreciation and delight in the doing."[28] This was Anne Savage's credo and probably Ethel Seath's as well.

Within a year of leaving the AAM school, Nora Collyer wrote to William Brymner, requesting a reference that would enable her to teach art. Brymner complied, stating that Collyer had done "excellent work" at the school, and would be capable of teaching drawing and painting.[29] In September 1925, Collyer was appointed art mistress at Trafalgar School,

her alma mater, with an annual salary of $800.[30] She had had no training in teaching, but probably developed her pedagogy in consultation with Savage and Seath (The Study was only a few blocks from Trafalgar).

Nora Collyer's teaching career lasted only five years. A note in the school magazine regrets her departure, saying: "Owing to her mother's sudden death in the autumn, she felt that home circumstances compelled her to give up her work at school. Apart from her great value as a teacher, she was always ready to help in all school activities, and took a keen interest in every individual girl."[31]

Gertrude Palmer Collyer died at the farm in Foster, on 20 September 1930. As the only daughter, Nora Collyer did what was expected of her, quitting her job to manage the household for her father and brother. She may have consoled herself with the hope that she would have more time for painting, but even with servants, the management of two large establishments (the house on Dorchester Street and Hillcrest at Foster) must have taken up much of her time.

Nora Collyer had been brought up to believe that women owed a duty to their community. Following the example of her mother, who had done volunteer work for the Anglican Church, Nora taught art at the Children's Memorial Hospital and other institutions.[32] After her father's death in 1946, she became more active as a teacher, organizing classes for children and adults in her own home. Kathleen Morris's niece, Susan Kilburn, attended one of Collyer's children's classes in the late 1940s and in 1953 took private lessons at Collyer's duplex on Elm Avenue.[33] Nora Collyer would drape a table and set up a still life for Susan to paint. "Light beside dark. Dark beside light," Collyer told her.

Mabel May's early teaching experience was mainly with adults. She and Lilias Newton taught a women's class in their Beaver Hall studio. Later, during the Depression, Mabel May organized sketching classes in the Eastern Townships. In 1936, forced to look for more dependable work, she accepted a job at Elmwood, a private girls' school in Ottawa.

As art mistress, May taught girls from kindergarten to graduation, introducing them to drawing, oil painting, finger painting, art history

and interior decoration. "This has been a wonderful year in Art," a student wrote at the end of May's first year. "We have begun to see that the ability to create and appreciate loveliness is given to all. Miss May has encouraged us to create; to express ourselves in whichever medium suits our personal feelings, and many of us have taken to oils." During the war, the students designed posters for the Red Cross, and many contributed to a school exhibition, which was praised in the *Ottawa Citizen* for "its elemental colour and bold freedom of line."[34]

In 1937, Mabel May set up the children's Saturday morning class at the National Gallery. The class accommodated about 50 children, but the demand was so great that admissions were increased the following year. As Mabel May told her pupils, "It is natural for every child to want to express himself creatively, to sing, dance, draw and dramatize."[35] By the time May left Ottawa, the programme involved 150 children, including about 50 teenagers who attended a senior class on Friday afternoon. May's salary, which started at $15 a week, was increased to $30 in 1941, when she took on the senior class.

As though two jobs were not enough, the indomitable May also taught an adult class at the NGC from 1944 to 1946.[36] Although she had taken up teaching for financial reasons, she enjoyed the work, particularly the children's class. After her return to Montreal in 1947, she wrote to H.O. McCurry, director of the NGC, about the possibility of resuming directorship of the Saturday morning class, but the cost of commuting was too high.[37] Mabel May continued to teach (probably in her studio) until she left Montreal in 1950.

Lilias Torrance Newton only turned to teaching when she needed the money. Before her marriage, she taught for a short while, and after her husband left her in 1931, she resumed teaching, initially in her studio. In September 1934, Newton and Edwin Holgate opened a school under the auspices of the AAM. Holgate took the Antique and Life classes, while Newton taught Portrait Painting and Still Life. Not satisfied with what they were earning, they quit in 1936, but returned under a new financial arrangement in 1938.[38]

Teaching did not come easily to someone of Newton's temperament. She was too impatient. A former student, artist Jeanne Rhéaume, told me that Newton would sometimes paint on her students' work, thus robbing them of their incentive.[39] In May 1940, Newton and Holgate resigned. It was a brave step for Newton, as teaching had provided some security, but she obviously preferred to focus on portrait painting.

As art educators, the Beaver Hall women helped to develop the taste of young people and to create an audience for Canadian painting. Anne Savage took this work a step further through her radio broadcasts and public lectures. In 1939, she gave eight short talks on Canadian art on CBC radio, an unusual venture for the time.[40] She began by linking Canadian landscape painting to the work of the 19th-century English painter John Constable, and ended with the Group of Seven. She also gave illustrated lectures on Canadian painting, sometimes showing the National Film Board's *Canadian Landscape* (1942). "I had your movie down at the church," she wrote to Jackson, who appeared on screen in a scarf knitted by Sarah Robertson, "and Sarah and Frances Porteous and Jessie Beattie saw it and loved it. Sarah was in the seventh heaven."[41]

When addressing a female audience such as the Canadian Women's Club, Savage emphasized the achievements of women artists, particularly Canadians. Like many successful women, Savage did not recognize any bias against women in her profession. Speaking of women artists, she said: "Their work is judged strictly on merit and any handicap they have comes from having to devote time to such things as housekeeping." Her lectures, delivered in the 1950s and widely reported, offered women inspiring role models. She celebrated the talents of her painting friends, and she decreed that artists like Emily Carr and Prudence Heward "with their powerfully controlled performances are second to none."[42]

As educators, the Beaver Hall women's greatest contribution was in the field of child art. They stimulated the creativity of thousands of students, and they helped to change the public perception of children's art. Exhibitions like the NGC's *Pictures by Children* (1937-38)—which included work by pupils of Savage, Seath, and May—encouraged viewers

to appreciate children's art as an expression of the child's personality, rather than for its approximation to adult art.[43]

Despite the surge of interest in child art in the 1930s, the new art education flourished mainly in the Saturday classes of art galleries. It was not formally adopted in Quebec schools until the 1960s, when the Parent Commission recommended sweeping changes to education, including a more creative approach to teaching and the appointment of specialist art teachers.[44] After 40 years, the child-centred approach that Anne Savage and Ethel Seath had pioneered in Montreal was finally established in the Quebec school system.

Finger paintings by pupils of Ethel Seath.
Reproduced from *The Study Chronicle*.
Courtesy of The Study.

Chapter Nine

~

The War Years

THE OUTBREAK of the Second World War in September 1939 was a shock
to many Canadians. Despite Hitler's repeated acts of aggression,
Canadians had hoped that the policy of appeasement practised by the
British government would bring peace. In the early months of the war,
Canada's main role was to supply provisions for Britain, but after the
surrender of France in the summer of 1940, Canada began to recruit in
earnest. Conscription was introduced for home defence, and intense
efforts were made to recruit volunteers to serve abroad. By late 1942,
Canada had five divisions overseas.[1]

The war touched many of the Beaver Hall women personally. Watch-
ing the mobilization of 1940, they remembered the brothers, cousins,
and friends they had lost in the First World War. After saying goodbye to
her nephew Hugh, a naval officer, Anne Savage remarked: "Heavens when
I think of it, we went through all that, they seem so much more efficient
and able to make a better job of it. I hope they do."[2]

The many references to the war in Anne Savage's and Prudence
Heward's correspondence suggest the way it pressed upon everyone's
consciousness, a dark shadow at every feast. "How did you feel about
Cologne, could you bear it—What a death agony Europe is in," Savage
wrote to Jackson after Cologne was bombed.[3] Evidence of the war was
everywhere, in ration books (gas, liquor, and certain foods were rationed),
registration cards (all Canadians sixteen and over were required to

register) and the ubiquitous propaganda posters—urging people to enlist, to send parcels to the men overseas, and to buy Victory Bonds.

"Isn't it wonderful to have some encouraging news," Prudence Heward wrote to Isabel McLaughlin (9 November 1942). "When I was walking down town today, I found myself feeling quite happy, something I haven't felt for years. So I said 'I wonder why' & realized it was the war news."

Anne Savage and Prudence Heward took British evacuees into their homes. The Hewards' visitor, a young girl, stayed for six years and left with a first class degree in Economics. Despite heavy teaching duties and an ailing mother, Anne Savage invited a family of three to Highland Avenue. As McDougall notes, Savage wore herself out during the war, taking care of everyone's interests except her own.[4]

The Beaver Hall women did volunteer work, as they had in the First World War. Prudence Heward was dissatisfied with her "small attempts at war work." She praised Isabel McLaughlin for working in a tomato factory, but concluded: "I shall start painting this week & hope this futile feeling I now have will abate a bit."[5]

Canadian artists made several collective contributions to the war effort. They donated works to an auction for the benefit of refugees, held at the National Gallery, 10 October 1940. Princess Juliana of the Netherlands, "a royal refugee," opened the sale, which raised $2,459. Acting as auctioneer, the energetic Arthur Lismer mixed wit and persuasion: "Pretend these pictures are little refugees and take them into your homes," he urged.[6] Newton's *Child's Head* went for $135, the second highest price at the auction. Savage contributed three paintings; Heward, Lockerby, and Seath, two works each; May, Morris, Collyer, and Robertson, one each.

In June 1941, artists, art educators, and critics met at Queen's University, Kingston, Ontario. The Kingston Artists' Conference was the "brainchild" of André Biéler, who acquired funding from the Carnegie Corporation and the NGC. It was the first time that artists from Eastern and Western Canada had come together. They were joined by a few

Kingston Artists' Conference, Queen's University, 1941.
Front row: Isabel McLaughlin (in dark hat), A.Y. Jackson, and
Pegi Nicol MacLeod (with papers). Second row: Prudence Heward
in hat. Behind her and to the right, Ethel Seath.
National Archives of Canada, PA 130636

Americans, including the Boston Workshop Group, who presented technical papers on painting methods. Heward, Newton, May, Savage, and Seath were among the 154 participants.[7]

The artists had a wonderful time getting to know colleagues from across the continent. After discussing cultural and technical issues, they elected a committee to draw up plans for a permanent national organization, the Federation of Canadian Artists (FCA).

The theme of the Conference was the artist's relationship to society, which was given a particular resonance by the war. Walter Abell (1897-1956), professor of Art at Acadia University, Nova Scotia, gave the keynote speech, "Art and Democracy." Abell, an American, praised the democratization of culture that had taken place under Roosevelt's New Deal. Arguing that the arts should serve the people as a whole, he cited programmes like the Works Progress Administration's Federal Art Project, which had employed thousands of artists while providing art for public spaces.[8]

Prudence Heward may have been thinking of Abell's lecture, or similar discussions, when she wrote to Isabel McLaughlin (4 July 1942): "I realize our social system must be bettered, but gosh I'm tired of the common people—everything for the masses everything public nothing private. To hear some people lecture it's even a sin to have a beautiful picture on your own wall—in your private house—it should be seen by the masses." While not opposed to social change, Heward refused to feel guilty for owning beautiful things. Her letter, thanking Isabel for some lingerie, is signed, "the proud owner of the most capitalist slip you ever saw."

Women made up about a third of the delegates at the Kingston Conference and played an active role in the discussions. Sculptor Frances Loring urged the participants to do something to counteract the prevalent attitude that it was "a disgrace to in any way patronize art until the war [was] over."[9] Her idea of a petition to the federal government was pursued by a committee of the FCA, who collected a thousand signatures to their Artists-in-the-War-Effort Petition, but failed in their attempts to deliver it personally to the Prime Minister. The Petition was finally mailed on

16 February 1943.[10]

The Canadian government was slow to embark on a war art project, despite the success of the Canadian War Memorials Fund (CWMF) in the 1914 war. But gradually the combined efforts of National Gallery Director H.O. McCurry, journalists, and the newly-formed Federation of Canadian Artists persuaded the government to act. The deciding factor may have been the public's enthusiastic response to an exhibition of British war art that toured Canada in 1941-42. In January 1943, the Cabinet gave final approval to a war art project, based on plans suggested by Vincent Massey, Canadian High Commissioner to England. A few months later, the Canadian War Artists Selection Committee, headed by H.O. McCurry, assigned fifteen war artists to the armed services.

Of the 32 war artists who were eventually appointed, Molly Lamb Bobak (b. 1922) was the only woman. Bobak, a private in the Canadian Women's Army Corps (CWAC), was not commissioned as a war artist until May 1945, despite having exhibited a talent for recording army life. The delay was due to bias in certain sections of the army and to a tardiness in admitting the need for documentation of the women's services, which were seen as temporary support for the men's forces.[11]

Both Massey and McCurry, however, recognized the importance of including the women's point of view. Massey tried unsuccessfully to get an official commission for Lilias Torrance Newton. Writing to McCurry in October 1943, Massey said that Newton would "do an extremely useful job here and her sex ought to be no bar. There was the same attitude expressed to the organization of the women's services early in the war but it seems archaic now."[12] Despite Massey's follow-up telegram to the Secretary of State in July 1944, Newton was not appointed.

McCurry did what he could for women artists, hiring Lilias Torrance Newton, Paraskeva Clark, Pegi Nicol MacLeod, and others to record the war effort at home. But as MacLeod remarked in the magazine *Canadian Art*: "It isn't easy when one is out of uniform to grasp the whole story of their [service women's] lives. Only if all the women painters in Canada were to cover all the activities of all the Women's Divisions could

this story ever be depicted properly." She concludes by admonishing the War Records committee for its neglect of women: "It is unfair enough to leave out the mothers of soldiers, the nurses, the factory girls. What an obvious flaw to neglect also the women in the armed services."[13]

When Lilias Torrance Newton was asked whether the war had a great effect on artists, she replied: "I don't think anything affects artists much outside being artists, do you? They are singularly simple that way."[14] Newton was not suggesting that artists did not care about the war, but rather that they see and feel as artists whatever they may be doing. Certainly, Newton did her part. She painted two portraits for the Department of National Defence to be used as recruiting posters: *Canadian Soldier No. 1* (1942) and *Wing Commander W.R. MacBrien, RCAF* (1942). She was eager to go overseas, telling McCurry that she wanted to "borrow a couple of pilots from the Ferry Command" to try out some sketches, "in case anything breaks about overseas."[15]

The artists' associations initiated several projects related to the war. Prudence Heward designed a poster for the CGP exhibition *Canadian War Posters*, which was shown at the Art Gallery of Toronto in December 1942. The CGP executive also considered asking all their members to produce a war painting, but met with stout resistance from Marian Dale Scott, who resented being told what to paint.[16] Although the project was not fully implemented, the 1944 CGP exhibition included many war-related works. The artists interpreted the subject freely—Marian Scott contributing an abstract, *Atom, Bone and Embryo*, as her meditation on war. Ethel Seath exhibited *Munition Plant, Montreal*; Kathleen Morris, *Airmen, Caughnawaga*; and Mabel Lockerby, *Marching*, a fanciful composition of soldiers parading under a row of jagged telephone wires.

According to Walter Abell, painting the war was important, not only as a historical record, but in order to "enrich the nation's consciousness of the experiences through which it is passing."[17] Much of the art produced during the 1940s, however, had no direct relation to the conflict. As Anne Savage recognized, art was a necessary spiritual antidote to the anxieties and regimentation of war. " . . . when you hear of all the people

working on dictated jobs," she wrote Jackson, after hearing a broadcast about Britain, "it makes you think that the work of the artist as an interpreter and relaxer is going to be very badly needed. They don't realize it but art is the only thing that will bring them back to normal."[18]

Savage, Heward, Robertson, and Seath exhibited at the Art Gallery of Toronto's Print Room, in February 1940. Heward contributed six portraits, five landscapes, and a still life. Looking at these works, Heward remarked to McLaughlin: "I feel as if I were sitting inside myself. Rooney is looking sadly at me, my Farmer's daughter reproachfully—Winnie bright but bored & my Indian girls are feeling dour. My landscapes say remember, remember, remember, but my petunias are nodding & blowing quite gaily in the breeze."[19]

Heward's fanciful remark about sitting inside herself suggests an emotional involvement with the subjects of her portraits. The sadness that she sees in the faces of women and children may be a projection of her own inner world. Her nephew, John Heward, remarked that she was much more concerned with the inner life than she admitted to herself.[20] In *Portrait Study* (1938), the sitter is Heward's older sister, Rooney. The intimate viewpoint (the figure is cropped at the bust and just above the hairline) focusses attention on Rooney's face, making us feel like intruders on a moment of private reflection. Rich, vibrant colours heighten the emotional impact of the work. This image, with its haunting resemblance to the artist, seems to evoke the personality of Prudence Heward, her introspection and her sadness.

In *Farmer's Daughter* (1938), Heward continues to explore the relationship between woman and the land, which she began in *Rollande* (1929), but now she comes closer to her model, creating a more intimate feeling. In a final work on this theme, also entitled *Farmer's Daughter* (c. 1945), the landscape is merely suggested and the fence (an important symbol in *Rollande*) is reduced to a squiggle. Heward no longer uses symbols to reinforce her meaning which is focussed on the inner strength and composure of this young woman.[21]

The four-woman show included Robertson's *Fort of the Sulpician*

Seminary (c. 1940), in which the grey-stone tower is framed by brilliant autumn foliage. The image suggests both flux—the changing season—and stability, the seeming permanence of the 300-year-old fort and the black-robed priests. Seath's *Cactus* (1938) and Robertson's *Lilies* (c. 1938; plate 19) present two different treatments of a plant on a window sill. Seath focusses on a geometric arrangement of cactus and pears, while Robertson freely combines still life and cityscape, letting the large pink petals curl out over the rooftops.

The following year, Mabel Lockerby and Kathleen Morris exhibited at the AGT's Print Room with Marian Dale Scott and Pegi Nicol MacLeod. Kathleen Morris included Quebec landscapes (*St. Sauveur* and *Rural Quebec*) and Montreal street scenes (*Old Tavern, Craig Street*). Jackson noted his impressions in a letter to Anne Savage (13 January 1941): "Kay Morris, conventional compared with the others. But good Canadian stuff. Mabel Lockerby, naive, almost a primitive, is attracting the most attention. They wonder how such a fine artist is so little known." Lockerby had been exhibiting since 1914, but only in group shows. There is an element of fantasy in some of her works, which led Robert Ayre to remark: "Christopher the cat, the bird on the bough, the pink house—all looked as if they came out of a child's book, and a nice book, too."[22] In *The Pink House* (c. 1940), a flattened image of a house, rather like a child's drawing, occupies the middle ground with trees and green hummocks in the foreground.

Heward, Newton, Savage, and Seath exhibited at the Art Association of Montreal, in December 1944. Each artist contributed twenty works. Heward was pleasantly surprised when H.S. Southam, Chairman of the Board of the National Gallery, came to see the show. As she told Isabel McLaughlin (9 December 1944): "I am very flattered for myself & the others. We say there is life in the old girls yet."

A selection of paintings by Heward, Savage and Seath was sent from this exhibition to the Willistead Art Gallery in Windsor, Ontario. A review in the *Windsor Daily Star* remarked on the "essentially contemporary" style of the painters. "There is simplification of detail, bold treatment of masses,

skilful handling of colour. The general effect may be posterish at times, but there is unfailing vigour and interest."[23]

Anne Savage included three paintings of Métis, the resort on the Lower St. Lawrence which she had visited since childhood. As a girl she had not liked the sea, but later she was intrigued by the configuration of rocks and pools. "It's wonderful the way the land rolls away in great sweeping folds," she told Arthur Calvin. "It was like a patchwork quilt, it just unfolded to perhaps dark fir trees and spruce and poplar." In *The Lighthouse, Métis* (c. 1944), she creates a dramatic contrast between light and dark masses of rock and between the long curving lines of the fishing nets and the sharp diagonals of the supporting poles. Although the subject of Savage's painting had no direct reference to the war, her wish to engage with what she saw as "the everlastingness of the sea and the rocks" may have been a reaction to the uncertainties of war time.[24]

By the spring of 1945, the war was in its final phase. "Last night the whole world was glued to the radio waiting for the announcement that the war was over but nothing happened," Savage wrote Jackson on 29 April 1945. A few days later the German surrender was announced; people all over the country joined in celebration. Prudence Heward listened to Churchill's victory speech and went to church, where she was thrilled by the singing of Blake's "Jerusalem." "Isn't peace in Europe unbelievably wonderful," she wrote to Isabel McLaughlin, "but such an awful price. I keep thinking of the ones who will never return."[25]

As a feeling of euphoria swept through the country, Canadian artists had their own reasons to cheer. In June 1944, the Federation of Canadian Artists presented a brief to the Commons Committee on Reconstruction and Reestablishment, which recommended the formation of community art centres, increased support for the National Gallery and the National Film Board, and the creation of a government body to supervise all cultural activities. The brief, which owed much to the efforts of Toronto sculptor Elizabeth Wynn Wood, was heralded in the Toronto *Daily Star* as "A Noble Vision For Canada."[26] Within a month, the federal government announced plans for a new National Gallery—plans that were only fully

realized with the opening of the present purpose-built gallery in 1988.[27] Nevertheless, the warm reception of the FCA brief and the anticipation of more federal support for the arts encouraged a new optimism among artists at the end of the war.

Lilias Torrance Newton in her studio apartment, c. 1938.
Courtesy of Francis Forbes Newton.

Chapter Ten

~

Endings

AFTER THE SECOND WORLD WAR, Canadians enjoyed a period of
unparalleled prosperity. The federal government, anxious to ward off
unemployment as the factories converted to peacetime production,
offered a range of benefits to returning veterans, including university
education. The need to provide houses for the veterans and their young
families spurred the construction industry and led to the growth of new
suburbs around Montreal.[1] Artists benefited directly and indirectly from
the post-war boom. Some were involved in reconstruction projects,
others found teaching jobs as universities and schools introduced new
art programmes. Artists also benefited from the opening of private
galleries that were willing to promote Canadian work and from the grants
offered by the Canada Council, established in 1957.

Lilias Torrance Newton was the Beaver Hall painter best situated to
take advantage of the new prosperity. After the war, she criss-crossed the
country painting influential men, and a few women, in Toronto, Calgary,
Edmonton, and Vancouver. By her own count, she painted about 300
portraits.[2] Her subjects ranged from the Governor General, Earl
Alexander of Tunis, to golfer Sandy Somerville and skier Margaret
Morrison. In 1944, she earned $1000 for the *Portrait of R.Y. Eaton, Esq.,*
President of the Art Gallery of Toronto. By 1952, her fee had risen to $1500.
Painting scores of men in dark suits or academic robes did not challenge
Lilias Newton's imagination, however, and her post-war portraits do not

have the freshness and excitement of her earlier ones. Referring to Newton's commissioned work, Jackson remarked: "It has not much to do with art, and if it goes on too long I don't know what happens."[3]

Lilias Newton's new affluence enabled her to visit Mexico in the late 1940s and Italy in 1953. She gave up her studio-apartment on Pine Avenue in 1956, and moved to the Linton Apartments on the corner of Sherbrooke and Guy Streets. From her new, 30-foot studio, which had once been a billiard room, she enjoyed a spectacular view of Mount Royal.[4]

Her status as Canada's foremost portrait painter was confirmed in 1957, when she was commissioned by the Canadian government to paint the Queen and the Duke of Edinburgh. Interviewed by a *Gazette* reporter before her departure for London, Lilias Newton explained that she liked to begin a project by making a few quick drawings. "As I sketch, my subject becomes more natural, more unconscious, and I catch an impression I may have missed at first."[5] In her pocket diary for 14 March 1957, Newton notes, "First sitting [with] Queen. Very pretty, shy, stiff in pose. Considerate, but not easy."[6] The royal portraits were not a complete success, probably because Newton was unable to establish an easy rapport with her sitters. She was sufficiently pleased with a preliminary sketch of Prince Philip, however, to hang it in her studio in the Linton.

Prudence Heward and Sarah Robertson were still developing as artists in the early 1940s, when their health began to deteriorate. Sarah had bone cancer which settled in her hip, and Prudence had asthma. Ann Johansson was having tea with the Hewards when they heard a commotion in the hall below. They ran downstairs and found Prudence, who had been visiting Sarah, sobbing uncontrollably. She had just learnt that Sarah had cancer.[7]

Although it is not known when Sarah's illness was diagnosed, it must have been before 24 August 1943, when Jackson wrote to Prudence, saying: "I had a letter from Sarah, bright and hopeful. I don't feel there is too much justification for it." Sarah appears to have had a remission, but by 1946, Jackson was reporting regularly to his niece, Naomi Jackson Groves, on the health of his two friends. "Sarah is much better and painting

again," he wrote in March. "Prue still laid up. Doctors made a mess of it, I think."[8]

Prudence Heward's nose was injured in a car accident in May 1939. At the time, she was more concerned about her broken arm, which prevented her from painting. Jackson, who visited Fernbank in September, remarked: "Prue is getting along nicely, but it's a slow business. She is lucky to have her arm at all. She can't paint with it yet, but is doing some left handed sketches."[9] Heward soon resumed painting, but the damage to her nose aggravated her asthma. For the next few years, her health and spirits went up and down. On 4 July 1942, she wrote Isabel McLaughlin explaining that two members of her family were hospitalized and adding: "I was glad to be able to help, also glad it wasn't I in the hospital—for a change."

In the early 1940s, Prudence Heward's younger sister, Honor Grafftey, had a severe nervous breakdown from which she never recovered. Prudence did what she could to help Honor and the teen-aged children, Ann and Heward, who were confused by the drastic change in their formerly high-spirited mother. On 25 November 1943, Honor killed herself, while undergoing treatment at a sanatorium in Hartford, Connecticut.

Prudence was devastated. "Honor's death has been a cruel blow to us all," she wrote Isabel McLaughlin. "To me, my personal loss is so great it staggers me. Honor & I have done everything all our lives together, we were always very close & more so of late years—She was always the most understanding loving & the loyalest of sisters. So bright & gay & amusing—always the greatest admirer of my paintings. She loved me & I loved her. She clung to me all through her dreadful illness & I tried so hard to help her, Issy, it was all so cruel & Honor was so brave through it all. . . . I miss her witty, naughty remarks, however life is a hard school & we just have to stand up to its blows."[10]

Prudence also struggled bravely, painting and preparing for art shows between bouts of asthma. A letter to Isabel McLaughlin (7 November 1944) reveals the resilience and humour that helped her survive. As

Prudence explains, she had gone to the doctor feeling "hellish," but when asked to undress she couldn't resist saying: "Oh doctor, is it all right if I keep on my bracelet?" A caricature of a naked Prudence wearing the bracelet is attached to the letter.

A new diet seemed to bring some relief, and Prudence was feeling more optimistic when she wrote to thank Isabel for a plant, on 8 May 1945: "I simply love it & am now fixed up with a model for the next six weeks.... A week ago Monday was a swell day for me. At breakfast there was a nice letter from Frank [Heward] & in the afternoon the maid came up with your lovely plant, so I didn't feel unloved!" Prudence's canvas, *Caladium*, painted that summer, shows a green plant on the window sill of her room. It was her last canvas.

She spent the next winter in and out of hospital, incurring horrible expenses, as she wrote Jackson, on 27 June 1946. In this long letter, written from Fernbank, Prudence Heward speaks of friends and future plans, but her weariness is apparent: "I often wonder how much longer I can go on, as it is a night & day affair & I am completely worn out. I get up part of the day but it is an effort." She invites Jackson to Fernbank and refers nostalgically to their sketching parties. "It would be lovely to be going on sketching picnics again. I miss my painting terribly but most of the time I just long for rest & to be able to breathe properly." Despite her own pain, Prudence worries about Sarah Robertson, whose cancer has returned. "It has been a big blow for her as she thought everything was arrested. I suppose there is some hope. She came to see me before I left & looked quite well but has lost weight."

That visit in June 1946 was the last time that the two painting friends were together. After spending the summer at Fernbank, Prudence travelled to California with her mother and sister Rooney to try a new treatment at the Hospital of the Good Samaritan in Los Angeles. There, surrounded by family members, Prudence Heward died on 19 March 1947.

Ten days earlier, she had called Sarah from the hospital. Describing their conversation to Jackson, Sarah wrote: "[Prue] sounded so well &

Sarah Robertson sketching, September 1936.
Courtesy of Naomi Jackson Groves.

Anne Savage at her easel, summer 1951.
Courtesy of David McCall.

said, 'Give my love to the Gang,' & I had all their names on my tongue, and she laughed. It was when she was so well—and then she went down. Her suffering had been so great that for her I could only feel it was a release." Sarah does not mention her own grief, but her love for Prudence shines through the stilted phrases: "Her painting friends meant a lot to her. Prue was one of those people that if you were her friend, you were her friend."[11]

Sarah Robertson survived her companion by twenty months, mustering her energy to help organize the Prudence Heward Memorial Exhibition at the National Gallery. Sarah Robertson, Ethel Seath, and A.Y. Jackson chose the paintings, in consultation with the painter's family. After reading the first draft of Jackson's catalogue essay, Sarah Robertson pronounced it "beautiful" but a little too intimate for the general public and suggested a few cuts.[12]

The published essay portrays Prudence Heward as a devoted friend and a thoughtful painter. But Jackson qualifies his praise for her painting, saying: "There was nothing very revolutionary or controversial about her work, nor was there even very much of it. . . ." Such a comment overlooks the originality of works like *Rollande*, *Autumn* (cover and plate 23), and *Girl in the Window* (plate 16), which challenge conventional images of women. Edwin Holgate, a figure painter himself, was more aware of Heward's achievement. Paying tribute to her in *Canadian Art*, he says: "Strongly individual, carefully organized, her work was drawn with great fullness of form and painted with a richness and care which alone could bring out the contemplative aspect."[13] Despite his friendship and admiration for Heward, Jackson failed to see the revolutionary element in her work. Heward portrayed women not as passive objects but as complex individuals with their own personalities and histories.

The Prudence Heward Memorial Exhibition opened at the NGC on 4 March 1948. Efa Heward and other members of the Heward family were present to hear the address delivered by Anne Savage's brother-in-law Brooke Claxton, Minister of National Defence. The exhibition comprised 102 works, including 26 sketches. It was seen by 9241 people

during its three-week stay in Ottawa and many thousands more on its sixteen-month tour of nine Canadian cities. The response from the critics was enthusiastic. Paul Duval recognized Heward's particular sensitivity as a painter of women and children. Writing in *Saturday Night* (24 April 1948), he said: "Her subjects look out of their frames wondering, and a little afraid. They strike one strongly as people living in a world which they cannot quite comprehend."

The National Gallery wanted to buy several works from the Memorial Exhibition. But the Heward family, influenced by McCurry's vision of a Prudence Heward room, generously donated "six of Prue's best pictures and sixteen oil sketches" to the NGC.[14] The Hewards believed that the Gallery had promised to create a Prudence Heward room when space became available, and they are extremely disappointed that this commitment has not been fulfilled. Even today, when the NGC has a large, new building, it seldom displays more than one of its 26 works by Prudence Heward.

Sarah Robertson's health deteriorated slowly, but she continued to paint as long as she could. *October* (1947), her last canvas, is a close-up of a virginia creeper, splashes of colour—orange, yellow, and green—against a dark grey sky. Having feared that the painting would not please the jurors of the CGP exhibition, Robertson was delighted that it was accepted. Writing to Jackson on 15 November 1947, she confided: "It gives me the greatest pleasure that you like it, for it is really a very simple subject. I just looked at it on my walks around here & made a try & it's small."

With her friends, Sarah Robertson was always cheerful, making light of her pain. In the same letter, she admits that she is confined to bed with "a bit of a game hip." Her last months were made more difficult by her mother's illness, but Sarah remained serene, saying: "As you know we always feel that—all is well—whatever comes."[15] Jessie Robertson died on 7 October 1948.

Sarah Robertson's friends continued to support her throughout her long illness. Nora Collyer helped financially by selling some of

Robertson's sketches. Anne Savage, who visited her friend regularly, marvelled at Sarah's alertness. "The frame for her *Waterfall* came back and so she was lying back enjoying it on the dressing table. I showed her a couple of things I had and she analyzed and criticized them as clearly and directly as ever, wonderful."[16] Sarah Robertson died two months later, on 6 December 1948.

Everyone who knew Sarah Robertson was impressed by the way she handled her problems. As Jackson remarked to Savage (20 October 1948): "So much happiness she has had out of life, and created out of next to nothing in so far as material blessings go. She never had anything nor did she lack anything."

Sarah's sister Marion, Anne Savage, and A.Y. Jackson helped organize the Sarah Robertson Memorial Exhibition at the NGC. The exhibition was small—only 55 works, many of which were oil sketches and watercolours. Delicate health and a difficult domestic situation had limited Sarah Robertson's productivity. But, as Jackson suggests in the catalogue essay: "If conditions were not favourable for her art, there is no evidence of it in her painting which expresses a bright, eager spirit with very definite convictions, sensitive to all the beauty of nature—the sun, the wind, the trees and fields and flowers."

Sarah Robertson's sisters and many of her friends were at the National Gallery for the opening of the Memorial Exhibition on 3 November 1951. The exhibition was later shown at the Montreal Museum of Fine Arts (formerly the AAM), 16 February to 5 March 1952, where it was seen by an estimated 4550 people, and in six other Canadian cities.

During the late 1940s, public galleries showed an unprecedented interest in Canadian women painters. The NGC organized memorial exhibitions for Emily Carr, Prudence Heward, and Pegi Nicol MacLeod. An exhibition, *Canadian Women Artists* (1947-48), sponsored by the National Councils of Women of Canada and the United States, opened at the Riverside Museum, New York, and travelled to the NGC and other Canadian galleries. But by the time Sarah Robertson's show opened in 1951, art curators were turning away from representational work to

woo the Abstract Expressionists. The Art Gallery of Toronto, which had shown an exhibition of contemporary art including Jackson Pollock and Mark Rothko in 1949, cancelled the Sarah Robertson exhibition, as did the Musée du Québec.[17] The latter may have been influenced by the hostile review of Jean De La Lune, which appeared in Ottawa's *Le Droit* (6 November 1951). Without mentioning a single painting, he condemned Robertson's work as derivative and hesitant. "Pourquoi, diable! consacrer deux salles à cette exposition qui ne passe pas le médiocre."

For Robert Ayre, however, the exhibition was "a heart-warming experience." Reviewing it for the *Montreal Star* (23 February 1952), he wrote: "The show follows her development from the hooked rug flatness of the delightful *Blue Sleigh* to the almost tropical sumptuousness of our own Museum's *Fort of the Sulpician Seminary*, noting here and there acknowledgements of the styles of her friends as she came to the fullness of her own style."

The death of Prudence Heward and Sarah Robertson deprived the Beaver Hall network of two inspiring leaders. As Jackson remarked on hearing of Heward's death: "The poor old Montreal Group are in a bad way. Prue was their best painter. It will be terribly hard on Sarah."[18]

It was hard on them all. These women had been together since their student days, painting, sketching, and exhibiting. How did the survivors cope with their grief and the premonitions of death that such losses evoke? One can only surmise that they found strength in their work and in each other. The friendships continued, but they no longer thought of themselves as a "gang." The group that they supported, and to which all except Nora Collyer belonged, was the Canadian Group of Painters (CGP).

Anne Savage was president of the Montreal branch of the CGP four times. Her niece Anne McDougall would sometimes arrive at Savage's house to find the painters still sitting round the tea table: "stocky, grey-suited Miss Seath; nervous, charming Miss Morris; golden-haired Gordon Webber; and a dark mass of others, all chatting happily." Meetings were not always serene, however, as some of the members had strong wills. Anne Savage tried to keep the Montreal painters together, unlike Fritz

Brandtner, who resigned in a pique when the others would not agree to a lavish illustrated catalogue.[19]

The CGP continued to hold exhibitions every two years until 1967, when the members voted to disband. Although the Group attracted some new members in the 1960s, painters now had more opportunities for sales and felt less inclined to band together. Anne Savage claimed that the younger painters were "a little more conscious of their own advertisement" and "not quite as selfless" as the original members."[20] For Savage, personal ambition had never been enough; commitment to other artists (the Beaver Hall women, the CGP) and a cause (creating an art for Canada) were an important part of her identity as an artist.

After her retirement in 1953, Anne Savage had time to experiment with new techniques. A comparison of her sunflower paintings from different periods shows her moving towards greater abstraction. In *Autumn, Eastern Townships* (or *Autumn*, c. 1935; plate 22), she combines a close-up of sunflowers with a view of fields and rolling hills. In the later *Sunflowers and Lake Wonish* (c. 1968), the stylized blooms are set against a background of geometrical shapes.[21]

Wanting to get more light into her work, she tried using panels whitened with gesso. As her former student Tobie Steinhouse suggests, Savage may have been most herself in these late works. In *Laurentian Landscape* (c.1960), the white shining through the soft yellows and greens creates a feeling of light and space. Anne Savage was "stunned" to hear that the Montreal Museum of Fine Arts (MMFA) wanted to buy this work, saying: "I had given up any anticipation of being included in the new collections—I was too 'old hat.'"[22]

During the 1950s, the Beaver Hall women had difficulty getting their work into juried exhibitions. The younger Montreal painters, like their confrères in Paris and New York, were rejecting figurative painting in favour of Surrealism (the Automatistes) and other free forms of expression.[23] Kathleen Morris exhibited with the CGP only twice in the 1950s. "Poor Kay," Anne Savage remarked to Jackson (10 November 1954), "she has been ill and was so depressed when both the Academy

and the Group [CGP] turned her down. . . ."In 1961, Savage complained to Jackson that there was "too much of one type of space filling" at the Spring Exhibition. She added, "My own painting looks like a fish out of water, as Lilias says—we are both practising a lost art—portraiture and landscape."[24]

Fortunately, the friends found other ways to show their work. Savage, Seath, Morris, Lockerby, Collyer, and Beatrice Hampson exhibited at the MMFA's Gallery XII in May 1950. Anne Savage exhibited at the new YWCA on Dorchester Street (now Boulevard René Lévesque) in 1956, and Ethel Seath in 1957. Savage sold ten of the twenty works that she showed—a "windfall" that enabled her to make improvements to her studio at Wonish.[25]

In the 1960s, a new interest in women painters, inspired by the Women's Movement, and the opening of more private galleries made it easier for the friends to exhibit. Anne Savage shared space with André Biéler at Artlenders Gallery in 1963, and Nora Collyer exhibited at Walter Klinkhoff Gallery in April 1964, and at Paul Kastel Gallery in October 1971. According to Paul Kastel, Nora Collyer showed about 40 or 50 works, most of which were sold on the first evening.

The invitation for a retrospective exhibition at the Walter Klinkhoff Gallery in 1976 came as a wonderful surprise to Kathleen Morris; she had been devastated the previous year when Charles Hill did not include her in the NGC exhibition *Canadian Painting in the Thirties* (1975). "I am of course feeling very, very badly about this as it is the end of my Art for good I am afraid," she wrote to her friend Michael Dunn, "as no one will think much of pictures by artists who were not in that marvellous catalogue."[26]

The opening of the retrospective was an intensely emotional experience for the octogenarian painter, who was overwhelmed by her warm reception and the joy of being reunited with the works of her youth. There were 55 paintings: images of Montreal streets, Berthierville, the Laurentians, the Ottawa market, and cows at Marshall's Bay. Although the works were not for sale, the show greatly enhanced Kathleen Morris's

Nora Collyer sketching at Cap à l'Aigle, Quebec,
summer 1968.
Courtesy of Jane Wandell.

reputation. Claiming that Morris had left "one of the finest testaments to the joy of Canadian life," a critic said: "Her love affair is declared with every bold brush stroke. The happiness and joie de vivre it brought is told with each robust splash of colour."[27]

Anne Savage had a retrospective exhibition at the Sir George Williams gallery in April 1969—thanks to the efforts of Alfred Pinsky and Leah Sherman, who were on the Sir George faculty. At the opening, a radiant Anne Savage, supporting herself with a cane, explained that what really pleased her about the show was that it was organized by her own students.[28] The retrospective, which included sixty works, was Savage's first major solo exhibition. In a review in the *Montreal Star* (12 April 1969), Robert Ayre welcomed the opportunity to see "the full range of her work," claiming that "the exhibition comes to us as a renewal and a discovery."

Ethel Seath exhibited in Gallery XII of the MMFA in October 1962. The Study Old Girls handled the sales, hoping to raise some money for Seath, who had retired earlier that year. The paintings (eleven oils and ten watercolours) were mostly still lifes and landscapes of the Eastern Townships and Lower St. Lawrence. Robert Ayre remarked that "while she clings to the objects she knows and loves, she has a strong sense of their abstract qualities, which she emphasizes, especially in some of her still life compositions."[29] In an interview quoted in the *Montreal Star* (26 October 1962), Ethel Seath said: "I plan to do some non-objective work now that I am retired." But she had not left herself enough time. She died the following spring, on 10 April 1963.

What compelled Ethel Seath to go on teaching until she was eighty-three? Her motivation may have been partly financial since the school did not have a pension fund until the mid-1950s, but she also felt a deep commitment to The Study, to the memory of Margaret Gascoigne, and to her pupils. Shy and reserved with adults, except for a few intimate friends, Ethel Seath blossomed in the company of children.

"Oh, she was lovely. Oh my, and now she's gone. Oh my, our little group has been so decimated," Anne Savage lamented to Arthur Calvin.

Earlier she had told him of her painting friends, saying, "I was really very sad that I'm the last one, there were only six of them. They have all died, all died."[30] Anne Savage was interviewed by Calvin in 1967, when only three of the Beaver Hall women had died. Her error suggests that the ties that held the painters together for so long had dissolved.

Despite a mastectomy in April 1965, that affected her right arm, Anne Savage continued to paint. *Le Petit Jardin, Sandy Bay, Métis* (1969) was probably the last canvas that she completed. She died at Pierrefonds, Quebec, on 25 March 1971.

Two other Beaver Hall painters died the same year. Emily Coonan, who had not been in touch with the other women for many years, died on 23 June 1971. Mabel May spent the last twenty years of her life in Vancouver. She died on 8 October 1971 at the age of ninety-four.

Mabel Lockerby could not paint in her last years, because of failing eye sight. She retained her sense of humour and, according to a cousin, was full of life even in her nineties. Shortly after her sister Hazel's death in January, 1976, Mabel Lockerby suffered a stroke. She died on 1 May 1976.

Lilias Torrance Newton continued to accept portrait commissions until she was in her late seventies. Anne McDougall, who interviewed Newton in the 1970s, described her as looking "chic" in a dark brown silk blouse and modish tweed skirt.[31] Newton had her easel up and a portrait under way, even though by then she was having problems with her sight and hearing. After a bad fall in 1975, Lilias Newton was forced to give up her apartment in the Linton and move to a nursing home. She died in Cowansville, Quebec, on 10 January 1980.

Kathleen Morris did not paint much after her retrospective exhibition in 1976. She spent her last years in a nursing home in Rawdon, Quebec. She died on 20 December 1986, aged ninety-three.

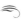

In writing this book, I have had the privilege of sharing imaginatively in the lives of ten gifted women. The Beaver Hall women were remarkable for their commitment to painting and for their friendship. I like to think

of them gathered at the Art Association of Montreal for the opening of the Prudence Heward Memorial Exhibition. Most of them had already seen the exhibition in Ottawa, but this evening, 13 May 1948, is special. Anne Savage, one of their own group, is opening the exhibition. It was not an easy thing to do, as Lilias Newton observed, to speak about a friend who had just died. But Anne Savage was superb. Thirty years later the image of Savage in a long, black velvet gown remained with Lilias Newton. "She was not in the least self-conscious, and I remember thinking this must be how she teaches."[32]

Anne Savage begins by paying tribute to Prudence Heward as a woman painter. "Not since the days of J.W. Morrice has any native Montrealer brought such distinction to her native city, and never before has such a contribution been made by a woman." She speaks of Prudence Heward's "driving will—which never allowed her to leave anything unfinished" and her readiness to help others. "To her friends she was invaluable, as she could give the kind of criticism which penetrated but didn't hurt." Recognizing Prudence Heward's ability to "liberate the inner spirit of the sitter," Anne Savage concludes: "It is as a painter of women and children that she will be remembered."[33]

During the talk, Anne Savage refers to her friend's painting *A Summer Day* (1944), which combines a still life with a view of the lake at Fernbank. It is easy to see why this painting appealed to Anne Savage. The image of a tea table on the veranda at Fernbank evokes memories of the Beaver Hall women's hours together: at the tea table, and on sketching picnics. But to me, the work that best conveys the spirit of the Beaver Hall painters is Prudence Heward's *At the Theatre* (1928; plate 4). This image of women enjoying a performance together is a celebration of women's friendship. And since the models were Sarah Robertson's sisters, the reference to the Beaver Hall painters is clear.[34] *At the Theatre* is an evocation of the affection, shared goals, and passion for painting that united these painting friends.

Notes

INTRODUCTION

1. See, for example, Joyce Millar, "The Beaver Hall Group, Painting in Montreal, 1920-1940," *Woman's Art Journal* 13/1 (1992): 3-9.

2. See Natalie Luckyj, *Expressions of Will: The Art of Prudence Heward* (Kingston: Agnes Etherington Art Centre, 1986), 45.

3. W.G. Constable, "Artists of the Empire," *The Listener* 5 May 1937.

4. Eleanor Tufts, *Our Hidden Heritage: Five Centuries of Women Artists* (New York: Paddington Press, 1974); Elsa Honig Fine, *Women and Art: A History of Women Painters and Sculptors from the Renaissance to the Twentieth Century* (Montclair, N.J.: Allanheld and Schram, 1978); Linda Nochlin and Ann Sutherland Harris, *Women Artists: 1550-1950* (Los Angeles: Los Angeles County Museum of Art, 1976).

5. Rozsika Parker and Griselda Pollock, *Old Mistresses: Women, Art and Ideology* (London: Pandora Press, 1981), xviii.

6. Cited in Octave Uzanne, *The Modern Parisienne* (London: Heinemann, 1912), as quoted in Parker and Pollock, 8; their italics.

7. See Deborah Cherry, *Painting Women: Victorian Women Artists* (London: Routledge, 1993), 66.

8. Dorothy Farr and Natalie Luckyj, *From Women's Eyes: Women Painters in Canada* (Agnes Etherington Art Centre, Queen's University, Kingston, Ont., 1975); Natalie Luckyj, *Visions and Victories: 10 Canadian Women Artists 1919-1945* (London Regional Art Gallery, London, Ont., 1983); Maria Tippett *By a Lady: Celebrating Three Centuries of Art by Canadian Women* (Toronto: Viking, 1992).

9. *By Woman's Hand: A Tribute to Three Women Artists whose Lives and Works Were Almost Forgotten*, Animations Piché Ferrari and National Film Board of Canada.

10. See Cherry, 8.

CHAPTER ONE

1. See Ronald Rudin, *The Forgotten Quebecers: A History of English-Speaking Quebec 1759-1980* (Quebec: Institut québécois de recherche sur la culture, 1985), 204.

2. The remainder were Jews, 2.5%; Europeans, 2.1%; Asiatics, 0.3%; and others, 0.5%. See Paul-André Linteau, *Histoire de Montréal depuis la Confédération* ([Montréal]: Boréal, 1992), 160-62.

3. See Herbert Brown Ames, *The City Below the Hill* (Montreal, 1897; rpt. Toronto, University of Toronto Press, 1972), 80-86 and 106.

4. See François Rémillard and Brian Merrett, *Mansions of the Golden Square Mile, Montreal, 1850-1930* (Montreal: Meridian Press, 1987), 21. The term "Golden Square Mile" is a recent variation.

5. See Rudin, 205.

6. See Ames, 88-97; and Rémillard and Merrett, 22.

7. Margaret W. Westley, *Remembrance of Grandeur: The Anglo-Protestant Elite of Montreal, 1900-1950* (Montreal: Libre Expression, 1990), 25.

8. See "J.G. Savage, Fenian Raid Veteran, Dead," Montreal *Gazette* 26 June 1922; and "Business Man Dies," *Montreal Star* 28 June 1926.

9. See Karen Antaki, "Rediscovering Emily Coonan," in *Emily Coonan (1885-1971)* (Montreal: Concordia Art Gallery, 1987), 14.

10. See "Mr. A.R.G. Heward Stricken in Street," Montreal *Gazette* 17 May 1912; and "J.G. Savage," Montreal *Gazette* 26 June 1922.

11. See "Late Mr. E. May Buried," Montreal *Gazette* 8 January 1916.

12. See "Alfred Collyer, 73, to be buried today," Montreal *Gazette* 7 Jaunary 1946.

13. *Lovell's Montreal Directory*, vols. 1878 to 1900; and Interview with Bill Mahaffy, 26 October 1989.

14. Anne Savage, Autobiographical Notes, File I, Item 1.2, Savage Archives, Concordia University.

15. See John Ruskin, *Sesame and Lilies, Unto this Last, and The Political Economy of Art* (London: Cassell, 1907), 73-4. For a critique of the separate spheres concept, see Amanda Vickery, "Golden Age to Separate Spheres? A Review of the Categories and Chronology of English Women's History," *Historical Journal* 36/3 (1993): 383-414.

16. See Alison Prentice, et al., *Canadian Women: A History* (Toronto:

Harcourt Brace Jovanovich, 1988), 143-46; and Clarissa Campbell Orr, ed., introduction, *Women in theVictorian ArtWorld* (Manchester: Manchester University Press, 1995), 4-5.

17. See Robert Sedgewick, "The Proper Sphere and Influence of Woman in Christian Society," in Ramsay Cook and Wendy Mitchinson, eds. *The Proper Sphere:Woman's Place in Canadian Society* (Toronto: Oxford University Press, 1976), 8-34.

18. Veronica Strong-Boag, "'Setting the Stage': National Organization and the Women's Movement in the Late 19th Century," in Susan Mann Trofimenkoff and Alison Prentice, eds. *The Neglected Majority: Essays in Canadian Women's History* (Toronto: McClelland & Stewart, 1977), 87.

19. See Strong-Boag, 90.

20. NCWC *Report* (1894), 22, as quoted in N.E.S. Griffiths, *The Splendid Vision: Centennial History of the National Council ofWomen of Canada* (Ottawa: Carleton University Press, 1993), 23.

21. The keynote speech was given by Lady Ishbel Aberdeen. See "The Countess' Busy Day," Montreal *Gazette* 1 December 1893.

22. See Catherine Lyle Cleverdon *The Woman Suffrage Movement in Canada* (Toronto: University of Toronto Press, 1950), 214-64.

23. See Marie Gérin Lajoie, "Legal Status of Women in the Province of Quebec," *Women of Canada:Their Life andWork*, ed. National Council ofWomen of Canada (1900; rpt. N.p: NCWC, 1975), 42.

24. See Griffiths, 51-52.

25. See A Bystander [Goldwin Smith], "The Woman's Rights Movement," *The Canadian Monthly and National Review*, 1 (March, 1872), reprinted in Cook and Mitchinson, 34-50; and Prentice, et al, 194-96.

26. Louisa Chapman to Frances K. Smith, 9 February 1983, Frances K. Smith papers, Collection 3726.1, Queen's University Archives, Kingston, Ontario.

27. The fees for 1913-14 ranged from $20 in Kindergarten to $60 in the Sixth Form. An excerpt from the *High School for Girls Prospectus, 1913-14*, and Anne Savage's academic record were kindly provided by the Protestant School Board of Greater Montreal.

28. See Arthur H. Calvin, "Anne Savage, Teacher," M.A. thesis, Sir George Williams University, 1967, transcript of audiotapes, tape 1, 2. Further references are to tape 1, unless otherwise indicated.

29. See Albert Cloutier, "Lilias Torrance Newton, R.C.A.," undated typescript, Newton Papers, NGC.

30. Mt. Allison, N.B., granted a B.Sc. to Grace Annie Lockhart in 1875,

making Lockhart the first woman to earn a degree in the British Empire.

31. See Margaret Gillett, *We Walked Very Warily: A History of Women at McGill* (Montreal: Eden Press, 1981), 15-17, and 70-148.

32. See Alison Prentice, "The Feminization of Teaching," *The Neglected Majority*, ed. Susan Mann Trofimenkoff and Alison Prentice (Toronto: McClelland & Stewart, 1977), 49-65.

33. The McGill Medical Faculty did not admit women until 1918. See Gillett, 280-97.

34. See Gillett, 303-12.

35. See Cherry, 54-55.

36. See Pamela Gerrish Nunn, *Victorian Women Artists* (London: Women's Press, 1987, 44-56.

37. See Colin S. MacDonald, *Dictionary of Canadian Artists*, 7 vols. (Ottawa: 1967-90), and Russell J. Harper, *Early Painters and Engravers in Canada* (Toronto: University of Toronto Press, 1970).

38. See Clive Holland, "Lady Art Students' Life in Paris," *International Studio*, 21 (1903-04), 229.

39. See "The Spring Exhibition Opened at the Art Gallery Last Night," *Montreal Star* 7 March 1895.

40. See Anne Mandely Page, "Canada's First Professional Women Painters, 1890-1914," unpub. M.A. thesis, Concordia University, 1991, 14-15.

41. The WAS was known as the Montreal branch of the Women's Art Association of Canada until 1906, when it reorganized as the WAS. See Mary Phillips, "The Story of the Montreal Women's Art Society," typescript of lecture, 2 January 1917, McCord Museum, McGill University.

42. See Heather Victoria Haskins, "Bending the Rules: The Montreal Branch of the Women's Art Association of Canada, 1894-1900," unpub. M.A. thesis, Concordia University, 1995, 27-8.

43. Phillips, 3.

44. "Studio-Talk. London," *Studio*, 20 (June, 1900), 49.

45. See Rebecca Sisler, *Passionate Spirits: A History of the Royal Canadian Academy, 1880-1980* (Toronto: Clarke, Irwin, 1980), 37. The restrictions were removed when the constitution was amended in 1913.

46. Scrapbook, WAAC Archives, Toronto, as quoted in Haskins, 30.

47. See Mary Ella Dignam, "Canadian Women in the Development of Art," *Women of Canada*, ed. NCWC, 212-13.

48. Art historian Esther Trépanier confirmed this impression in a telephone interview, but added that more research should be done.

49. See Janet Brooke, *Discerning Tastes: Montreal Collectors 1880-1920*

(Montreal: MMFA, 1989).

50. Eliza Maria Jones, *Dairying for Profit; Or the Poor Man's Cow* (Montreal, 1894).

51. Calvin, 9.

52. See Cloutier.

53. Harris to his wife Bessie, 8 April 1901, Harris Archives, as quoted in Frances K. Smith, *Kathleen Moir Morris* (Agnes Etherington Art Centre, Queen's University, Kingston, Ont., 1983), 11.

CHAPTER TWO

1. The AAM became the Montreal Museum of Fine Arts (MMFA) in 1949 and a semi-public corporation in 1972.

2. See Janet Braide, *William Brymner (1855-1925): A Retrospective* (Kingston, Ont.: Agnes Etherington Art Centre, 1979), 35-36.

3. AAM Annual Report, 1895.

4. In 1903, the Elementary section was divided into a Junior class, taught by Cleland, and a Senior class, taught by Brymner and Cleland.

5. Since no school records survive, I have drawn on the AAM Annual Reports and outside sources to estimate dates of attendance.

6. Colin MacDonald's *Dictionary of Canadian Artists* and other sources give Lockerby's year of birth as 1887 and May's as 1884.

7. See Gilles Janson, introduction, Répertoire numérique détaillé du fonds du Conseil des Arts et Manufactures (UQAM Archives, Montreal, 1984); and André Comeau, "Institutions Artistiques du Québec de l'entre-deux-guerres, 1919-1939" (unpub. diss., Univ. de Paris, 1983), 130.

8. See Comeau, 131-32.

9. Margaret Nina Owens kindly showed me the sketchbooks of her grandmother, Nina May Owens (1869-1959).

10. See Appendix One, Chronologies, for other awards.

11. "Pictures Shown at Spring Exhibition of the Art Gallery Reach a High Level," *Montreal Star* 15 March 1912.

12. See Laurier Lacroix, "Peindre à Montréal 1915-1930," in Laurier Lacroix et al., *Peindre à Montréal 1915-1930: Les peintres de la Montée Saint-Michel et leurs contemporains* (Québec: Musée du Québec et Galerie de l'UQAM, 1996), 62.

13. Interview with Jori Smith, 22 October 1991.

14. Interview with Jori Smith; and Charles Hill, Interview with Lilias

Torrance Newton, audiotape, 11 September 1973, NGC.

15. Braide, *William Brymner*, 40.

16. Interview with Marian Dale Scott, 12 October 1989.

17. See Cherry, 54-55.

18. The sketches of Emily Coonan (1909) and Mabel May (1911) are reproduced in Monique Nadeau-Saumier and Margaret Nina Owens, *Nina M. Owens (1869-1959)* (Sherbrooke: Musée des beaux-arts de Sherbrooke, 1992), 53.

19. See Calvin, 22.

20. Robert W. Pilot, "Recollections of an Art Student," *Sun Life Review*, April 1958, 5.

21. Interview with Marian Dale Scott, 12 October 1989.

22. "Address of Miss Anne Savage at Opening of [Prudence Heward] Memorial Exhibition, 13 May 1948," typescript, MMFA.

23. Savage, "Women Painters of Canada," undated typescript, Savage papers, MG30 D374, Vol. 2, NAC.

24. See Sylvia Antoniou, *Maurice Cullen (1866-1934)* (Agnes Etherington Art Centre, Kingston, 1982), 10-11.

25. Calvin, 22.

26. Handwritten note from Kathleen Morris to Eric Klinkhoff, 2 October 1975, private collection.

27. 1910 was one of only two occasions when Brymner conducted the sketching trip.

28. Calvin, 38.

29. See *First Annual Loan and Sale Exhibition of the Newspaper Artists' Association* (Montreal: Art Association of Montreal, 1903), NGC; and Ethel Seath to Miss Julien, 19 September 1908, Henri Julien Papers, MG29 D103, NAC.

30. See Ceta Ramkhalawansingh, "Women during the Great War," *Women at Work: Ontario, 1850-1930*, ed. Janice Acton, et al. (Toronto: Canadian Women's Educational Press, 1974), 276.

31. See Sisler, 93-94. Coonan's *The Green Door* and May's *Canal Scene, Venice* toured with the show.

32. "The Canadian War Memorials Fund; Its History and Objects," reprinted from *Canada in Khaki*, 2 (1917), Doc/CSU, NGC. See also Maria Tippett, *Art at the Service of War: Canada, Art and the Great War* (Toronto: University of Toronto Press, 1984), 3-13.

33. The other Canadian women artists were Dorothy Stevens and sculptors Florence Wyle and Frances Loring. After the War, Mary Riter Hamilton

was commissioned by the Amputations Club of British Columbia to paint European battlefields.

34. Mabel May to Eric Brown, 25 September 1918 and 5 October 1918, Canadian War Records, 5.42.M, NGC.

35. See Kristina Huneault, "Heroes of a Different Sort: Representations of Women at Work in Canadian Art of the First World War," M.A. thesis, Concordia University, 1994, 24-30, and her article "Heroes of a Different Sort," *JCAH*, XV/2 (1993): 27-45.

36. See Cloutier.

37. See Luckyj, *Prudence Heward*, 29-30. It is unlikely that Heward saw exhibitions of the Vorticists, as suggested by Luckyj, as most of their shows took place before 1916.

38. Nellie McClung, *In Times Like These* (rpt; Toronto: University of Toronto Press, 1972), 15, as quoted in Prentice, et al., 207.

39. See Desmond Morton, "World War I," *The Canadian Encyclopedia*, 1988.

40. Telephone interview with Patricia Coonan.

41. See Morton.

42. Interview with Queenie MacDermot, 30 April 1991.

43. Calvin, 9.

44. See AAM Annual Report, 1918.

45. Robert Pilot, notes on William Brymner, dated 22 June 1958, Artist's File, NGC.

46. See Dorothy Farr, *Lilias Torrance Newton, 1896-1980* (Kingston, Ont.: Agnes Etherington Art Centre, 1981), 11-12.

47. See Luckyj, *Prudence Heward*, 59.

48. Calvin, 3.

49. Additions to the library are mentioned in the AAM Annual Reports.

50. Conversation with Leah Sherman, 12 December 1989.

CHAPTER THREE

1. See Tippett, *Art at the Service of War*, 94.

2. See Charles Hill, *The Group of Seven: Art for a Nation* (Ottawa: NGC, 1995), 38-40.

3. William R. Watson, *Retrospective: Recollections of a Montreal Art Dealer* (Toronto: University of Toronto Press, 1974), 40.

4. See Hill, *The Group of Seven*, 24-29.

5. See Ramsay Cook, *Canada, Quebec and the Uses of Nationalism* (2nd ed.

Toronto: M&S, 1995), 175-86.

6. See Mary Vipond, "The Nationalist Network: English Canada's Intellectuals and Artists in the 1920s," *Canadian Review of Studies in Nationalism*, 7 (Spring 1980), 32-51.

7. Editorial *Canadian Forum* 1 (October 1920), 3.

8. Foreword, catalogue *Group of Seven Exhibition of Paintings*, Art Gallery of Toronto, 7 to 27 May 1920.

9. See Cook, 203-04.

10. Jackson to Florence Clement, 28 May 1920, transcript, Beaver Hall Group file, NGC.

11. See Norah McCullough, *The Beaver Hall Hill Group*, a travelling exhibition, organized by the NGC, 1966; and undated NGC information form, Mabel Lockerby documentation file, NGC.

12. See *Lovell's Montreal Directory, 1922-23*; and Savage, "Women Painters of Canada," NAC.

13. Sybil Robertson was a portrait painter who exhibited occasionally at the AAM Spring Exhibitions.

14. "Public Profession of Artistic Faith: Nineteen Painters Represented in 'Beaver Hall Group's' Exhibition," Montreal *Gazette* 18 January 1921.

15. Calvin, 12.

16. *Ibid.*, 11-12.

17. See François-Marc Gagnon, "Painting in Quebec in the Thirties," *JCAH* 3 (Fall 1976): 5-7; and Virginia Nixon, "The Concept of 'Regionalism' in Canadian Art History," *JCAH* 10 (Fall 1987): 35-37.

18. The Women's Art Society organized a large arts and crafts exhibition in 1900 and, in 1905, set up the Canadian Handicrafts Guild. See Phillips.

19. See Hill, *The Group of Seven*, 176-93.

20. *Chansons of Old French Canada* (Quebec: Chateau Frontenac, 1920; rpt. 1971), with a preface by Marius Barbeau, was used by the CPR railway to promote Quebec in the USA.

21. See Calvin, 13-14; and Anne McDougall, *Anne Savage: The Story of a Canadian Painter* (Montreal: Harvest House, 1977), 72-76.

22. Marius Barbeau, in *Canadian West Coast Art*, NGC, December, 1927, as quoted in Hill, *The Group of Seven*, 192.

23. Hewton to Eric Brown, 16 February 1924, File 7.1 Hewton, NGC. The last show mentioned by Hewton was probably the one reviewed in *La Presse*, 21 January 1922, as suggested in Susan Avon, "The Beaver Hall Group and Its Place in the Montreal Art Milieu and the Nationalist Network," M.A. thesis, Concordia University, 1994, 48.

24. An invitation from the Beaver Hall Group to a *vernissage* (on 20 November 1920) is in a private collection.

25. See Savage to Norah McCullough, 6 May 1966, *The Beaver Hall Hill Group*, File 12.4.307, NGC; Hill, Interview with Newton; undated NGC information form, Robertson documentation file, NGC; and Brymner to Collyer, 11 November 1921, private collection.

26. See Smith, Interview with Holgate, quoted in Smith, *Kathleen Morris*, 12.

27. Calvin, 13.

28. Anne Savage, "Notes for Lecture on Canadian Women Artists," Anne Savage Archives, File 4, document 2.19, Concordia University.

29. Jackson to Robertson, 6 January 1928, Jackson/Robertson correspondence, NGC. All correspondence between these painters quoted in this book is in this location.

30. Telephone interview with Norah McCullough, 7 November 1992.

31. McCullough's earlier title for the show, "Painters of the Beaver Hall Hill," would have been more accurate. See McCullough to Savage, 3 March 1966, *The Beaver Hall Hill Group*, File 12.4.307, NGC.

CHAPTER FOUR

1. See Ann Davis, "The Wembley Controversy in Canadian Art," *The Canadian Historical Review* 54/1 (1973): 48-74.

2. Esther Trépanier distinguishes between Modernity, a transitional phase that includes painters like the Beaver Hall women, and Modernism, which does not take hold in Canada until the 1940s. See her review of *Les Esthétiques Modernes au Québec de 1916 à 1946*, by Jean-René Ostiguy, *JCAH* VI/2 (1982): 232-39.

3. H.F. Gadsby, "The Hot Mush School or Peter and I," Toronto *Daily Star* 12 December 1913; Hector Charlesworth (unsigned) "Freak Pictures at Wembley," *Saturday Night* 39 (13 September 1924); J.A. Radford, "Grotesque Fantasies," *Vancouver Sun* 14 June 1932.

4. Morgan-Powell, "Art Association Exhibition Shows Notable Advance," *Montreal Star* 20 November 1913.

5. Morgan-Powell, "Spring Exhibition at Art Galleries is an Indifferent Show," *Montreal Star* 7 April 1926.

6. See Albert Laberge (unsigned), "Des artistes qui affirment de beaux dons," *La Presse* 21 January 1922; and Laberge (unsigned), "Une visite à

l'exposition de peintures," *La Presse* 22 March 1922.

7. See Charles Hill, "Collecting Canadian Art," *Catalogue of the National Gallery of Canada: Canadian Art* (1988), Vol. 1, xi-xiv.

8. Louisa Chapman to Frances K. Smith, 9 February 1983, Frances K. Smith papers, collection 3726.1, Queen's University Archives, quoted in Smith, *Kathleen Morris*, 15.

9. See Luckyj, *Visions and Victories*, Appendix II, "Women Artists: Exhibitors in a selection of major international exhibitions."

10. F. Maud Brown, *Breaking Barriers* (Ottawa: Society for Art Publications, 1964), 71.

11. "Palace of Arts, Colonial Painting," *Morning Post* (London) 22 April 1924, as quoted in *Press Comments on the Canadian Section of Fine Arts, British Empire Exhibition, 1924-1925*. Ottawa: National Gallery of Canada, n.d., 7.

12. "Art at Wembley," *Sunday Times* (London) 10 May 1925, as quoted in *Press Comments*, 45.

13. All eight jurors were members or associates of the RCA, and only two—Arthur Lismer and Randolph Hewton—could be considered modernists. See Davis, 70-71.

14. See letter to the Chairman of the Board of Trustees, NGC, from eight Montreal artists, 7 March 1927 , and letter from ten Ottawa artists, 31 March 1927, Controversy/NGC, 9.9-C, 1927, NGC; and counter-petition, Controversy/NGC, 9.9-C, 1932-34, NGC.

15. For a discussion of these paintings, see Luckyj, Prudence Heward, 59.

16. See Mary Vipond, "The Image of Women in Mass Circulation Magazines in the 1920s," *The Neglected Majority*, ed. Susan Mann Trofimenkoff and Alison Prentice (Toronto: McClelland & Stewart, 1977), 118.

17. By 1922, women could also vote in provincial elections except in Quebec. See Prentice et al., 207-08.

18. Anne Anderson Perry, "Is Woman's Suffrage a Fizzle?", *MacLean's* XLI (1 February 1928), as quoted in Vipond, "The Image of Women," 124.

19. See Griselda Pollock, *Vision and Difference: Femininity, Feminism and the Histories of Art* (London: Routledge, 1988), 56-70.

20. See Pollock, 75-76.

21. Earlier self-portraits of women artists at work include Adélaide Labille-Guyard's *The Artist with Two Female Pupils* (1785), Marie Bashkirtseff's 19th-century *Self-Portrait* (n.d.), and Suzanne Valadon's witty drawing *Nu à la Palette* (1927).

22. See, for example, Berthe Morisot's *Psyche*.

23. Interview with Patricia Coonan, 6 February 1992.

24. See Lacroix, et al., *Peindre à Montréal*.

25. See Pierre L'Allier and Esther Trépanier, *Adrien Hébert* (Québec: Musée du Québec, 1993).

26. See, for example, Clarence Gagnon, *Village dans les Laurentides* (c. 1926, NGC), and Albert Robinson, *Winter, Baie-Saint-Paul* (c. 1923, MMFA).

27. See Janet Braide, *Anne Savage: Her Expression of Beauty* (Montreal: MMFA, 1979), 33.

28. The American tour of *Modern Canadian Paintings* opened in Minneapolis in November 1923, and closed at the Brooklyn Museum in August 1924.

29. Jackson to Robertson, 8 February 1928.

30. See Jackson to Robertson [7 July 1927]; and Jackson to Savage, 30 January [1931], Anne Savage Papers, MG30 D374, NAC. All letters from Jackson to Savage quoted in this book are in this location.

31. *A Painter's Country: The Autobiography of A.Y. Jackson* (Toronto: Clarke, Irwin, 1958), 117.

32. Savage, "Women Painters of Canada," Savage papers, NAC.

33. For the history of the word "genius," see Christine Battersby, *Gender and Genius* (Bloomington: Indiana University Press, 1989).

34. See Calvin, 30-32; and Paula Blanchard *The Life of Emily Carr* (Vancouver: Douglas & McIntyre, 1987), 180.

35. Painter Jori Smith, who, with her husband Jean Palardy, mixed with French and English artists, told me there was little interaction between the two groups in the 1930s.

36. Frederick Housser, "The Amateur Movement in Canadian Painting," *The Yearbook of the Arts in Canada, 1928-29*, ed. Bertram Brooker (Toronto: Macmillan, 1929), 89; clipping from an unidentified Toronto newspaper, 8 February 1930, private collection; typed excerpt from the *Chicago Illustrated Tribune* 18 May 1930, enclosed in letter from Jackson to Robertson (17 June 1930).

37. Morris to McCurry, 18 May 1929, Miscellaneous Correspondence with Artists, 7.1-M, NGC.

38. The prices the NGC paid for Canadian oil paintings in 1930 ranged from $200 for Yvonne McKague Housser's *Rossport, Lake Superior* to $1000 for Randolph Hewton's *Sleeping Woman*. See Annual Exhibition of Canadian Art - 1930, 5.5.A, NGC.

39. See Hill, *The Group of Seven*, 223-24.

CHAPTER FIVE

1. See Cherry, 75.

2. See Sheila Jeffreys, *The Spinster and her Enemies: Feminism and Sexuality, 1880-1930* (London: Pandora, 1985), 128-43.

3. See Blanchard, 92.

4. Prudence Heward to Isabel McLaughlin, 11 May [1934], private collection.

5. See Virginia Woolf, "Professions for Women," *Virginia Woolf: Women and Writing*, ed. Michèle Barrett (London: Women's Press, 1979), 57-63.

6. John Bertram to Barbara Meadowcroft, 22 October 1990.

7. Interviews with members of the Robertson family and Marguerite Rexford Blunt, Orin Rexford's sister.

8. Jackson to Robertson, 1 November [1936]. Robertson saw the Van Gogh exhibition, as did Heward, Savage, and Collyer.

9. Interview with Naomi Jackson Groves, 28 January 1990.

10. Anne Savage, "Notes for Lecture on Canadian Women Artists," Anne Savage Archives, File 4, document 2.19, Concordia University,

11. Information on Lockerby was kindly provided by her cousins, Gwen Floud, Barbara Marcolin, and Margaret Pope.

12. See Smith, *Kathleen Morris*, 25.

13. Interview with Peter Kilburn, 16 October 1992; and Louisa Chapman to Frances K. Smith, 9 February 1983, quoted in Smith, *Kathleen Morris*, 12.

14. Conversation with Betty Galbraith-Cornell Houghton, whose mother, Ethel Liddell Galbraith, taught Morris to play the piano.

15. Interview with Angus Morris, 25 September 1993.

16. Kathleen Morris to J. Russell Harper, 29 April 1968, quoted in Smith, *Kathleen Morris*, 13.

17. Wini Rider "Portrait of the Artist as an Expression of Joy," Montreal *Gazette* 16 June 1976; and Michael Dunn to Frances K. Smith, 13 January 1983, quoted in Smith, *Kathleen Morris*, 13.

18. Information on the Heward family comes from interviews with Prudence's nephews and nieces.

19. Interview with Ann Grafftey Johansson, 29 January 1992.

20. See Luckyj, *Prudence Heward*, 31.

21. Interview with John Heward, 31 October 1991.

22. See McDougall, 22. Savage often signed sketches and notes "ADS."

23. Brooke Claxton (1898-1960) was Minister of National Defence for Canada, 1946-54. Terry MacDermot (1896-1966) taught at Lower Canada College before joining the diplomatic service.

24. Calvin, 36.

25. Savage to Jackson, 7 June 1925, private collection. All letters from Savage to Jackson quoted in this book are in this location. As I did not have access to the original letters, I have quoted from photocopies or from typed copies when photocopies were unavailable.

26. Savage to Jackson, 11 June 1933.

27. Jackson to Savage [25 September 1933].

28. As quoted in McDougall, 174-75. No reply from Jackson is extant.

29. Interview with Geneva Jackson Baird, 14 March 1992.

30. Conversation with Pat Claxton, Anne Savage's niece-in-law.

31. Loise Rhodes to Barbara Meadowcroft, 24 October 1993, and telephone conversations with Loise Rhodes and Barbara Sutherland.

32. May to H.O. McCurry, 3 May 1950, "Miscellaneous Correspondence with Artists," File 7.1-M, NGC.

33. Interview with Marian Scott, 19 October 1989.

34. *Ibid.*

35. Interview with Antonia Seiden Robinson, 6 February 1991.

36. "Canadian Women in the Public Eye: Lilias Torrance Newton," *Saturday Night* 12 November 1927.

37. Theodore F.M. Newton, "Obit Appraisal: Lilias Torrance Newton," Newton papers, NGC.

38. See Prentice et al., 254-55.

39. Newton to Eric Brown, 29 May 1938, Miscellaneous Correspondence with Artists, 7.1-N, NGC.

40. Robert Ayre, "Lilias Torrance Newton, Painter of the Queen," *The Montrealer*, February 1957; and "Foremost Canadian Woman Artist Visits City on First Trip West," *Lethbridge Herald* 30 August 1946.

41. Interview with Forbes Newton, 1 November 1993; and Dorothea Fyfe to Newton, 16 March [1936] Newton papers, NGC.

42. Conversation with Johanna Newton, 1 November 1993.

43. See Newton to H.O. McCurry, 5 November 1942, 7.1-N, NGC.

44. In the 1990s, women continue to care for dependent adult relatives. See Nancy Guberman, Pierre Maheu, Chantal Maillé, *Et si l'amour ne suffisiait pas? Les femmes et la prise en charge des proches* (Montréal: éditions du remue-ménage, 1991).

45. "Women Painters of Canada," Anne Savage papers, NAC.

CHAPTER SIX

1. See Carolyn G. Heilbrun, introduction, *Testament of Friendship*, by Vera Brittain (Wideview Books, 1981), xvi.

2. See Cherry, 69-71, and Janice Helland, "The Glasgow School of Art: A Case Study of Women, Education, and Friendship in Late Nineteenth-Century Scotland," unpub. paper, presented at the North American Conference on British Studies, Montreal, 1993.

3. Robertson to Jackson, 3 April 1947.

4. See Pat O'Connor, *Friendships Between Women: A Critical Review* (Hemel Hempstead, Herts.: Harvester Wheatsheaf, 1992), 37-38.

5. See Carroll Smith-Rosenberg, "The Female World of Love and Ritual: Relations between Women in Nineteenth-Century America," *Signs: Journal of Women in Culture and Society* 1/1 (1975): 1-29.

6. Leo Cox, "Fifty Years of Brush and Pen," *The Pen & Pencil Club: 1890-1959*, Leo Cox and J. Harry Smith (Montreal, 1959), n. pag. See also Avon, 30-31.

7. Leo Cox, *Portrait of a Club: The Arts Club of Montreal* (Montreal: Arts Club, 1962); and conversation with Leslie Coppold, president of the Arts Club, 25 May 1998.

8. See transcript of Frances Smith's interview with André Biéler, 17 July 1968, Frances K. Smith papers, Collection 3726.1, Box 3, Queen's University Archives; and Calvin, 39.

9. Savage to Jackson, 9 April 1935.

10. Savage to Jackson, 12 August 1938; and Savage to Jackson, 3 September 1937.

11. See Morris to Brown, 19 March 1933, Miscellaneous Correspondence with Artists, 7.1-M, NGC; and Savage to Jackson, 28 October 1936.

12. Newton's portrait of Sarah Robertson has disappeared. See Newton to H.O. McCurry, 17 August 1951, 7.1-N, NGC.

13. Interview with Ann Grafftey Johansson, 29 January 1992.

14. Savage to Jackson, 9 April 1935.

15. See Newton to McCurry, 20 September 1936, Outside Activities, 7.4c, NGC; Robertson to McCurry, 2 December 1944, 7.1-R, NGC; and transcripts of the minutes of the RCA, MG28 I 126, vol. 17, NAC. Morris was elected on 22 November 1929.

16. Jackson to Robertson, 3 February [1940].

17. Robertson to Jackson, 3 February 1934; Heward to Eric Brown, 19 March [1932], 7.1-H, NGC; and Morris to H.O. McCurry, 14 January 1939, 7.1-M, NGC.

18. Robertson to Norah Thomson, 8 August 1927, Norah Depencier papers, MG30 D322, Vol. 2, NAC.

19. Jackson to Robertson, 1 February [1930].

20. Autograph draft of Jackson's introduction, *Prudence Heward Memorial Exhibition*, Exhibitions in Gallery, 5.5, NGC.

21. See Joan Murray, "Isabel McLaughlin and Modern Art in Canada," *Isabel McLaughlin: Recollections* (Oshawa, Ont.: Robert McLaughlin Gallery, 1983), 11-16.

22. Heward to McLaughlin, 9 March [1934], private collection.

23. See Luckyj, *Prudence Heward*, 32, fig. 6.

24. Heward to McLaughlin, 21 December [1933].

25. Interview with McLaughlin, 10 February 1990.

26. See Laureen Hicks, "Well Known Art Teacher Retires After 45 Years," *Montreal Star* 26 October 1962.

27. See Katharine Lamont, *The Study: A Chronicle* (Montreal: The Study, 1974), 1-4.

28. Ibid., 50.

29. Interview with John Collyer, 31 October 1992.

30. Marjorie Wellheisen, Collyer's neighbour and friend, kindly provided information on Collyer.

31. Wellheisen to Meadowcroft, 13 April 1992.

32. Interview with Patricia Coonan, 6 February 1992.

33. See, for example, Antaki, 29-30.

34. See S. Morgan-Powell, *Montreal Star* 12 April 1922 and 7 April 1926; and anonymous reviews of the AAM Spring Exhibition in the *Montreal Star* 22 March 1930 and 22 March 1933.

35. Coonan to Pinkerton, 13 March 1955, artist's file, MMFA.

CHAPTER SEVEN

1. See Linteau, 375-84.

2. Hugh MacLennan, *The Watch that Ends the Night* (London: Heinemann, 1959), 119.

3. See Prentice et al., 233-39.

4. Charles Hill, *Canadian Painting in the Thirties* (Ottawa: NGC, 1975), 14.

5. See Esther Trépanier, "Modernité et conscience sociale: La critique d'art progressiste des années trente," *JCAH* VIII/1 (1984): 81-85.

6. See Hill *Canadian Painting*, 95-98; and Blanchard, 234-36.

7. See Hill, *Canadian Painting*, 14.

8. Jackson to Savage, 30 January 1931.

9. Hill, Interview with Newton.

10. Lamont, 50; and Interview with Geneva Jackson Baird, 14 March 1992.

11. See Reynald, "Femmes-peintres dont l'art est viril," *La Presse* 9 February 1933.

12. See Luckyj, *Prudence Heward*, 61.

13. *Inédits de John Lyman*, ed. Hedwige Asselin (Montreal: Bibliothèque Nationale du Québec, 1980), 107; see also Luckyj, *Prudence Heward*, 61.

14. Heward to McLaughlin, 14 [April 1934]; and Arthur Lismer, "Works by Three Canadian Women," *Montreal Star* 9 May 1934.

15. W. Scott & Sons to Heward, 29 May 1934, enclosed in Heward to McLaughlin, 12 June [1934].

16. See St. George Burgoyne, "W. Scott & Sons Leaving Business as Art Dealers in Firm's 80th year," Montreal *Gazette* 4 March 1939.

17. See Sandra Djwa, *The Politics of the Imagination: a Life of F.R. Scott* (Toronto: McClelland & Stewart, 1987), 137.

18. See Hill, *Canadian Painting*, 16.

19. See Djwa, 167.

20. Esther Trépanier, "A Tribute to Marian Dale Scott, 1906-1993," *JCAH* XV/2 (1993): 86.

21. Interview with Angus Morris, 24 September 1993; and "Prominent Painters Contribute to Show," Montreal *Gazette* 10 December 1938.

22. See Charmaine A. Nelson, "*Coloured Nude*: Fetishization, Disguise, Dichotomy," M.A. Thesis, Concordia University, 1995, 3-7.

23. R.B.F., "Canadian Group of Painters Exhibit at Gallery," *Ottawa Journal* 15 February 1938, as quoted in Luckyj, *Prudence Heward*, 47.

24. See Dorothy W. Williams, *The Road to Now: A History of Blacks in Montreal* (Montreal: Véhicule Press, 1997), 49-50.

25. See Prentice et al., 228, and 233-35.

26. Interview with Madeleine Rocheleau Boyer, 12 January 1996.

27. Forbes Newton identified the sitter as Maurice Alaric, a local boy.

28. Newton to Martin Baldwin, 25 April 1942, AGO Archives.

29. Hill, Interview with Newton.

30. Julian Armstrong, "Montreal Artist Ready to Paint Queen," Montreal

Gazette 16 February 1957.

31. Hill, Interview with Newton.

32. See Farr, 20.

33. See Trépanier, "Modernité et conscience sociale," 86-92.

34. Bertram Brooker, "Art and Society," *Yearbook of the Arts in Canada, 1936*, ed. Bertram Brooker (Toronto: Macmillan, 1936), xiii-xxviii. See also Hill, *Canadian Painting*, 15-16.

35. Frank Underhill, rev. of *Yearbook of the Arts in Canada* (1936), ed. Bertram Brooker, *Canadian Forum* XVI (December 1936): 28; Elizabeth Wynn Wood, "Art and the Pre-Cambrian Shield," *Canadian Forum* XVI (February 1937): 13-15; Paraskeva Clarke [sic], "Come Out from Behind the Pre-Cambrian Shield," *New Frontier* I (April 1937): 16-17.

36. File 1, Item 1.2, Savage Archives, Concordia University.

37. Savage to Jackson, [c. 1954]; Savage to Jackson, 7 January 1956; and Savage to Jackson, 2 April 1944.

38. Calvin, Tape 2, 4.

39. Quoted in McDougall, 138.

40. Jackson to Savage, [3 December 1931]; and Savage to Jackson, [22 May 1933].

41. McDougall, 30.

42. Graham McInnes, "World of Art," *Saturday Night* 4 December 1937.

43. See Luckyj, *Prudence Heward*, 68-69.

44. Interview with Marian Dale Scott, 19 October 1989.

45. Robert Ayre, "Gentlemen, the Ladies!" *Montreal Star* 25 April 1964.

46. The canvas and sketch are reproduced in Smith, *Kathleen Morris*, 17.

47. See Foreword, *Catalogue of an Exhibition by Canadian Group of Painters* (Toronto: AGT, 1933); and Hill, *Canadian Painting*, 21-24.

48. The CGP held a show earlier in 1933 at the Heinz Art Salon, in Atlantic City, to which five of the Beaver Hall women contributed.

49. See Hill, Interview with Newton; and Jackson to Robertson, 29 January [1934].

50. Augustus Bridle, "New Democracy Seen In Latest Paintings," *Toronto Star* 3 November 1933, as quoted in Luckyj, *Prudence Heward*, 43.

51. Kenneth Wells, "An Artist Draws His Impression of 'Expressionist' Art!" Toronto *Evening Telegram* 25 November 1933. See illustration, 133.

52. Interview with Naomi Jackson Groves, 28 January 1990, who rescued the painting.

53. Jackson to Robertson, [18 November 1933]. Robertson received $150, less the CGP's 10% commission.

54. Heward to McLaughlin, 30 December [1933].

55. Jackson to Savage, 5 November [1933].

56. Graham McInnes, "Upswing in Art Has Come?" *Saturday Night* 4 November 1939; Robert Ayre, "Significant Exhibition at Toronto by Diligent Canadian Group of Painters," *Standard* 18 November 1939.

57. Jackson to Savage, 22 May [1939].

58. Lyman's journal mentions the Scotts, Ronnie McCall, Frances Porteous, Edwin Holgate, and other friends of the Beaver Hall women. See *Inédits de John Lyman*, 106.

59. "The Atelier," Smith papers, Collection 3726.1, Box 2, Queen's University. See also Smith, *André Biéler*, 75-77.

60. John Lyman, "Borduas and the Contemporary Arts Society," *Paul-Émile Borduas 1905-1960*, Evan Turner (Montreal: MMFA, 1962), 40.

61. Jackson to Savage, 30 April [1939]; and Jackson to Savage, 20 June [1939].

62. See Paul Duval, "Montreal Artists Establishing New Landmarks in Canadian Art," *Saturday Night* 10 November 1945.

63. See Luckyj, *Prudence Heward*, 45.

64. W.G. Constable, "Artists of the Empire," *The Listener* 5 May 1937.

65. Herbert Read, "At the Tate Gallery," *The Listener* 27 October 1938; and Northrop Frye, "Canadian Art in London," *The Canadian Forum* XVIII (1939): 304-05.

CHAPTER EIGHT

1. See Suzanne Lemerise and Leah Sherman, "Cultural Factors in Art Education History: A Study of English and French Quebec, 1940-1980," *Framing the Past: Essays on Art Education*, ed. Donald Soucy and Marianne Stankiewicz (Restan, Virginia: National Art Education Association, 1990), 184-86.

2. See Donald Soucy, *Waves: Approaches to Art Education, 1887-1987* (Halifax: Anna Leonowens Gallery, 1987), 2.

3. See Harold Pearse and Donald Soucy, "Nineteenth Century Origins of Saturday Morning Art Classes for Children in Halifax, Nova Scotia," *Studies in Art Education* 28 (Spring 1987): 143-44.

4. Soucy, *Waves*, 4.

5. As quoted in John A.B. McLeish, *September Gale* (London: J.M. Dent,

1955), 123.

6. See Betty Jaques, "Art Education in the Public English Protestant Schools in Quebec," *Art Education in Quebec, Presentations on Art Education Research* (Montreal: Concordia University, 1978) 1, 33.

7. Calvin, 6.

8. *Ibid.*, 10.

9. See *The Study Chronicle* (1936), 18-20.

10. Quoted in Lamont, 56.

11. Lismer to Savage, 11 August 1922, Savage papers, MG30 D373, Vol. 2, NAC.

12. Calvin, 24.

13. Leah Sherman, "Anne Savage: A Study of Her Development as an Artist/Teacher in the Canadian Art World, 1925-1950," *Histories of Art and Design Education*, ed. David Thistlewood (Longman Group, U. K., 1992), 147. Savage's library included books by Belle Boas, Ralph Pearson, Marion Richardson, and Herbert Read.

14. Calvin, Tape 2, Interview with Alfred Pinsky, 3.

15. *Ibid.*

16. See McDougall, 61. Savage lived at 20 Highland Avenue from 1918 until just before her death.

17. Calvin, 20.

18. See Calvin, Tape 2, Interview with Leah Sherman, 2.

19. Calvin, Interview with Pinsky, 1.

20. Savage to Jackson, 5 October 1948.

21. Lemerise and Sherman, 186. See also Francine Couture et al., *L'enseignement des arts au Québec* (Montreal: UQAM, 1980).

22. See AAM Annual Report, 1940. The AAM received a $10,000 grant from the Carnegie Corporation in New York, which enabled them to hire Lismer.

23. See Seath to H.O. McCurry, 16 September [1935], Miscellaneous Correspondence, 7.1-S, NGC; Savage to H.O. McCurry, 6 April 1946, Loans, Ontario, 5.13, NGC; and Calvin, Interview with Sherman, 4.

24. Head Mistress' Report, 1933-34, The Study Archives. The Study sent work to an international conference on education in South Africa, July 1934.

25. See "Art from The Study," *The Study Chronicle* (1956), 47.

26. See Calvin, 37-8.

27. See Calvin, Interview with Pinsky, 13.

28. Autobiographical Notes, File 1, Item 1.2, Savage Archives, Concordia

University.

29. Brymner's letter and the enclosed reference (dated Siena, Italy, 20 June 1922) are in a private collection.

30. See Minute Book of Trafalgar School. Collyer's salary rose annually, reaching $1,100 in 1930.

31. *Trafalgar Echoes* (1931), 76.

32. See NGC information form, 4 February 1952, artists's file, NGC.

33. Interview with Susan Kilburn, 27 October 1992.

34. *Samara* (1937), 39; *Samara* (1940), 20. Joy Grainger kindly sent me photocopies of the Art Notes from *Samara*.

35. *Ottawa Citizen* 23 November 1942.

36. My aunt, Jean Pierce, wife of diplomat Sydney Pierce, was a student in May's "Happy Art Class."

37. See May to McCurry, 6 October 1948, Children's Art Education, 7.4C, File 2, NGC. The Saturday class continued with a new team of instructors.

38. See Hill, Interview with Newton; and Farr, 15.

39. Conversation with Jeanne Rhéaume at Walter Klinkhoff Gallery, 1 June 1993.

40. Copies of these talks are in the Savage papers, MG30 D374, Vol. 2, NAC.

41. Savage to Jackson, 14 February 1943. Porteous attended the AAM school with the Beaver Hall women; Beattie, an amateur painter, was Robertson's cousin.

42. "Distaff Side Active in Art," *Montreal Star* 17 March 1952; and "Women Painters of Canada," Savage papers, NAC.

43. *Pictures by Children*, with a foreword by Arthur Lismer, was shown in seven Canadian cities, including Montreal.

44. See Lemerise and Sherman, 189-91. In the 1960s, Sherman and Pinsky helped design and implement the art education programme at Sir George Williams University to provide teacher training in the fine arts.

CHAPTER NINE

1. See C.P. Stacey, "World War II," *Canadian Encyclopedia*, 2nd ed. (1988). Conscription for overseas service was introduced following the plebiscite of April 1942.

2. Savage to Jackson, 21 May 1942.

3. Savage to Jackson, n.d. Internal evidence suggests June 1942.

4. See Heward to Jackson, 27 June [1946], private collection; and McDougall, 170-71.

5. Heward to McLaughlin, 4 July [1942]; and Heward to McLaughlin, 9 November [1942].

6. See "59 Paintings Auctioned for Refugees' Benefit Bring Total of $2,459," undated clipping from the *Ottawa Citizen*, Canadian National Committee on Refugees Exhibition and Auction of Paintings, NGC.

7. See Smith, *André Biéler*, 89-97; and *The Kingston Conference Proceedings* (1941; Kingston: Agnes Etherington Art Centre, 1991).

8. See *Kingston Conference*, 22-33. See also Hélène Sicotte, "Walter Abell au Canada, 1928-1944: contribution d'un critique d'art américain au discours canadien en faveur de l'intégration sociale de l'art," *JCAH* XI/1 (1988): 88-106.

9. *Kingston Conference*, 35.

10. See Michael Bell, introduction, *Kingston Conference*, x-xi.

11. See Brian Foss, "Molly Lamb Bobak: Art and War," *Molly Lamb Bobak: A Retrospective*, Cindy Richmond (Regina, Sask.: MacKenzie Art Gallery, 1993), 93-116.

12. Vincent Massey to H.O. McCurry, 6 October 1943, transcript, Lilias T. Newton file, Robert McLaughlin Gallery, Oshawa, Ontario.

13. Pegi Nicol MacLeod, "Recording the Women's Services," *Canadian Art* II/2 (1944): 49.

14. Hill, Interview with Newton.

15. Newton to McCurry, 15 October 1942, Canadian War Artists, File 5.42-N, NGC.

16. Interview with Marian Dale Scott, 19 October 1989.

17. Walter Abell, "War Records for the Canadian Army," *Canadian Art* I/2 (1943-44): 43.

18. Savage to Jackson, 29 November 1942.

19. Heward to McLaughlin, 17 January 1940.

20. Interview with John Heward, 31 October 1991.

21. See Luckyj, *Prudence Heward*, 71.

22. Robert Ayre, "Toronto Honors Memory of Artist: Exhibition of Thomson Paintings," *Montreal Standard* 1 February 1941.

23. Valerie Conde, "New Art Exhibition," *Windsor Daily Star* 3 February 1945.

24. Calvin, Tape 2, 2; and Calvin, Tape 2, 1.

25. Heward to McLaughlin, 8 May [1945], the day the war in Europe officially ended.

26. Editorial, Toronto *Daily Star* 13 July 1944; see also Bell, xv-xx. A revised form of this brief was later presented to the Massey Commission, leading in 1957 to the establishment of the Canada Council.

27. The Lorne Building, which became the NGC after the war, was a converted office building.

CHAPTER TEN

1. See Dave McIntosh, "War Veterans," *Canadian Encyclopedia*, 2nd ed. (1988); and Linteau, 491-94.

2. See Hill, Interview with Newton.

3. Jackson to Prudence Heward, 30 January [1944], Jackson/Heward correspondence, NGC. All Jackson's letters to Heward quoted here are in this location.

4. See Julian Armstrong, "Former Billiard Room Now a Home," Montreal *Gazette* 25 February 1960.

5. Julian Armstrong, "Montreal Artist Ready to Paint Queen," Montreal *Gazette* 16 February 1957.

6. Newton papers, NGC.

7. Interview with Ann Grafftey Johansson, 29 January 1992.

8. Jackson to Naomi Jackson Groves, 29 March [1946], MG30 D351, NAC. All Jackson's letters to Groves quoted in this text are in this location.

9. Jackson to Anne Savage, 23 September 1939.

10. Heward to McLaughlin, 29 December [1943].

11. Robertson to Jackson, 3 April 1947.

12. Robertson to Jackson, 10 September 1947.

13. Edwin Holgate, "Prudence Heward," *Canadian Art* IV/4 (Summer 1947): 160-61.

14. H.O. McCurry to Isabel McLaughlin, 8 September 1948, Heward Memorial Exhibition, 5.5-H, NGC.

15. Robertson to Jackson, 10 February 1948.

16. Savage to Jackson, 5 October 1948.

17. See proposed schedule, Robertson Memorial Exhibition, 5.5-R, NGC; and Marion Robertson to Dr. [Robert] Hubbard, 11 March 1952, 5.5-R, NGC.

18. Jackson to Naomi Jackson Groves, 4 April 1947.

19. McDougall, 184; and Interview with Marian Dale Scott, 19 October 1989.

20. Calvin, 41.

21. See Braide, *Anne Savage*, 55-56.

22. Interview with Tobie Steinhouse, 13 May 1992; and Savage to Evan Turner, 7 April 1961, curatorial files, MMFA.

23. See François-Marc Gagnon, *Paul-Émile Borduas* (Montreal: MMFA, 1988) and Patricia Smart *Les Femmes du Refus Global* (Montreal: Boréal, 1998).

24. Savage to Jackson, 21 April 1961.

25. Savage to Jackson, 26 May 1956.

26. Morris to Michael Dunn, 1 March 1975, transcript, Frances K. Smith papers, 3726.1, Queen's University Archives.

27. Wini Rider, "Portrait of the Artist as an Expression of Joy," Montreal *Gazette* 16 June 1976.

28. See McDougall, 209.

29. Robert Ayre, *Montreal Star* 20 October 1962. Ethel Seath exhibited with the Hamilton painter T.R. MacDonald.

30. Calvin, 39; *Ibid.*, 13. Savage's reference to six painting friends must be a temporary lapse, as elsewhere in the interview she names all of them except Coonan.

31. Anne McDougall, "Research Notes for Book on Anne Savage," which McDougall kindly lent to me.

32. *Ibid.*

33. "Address of Miss Anne Savage at Opening of [Prudence Heward] Memorial Exhibition," typescript, MMFA.

34. Interview with Ann Grafftey Johansson, 29 January 1992.

ABBREVIATIONS USED IN THE APPENDICES

AAM	Art Association of Montreal
AEAC	Agnes Etherington Art Centre
AGO	Art Gallery of Ontario
AGT	Art Gallery of Toronto
ARCA	Associate of the Royal Canadian Academy
MMFA	Montreal Museum of Fine Arts
NGC	National Gallery of Canada
RCA	Royal Canadian Academy
VAG	Vancouver Art Gallery

Appendix One

The chronologies include only solo exhibitions and group shows of six artists or less. See also Appendix Two: Exhibitions.

Nora Collyer (1898-1979)

1898	June 7	Nora Frances Elizabeth Collyer born in Montreal to Gertrude Ellen Palmer and Alfred Collyer.
1910	Oct	Enters Trafalgar School.
1911	May 7	Brother Ralph John Osborne born.
1913	May	AAM Scholarship in Junior Elementary Class.
1914	May	AAM Scholarship in Senior Elementary Class.
1917	June	Graduates from Trafalgar School.
1919		Exhibits at AAM Spring Ex. for first time.
1920	May	Wins Robert Reford Prize at AAM School.
1921	May	Leaves AAM school.
1921-24		Shares studio at 305 Beaver Hall Hill with Anne Savage.
1922		Exhibits at RCA Annual Ex. for first time.
1924		4th Hon. Mention in RCA poster competition.
1925	Sept	Art teacher at Trafalgar School.
1926	summer	Travels to England and France.
c. 1929		Sea voyage to Bermuda with Sarah Robertson.
1930	Sept 20	Mother dies.
		Retires from Trafalgar School.
1940		Teaches drawing with Sarah Robertson for children's Saturday morning art class at AAM.
1946	Jan 4	Father dies.
	March	Solo exhibition, Dominion Gallery, Montreal.
1947		Sells family home and moves to apartment at 3400 Ridgewood Ave, where she is joined by Margaret Reid.
1950	May	Six-woman show, with Beatrice Hampson, Mabel

	Lockerby, Kathleen Morris, Anne Savage, and Ethel Seath at MMFA, Print Room.
July	Buys property near Magog, Quebec, with Margaret Reid, and builds Strawberry Hill.
1964	Solo exhibition, Walter Klinkhoff Gallery, Montreal.
1967 Oct	Sells Strawberry Hill.
1971	Solo exhibition, Paul Kastel Gallery, Montreal.
1979 May 30	Margaret Reid dies.
June 11	Dies in Royal Victoria Hospital, Montreal.

Emily Coonan (1885-1971)

1885 May 30	Emily Geraldine Coonan born in Point St. Charles, Montreal, to Mary Ann Fullerton and William Coonan; second of five children.
c. 1890-99	Attends St. Ann's Academy for Girls.
c. 1898	Studies at the Conseil des Arts et Manufactures.
c. 1905	Enters AAM School.
1907	AAM Scholarship in Life Class.
1908	Exhibits at AAM Spring Ex. for first time.
1910	Exhibits at RCA Annual Ex. for first time.
1912-13	Travels to France with Mabel May. Visits Holland and Belgium with May and other artists.
1914	First recipient of NGC's Travelling Scholarship for young artists. Departure delayed by First World War.
1916	Wins Special Prize offered by the Women's Art Society for a work by a Canadian woman artist.
1919 March	Mother dies.
1920-21	Visits Europe on NGC Travelling Scholarship.
c. 1922-24	Rents studio at 305 Beaver Hall Hill.
1932 Sept	Father dies.
1933	Exhibiting career ends with last appearance at AAM Spring Ex.
c. 1966	Farm St. house sold.
Dec	Sister Eva dies.
c. 1968	Goes to live with niece Patricia Coonan.
1971 June 23	Dies in Montreal.

Prudence Heward (1896-1947)

1896	July 2	Efa Prudence Heward born in Montreal to Sarah Efa Jones and Arthur R.G. Heward; sixth of eight children.
1898	July 8	Sister Honor born.
1908		First drawing lessons. Poses for sister Dorothy and friends at AAM School.
1912	May	AAM Scholarship in Senior Elementary Class.
	May 16	Father dies.
	May 22	Sister Dorothy dies in childbirth.
	Oct 9	Sister Barbara dies.
1914		Exhibits at AAM Spring Ex. for first time.
1916		Goes to England with her mother and sisters Honor and Gladys (Rooney). Works for the Red Cross.
1918		Returns from England and re-enters AAM school.
1923		Wins Robert Reford Prize (shared with Sybil Robertson).
1924		Wins Robert Reford Prize and Women's Art Society Scholarship.
		Exhibits at RCA Annual Ex. for first time.
1925-26		Studies in Paris at Académie Colarossi and École des Beaux-Arts. Visits Italy.
1929		Wins Willingdon Prize for *Girl on a Hill*.
		Meets Isabel McLaughlin, and enrols with her in Scandinavian Academy, Paris.
		Tours Normandy with Isabel McLaughlin and Charles and Lucille Gagnon. Visits Italy.
1930		Moves with her mother to 3467 Peel St.
1932	April	Solo exhibition at W. Scott & Sons, Montreal.
1933		Founding member of Canadian Group of Painters.
1933-39		Vice-president of CGP.
1934	spring	Three-woman show with Sarah Robertson and Isabel McLaughlin at Hart House, Toronto, and at W. Scott & Sons, Montreal.
1936		Trip to Whitefish Falls, near Manitoulin Island, Ontario, with Isabel McLaughlin and others.
		Trip to Bermuda with Yvonne McKague to visit Isabel McLaughlin.

1939	Founding member of Contemporary Arts Society.
May	Involved in car accident; breaks her right arm and damages her nose.
1940 Feb	Four-woman show with Sarah Robertson, Anne Savage, and Ethel Seath at AGT, Print Room.
1941	Attends Kingston Conference, Queen's University.
1943 Nov 25	Sister Honor dies.
1944 Dec	Four-woman show with Lilias Torrance Newton, Anne Savage, and Ethel Seath at AAM, Print Room.
1945 Jan	Three-woman show with Anne Savage and Ethel Seath at Willistead Art Gallery, Windsor, Ontario.
1946	Asthma attacks worsen.
Dec	Travels with mother and sister Rooney to Los Angeles, California, for treatment.
1947 Mar 19	Dies in Hospital of the Good Samaritan, Los Angeles.

Mabel Lockerby (1882-1976)

1882 Mar 13	Mabel Irene Lockerby born in Montreal to Barbara Cox and Alexander Linton Lockerby; second of five children.
c. 1902	Begins studies at AAM.
1903	AAM Scholarship in Antique class (shared with Ruth Barr).
1914	Exhibits at AAM Spring Ex. for first time.
Sept	Cousin Ernest McNown enlists in Canadian army.
1915 Oct 7	Father dies.
	Exhibits at RCA Annual Ex. for first time.
1920	Founding Member of Beaver Hall Group.
1929 May	Hon. Mention in Willingdon Arts Competition for *Marie et Minou*.
1939 March	Mother dies.
	Elected member of Canadian Group of Painters.
c. 1940	Elected member of Contemporary Arts Society.
1941 Jan	Four-woman show with Kathleen Morris, Pegi Nicol MacLeod, and Marian Scott, at AGT, Print Room.
1946	Jury II prize for *Old Towers* at AAM Spring Ex.
1950	Six-woman show with Nora Collyer, Beatrice

		Hampson, Kathleen Morris, Anne Savage, and Ethel Seath, at MMFA, Gallery XII.
		Ernest McNown moves to Toronto.
1952		Three-woman show with Frances-Anne Johnston and Ethel Seath, at MMFA, Gallery XII.
1956		Exhibits for the last time at AAM Spring Ex.
		Sells 1444 Mackay St. and moves with her sisters to 2036 Vendôme Ave, Montreal.
1968		Sister Eva dies.
1976	Jan 23	Sister Hazel dies.
	May 1	Dies in Montreal.

Mabel May (1877-1971)

1877	Sept 11	Henrietta Mabel May born in Point St. Charles, Montreal, to Evelyn Henrietta Walker and Edward May; fifth of ten children.
1882	Sept 19	Sister Lillian Ruby born.
c. 1900		Moves with her family to 434 Elm Ave, Westmount.
c. 1902		Enters AAM School.
1910		Exhibits at AAM Spring Ex. for first time.
		AAM Scholarship in Life Class (shared with Adrien Hébert).
		Exhibits at RCA Annual Ex. for first time.
1911		AAM Scholarship in Life Class (shared with A.M. Pattison).
1912		Travels to France with Emily Coonan.
		Visits Holland and Belgium with Coonan and other artists. Visits family in England.
1913	May	Returns to Canada.
1914		Rents studio at 745 St. Catherine Street West.
		Jessie Dow Prize for watercolour at AAM Spring Ex.
1915		Women's Art Society Prize for Canadian Women Artists.
1915	Nov	Elected Associate of the RCA.
1916	Jan 5	Father dies.
1918		Jessie Dow Prize for oil painting at AAM Spring Ex.
1918-19		Paints *Women Making Shells* for Canadian War

	Memorials Fund.
1920	Founding member of the Beaver Hall Group.
1929 May	Hon. Mention in Willingdon Arts Competition for *Melting Snow*.
1930 Sept 7	Mother dies.
1933	Founding member of Canadian Group of Painters.
1936-47	Art teacher at Elmwood School, Ottawa.
1937-47	Supervises children's Saturday morning art class at NGC, Ottawa.
1939 Jan	Solo exhibition at James Wilson Art Galleries, Ottawa.
1944-46	Teaches "Happy Art Class" for adults, at NGC.
1947-49	Returns to Westmount. Teaches privately.
1950 Jan	Sells 434 Elm Ave.
Feb	Solo exhibition at Dominion Gallery, Montreal.
Apr	Moves to Vancouver, B.C., with sister Lillian.
1951 Apr	Solo exhibition at Roberts Gallery, Toronto.
1952 Feb	Solo exhibition at Vancouver Art Gallery.
1971 June	Solo show at Gallery of the Golden Key, Vancouver.
Oct 8	Dies in Vancouver.

Kathleen Morris (1893-1986)

1893 Dec 2	Kathleen Moir Morris born in Montreal, fourth and youngest child of Eliza Howard Bell and Montague John Morris.
c. 1899	Attends Misses Gardiner's private school.
1901 Feb-May	Stays with family of painter Robert Harris.
c. 1906	Begins studies at AAM.
1912	Hon. mention in Senior Elementary Class.
1914	Exhibits at AAM Spring Ex. for first time.
Feb 23	Father dies.
1916	Exhibits at RCA Annual Ex. for first time.
1917	Leaves AAM School.
1923	Moves to Ottawa with her mother.
c. 1920-27	Winter sketching trips to Berthierville.
1929	Elected Associate of the RCA.
May	Returns to Montreal with her mother.

1930		Hon. Mention in 2nd Willingdon Arts Competition, for *Nuns, Quebec*.
1939	Oct	Solo exhibition at AAM, Print Room.
1940		Elected member of Canadian Group of Painters.
1941	Jan	Four-woman show with Mabel Lockerby, Pegi Nicol MacLeod, and Marian Scott, at AGT, Print Room.
1945	Nov	Solo exhibition, Harris Memorial Gallery, Charlottetown, P.E.I.
1947	July	Breaks her right arm.
1949	March	Mother dies. Lives with her brother Harold at 3745 de l'Oratoire.
1950		Six-woman show with Nora Collyer, Beatrice Hampson, Mabel Lockerby, Anne Savage, and Ethel Seath, at MMFA, Gallery XII.
1956	Nov	Solo exhibition, Arts Club, Montreal.
1961	Aug	Brother Harold dies.
1962		Two-artist show with Lincoln G. Morris, Arts Club, Montreal.
1976	June	Solo exhibition, Walter Klinkhoff Gallery, Montreal.
1977		Injures herself in a bad fall.
1983	Sept-Oct	Solo exhibition, AEAC, Kingston, Ontario.
1986	Dec 20	Dies in nursing home at Rawdon, Quebec.

Lilias Torrance Newton (1896-1980)

1896	Nov 3	Lilias Torrance born after the death of her father, in Lachine, Quebec, fourth child of Alice Mary Stewart and Forbes Torrance.
1906-08		Attends Public School in Kingston, Ontario.
1908-10		Attends Mr. Hewton's School in Lachine, Quebec.
1908-10		Enters Junior Elementary Class at AAM School.
1910		AAM Scholarship in Junior Elementary Class.
1910-13		Attends Miss Edgar's and Miss Cramp's School in Montreal, as a boarder.
1914		AAM Scholarship in Life Class (shared with Annie Ewan).
1916		Exhibits at RCA Annual Ex. for first time. Brother killed in action in France.

1916-18		Goes to England with her mother; works with the Canadian Red Cross.
		Meets Captain Frederick G. Newton.
		Studies painting with Alfred Wolmark.
1920		Exhibits at AAM Spring Ex. for first time.
		Founding member of Beaver Hall Group.
1921	June 1	Marries Frederick G. Newton at Lachine, Quebec.
1923		Studies in Paris with Alexandre Jacovleff.
		Première Mention d'Honneur for portrait of Denise Lamontagne at annual Paris Salon.
		Elected Associate of the RCA.
1925	June 5	Mother dies.
1926	Apr 16	Son Francis Forbes born.
1929	summer	Travels to France with Forbes and his nanny.
1930		Solo exhibition, Hart House, Toronto.
1931	May	Husband abandons her.
	Nov	Three-artist show with Albert Robinson and sculptor Florence Wyle, Watson Art Galleries, Montreal.
1932	Oct	Exhibits drawings at Arts Club, Montreal.
1933	Apr 28	Divorced.
		Founding member of Canadian Group of Painters.
1934-36		Teaches with Edwin Holgate at AAM.
1937		Elected member of the RCA.
1938-40		Teaches with Edwin Holgate and Will Ogilvie at AAM.
1938-43		Rents cottage at St. Adolphe de Howard in summers.
1939	Oct-Nov	Solo exhibition at AAM, Print Room.
1940	April	Four-artist show with Edwin Holgate, A.Y. Jackson, and Arthur Lismer, at AGT, Print Room.
1942		Paints portraits of Canadian soldiers for National Department of Defence.
	Nov 2	Brother Stewart dies.
1944	Dec	Four-woman show with Prudence Heward, Anne Savage, Ethel Seath at AAM, Print Room.
1945	Feb	Solo exhibition at Photographic Stores, Ottawa.
1946		Visits Banff School of Fine Arts, and paints portraits in Banff, Calgary, and Edmonton.
1953		Travels to Florence, Rome, and Paris.
1956		Moves to studio apartment at The Linton, Sherbrooke Street, Montreal. Breaks her right arm.

1957	March	Visits Madrid and London. Paints portraits of Queen Elizabeth and Prince Philip.
1958		Solo exhibition at Victoria College, Toronto.
1960		Visits England.
1972	May 31	LL.D. University of Toronto.
1975		Last professional work. Breaks her collar bone.
1980	Jan 10	Dies in nursing home, Cowansville, Quebec.

Sarah Robertson (1891-1948)

1891	June 16	Sarah Margaret Armour Robertson born in Montreal to Jessie Ann Christie and John Armour Robertson; eldest of four children.
1910	May	AAM Scholarship in Senior Elementary Class.
1912		Exhibits at AAM Spring Ex. for first time.
1916	July	Brother Louis killed in action, aged 24.
1919		Wins Women's Art Society Scholarship.
1920		Wins Kenneth R. Macpherson Prize (shared with Donald Hill).
		Exhibits at RCA Annual Ex. for first time.
1922		Country house at Chambly sold.
		Wins Kenneth R. Macpherson Prize (shared with Donald Hill).
1923		Wins Women's Art Society Scholarship.
1926	June 26	Father dies.
1927		Moves with her family to 1470 Fort Street.
c. 1929		Sea voyage to Bermuda with Nora Collyer.
1933		Founding member of Canadian Group of Painters.
1934	spring	Three-woman show with Prudence Heward and Isabel McLaughlin at Hart House, Toronto, and at W. Scott & Sons, Montreal.
1936	Nov	Visits Toronto to see the Van Gogh exhibition.
1940	Feb	Four-woman show with Prudence Heward, Anne Savage, and Ethel Seath, at AGT, Print Room.
		Teaches drawing with Nora Collyer for children's Saturday morning art class at AAM.
1947		Works on Prudence Heward Memorial Exhibition.
1948	Oct 7	Mother dies.
	Dec 6	Dies in Montreal.

Anne Savage (1896-1971)

1896	July 27	Annie Douglas Savage (and twin Donaldson Lizars) born in Montreal; second daughter of Helen Lizars Galt and John George Savage.
1904-14		Attends the High School for Girls in Montreal.
1911		Father buys Lake Wonish, Quebec.
1914-19		Attends classes at AAM.
1915		AAM scholarship in Antique Class.
1916	Nov 15	Brother Donaldson killed in action.
1917		Exhibits at AAM Spring Ex. for first time.
1918		Exhibits at RCA Annual Ex. for first time.
		Moves with her family to 20 Highland Ave, Montreal.
1919		Wins Kenneth R. Macpherson Prize.
		Medical artist in military hospitals in Montreal and Toronto.
1919-20		Medical artist in Minneapolis and student at the Minneapolis School of Design.
1920		Works for Ronald's Press, Montreal.
		Founding member of the Beaver Hall Group.
1921		Art teacher at Commercial and Technical High School.
1922	June 24	Father dies.
	Sept	Begins teaching at Baron Byng High School.
		Finalist in mural decoration competition, NGC.
1924		Travels in France and England.
1927		Travels with Marius Barbeau, Florence Wyle, and Pegi Nicol MacLeod to the Skena River, B.C.
1933		Founding member of Canadian Group of Painters.
	July	Visits Georgian Bay with A.Y. Jackson and others.
	Sept	Turns down A.Y. Jackson's proposal of marriage.
1937-41		Directs children's Saturday morning art class at AAM.
1939	Jan-Feb	Gives radio talks on "The Development of Canadian Art."
	June	Elected to executive of CGP.
1940	Feb	Four-woman show with Prudence Heward, Sarah Robertson, and Ethel Seath, at AGT, Print Room.
1942	Sept 5	Mother dies.
1943		Receives Order of Scholastic Merit for Art Teaching from Montreal Protestant School Board.

1944 Dec	Four-woman show with Prudence Heward, Lilias Torrance Newton, and Ethel Seath at AAM, Print Room.
1945 Jan	Three-woman show with Prudence Heward and Ethel Seath at Willistead Art Gallery, Windsor, Ontario.
1948-50	Appointed Art Supervisor for Montreal Protestant School Board, part time.
1949	Elected president of CGP, Montreal branch. Teaches at Banff Summer School.
1950	Appointed Art Supervisor, full time. Six-woman show with Nora Collyer, Beatrice Hampson, Mabel Lockerby, Kathleen Morris, and Ethel Seath, at MMFA, Gallery XII.
1953 June	Retires as Art Supervisor.
1954-59	Teaches a course in Art Education at McGill.
1956 May	Solo exhibition at YWCA.
1963	Two-artist exhibition with André Biéler at Artlenders Gallery, Montreal.
1965 March	Operation for breast cancer.
1969 April	Retrospective exhibition at Sir George Williams University, Montreal.
1971 Mar 25	Dies in nursing home, Pierrefonds, Quebec.

Ethel Seath (1879-1963)

1879 Feb 5	Ethel Seath born in Montreal to Lizetta Annie Foulds and Alexander Stuart Seath; second of five children.
c. 1893	Studies drawing with Miss Stone.
c. 1895	Joins the art staff of the Montreal *Witness*.
c. 1898	Studies at the Conseil des Arts et Manufactures.
1901 Oct	Joins the art staff of the *Montreal Star*.
1905	Exhibits at AAM Spring Ex. for first time.
1906	Exhibits at RCA Annual Ex. for first time.
1910 June	Attends Brymner's sketching class at Phillipsburg.
1917 Sept	Appointed art teacher at The Study school.
1924 Dec 29	Father dies.
1934 Nov 16	Margaret Gascoigne dies.

1935	summer	Visits England; meets art educator Marion Richardson.
1937-41		Teaches modelling for children's Saturday morning art class at AAM.
1939		Elected member of Canadian Group of Painters.
c. 1940		Elected member of Contemporary Arts Society.
1940	Feb	Four-woman show with Prudence Heward, Sarah Robertson, and Anne Savage, at AGT, Print Room.
1944	Dec	Four-woman show with Prudence Heward, Lilias Torrance Newton, and Anne Savage, at AAM, Print Room.
1945	Jan	Three-woman show with Prudence Heward and Anne Savage, at Willistead Art Gallery, Windsor, Ontario.
1950		Six-woman show with Nora Collyer, Beatrice Hampson, Mabel Lockerby, Kathleen Morris, and Anne Savage, at MMFA, Gallery XII.
1951	Dec 5	Mother dies.
1952		Three-woman show with Frances-Anne Johnston and Mabel Lockerby.
1955	Nov 22	*Art from The Study*, sale of work by Ethel Seath and her students, in aid of The Study's Retirement Fund.
1957	Dec	Solo exhibition at YWCA.
1962	June	Retires from The Study. Moves in with widowed sister, Gladys Baker.
	Oct	Two-artist exhibition with T.R. MacDonald, at MMFA, Gallery XII.
1963	Apr 10	Dies in Montreal.

Appendix Two

EXHIBITIONS

This list does not include the Annual Spring Exhibitions of the Art Association of Montreal (after 1948, Montreal Museum of Fine Arts), or the Annual Exhibitions of the Royal Canadian Academy of Arts, the Ontario Society of Artists, and the Canadian National Exhibition.

1914-15	Public Library, Toronto, and circulating, organized by RCA, *Canadian Artists' Patriotic Fund Exhibition*: Emily Coonan, Mabel May.
1919	AGT, Toronto, *Canadian War Memorials Exhibition* (the Home Front): Mabel May.
1921	305 Beaver Hall Hill, Montreal, First annual exhibition of the Beaver Hall Group: Mabel Lockerby, Mabel May, Lilias Torrance Newton, Anne Savage.
1922	305 Beaver Hall Hill, Montreal, Exhibition of the Beaver Hall Group: Mabel Lockerby, Mabel May, Lilias Torrance Newton, Sarah Robertson, Anne Savage.
1923	NGC, Ottawa, *Exhibition of Canadian War Memorials*: Mabel May.
1923-24	Group of Seven, U.S. Tour, *An Exhibition of Modern Canadian Paintings*: Emily Coonan, Lilias Torrance Newton.
1924	Wembley, England, *British Empire Exhibition, Canadian Section of Fine Arts*: Emily Coonan, Mabel Lockerby, Mabel May, Kathleen Morris, Lilias Torrance Newton, Sarah Robertson, Anne Savage.

Hart House, Toronto, *Pictures Exhibited by the Montreal Group of Artists*: Emily Coonan, Mabel May, Lilias Torrance Newton, Sarah Robertson, Anne Savage.

1925 Wembley, England, *British Empire Exhibition, Canadian Section of Fine Arts*: Prudence Heward, Mabel Lockerby, Mabel May, Kathleen Morris, Lilias Torrance Newton, Sarah Robertson, Anne Savage, Ethel Seath.
Chowne Art Dealer, Montreal, *Contemporary Canadian Artists*: Mabel Lockerby, Mabel May, Kathleen Morris, Lilias Torrance Newton, Sarah Robertson.

1926 NGC, Ottawa, *Special Exhibition of Canadian Art* (first annual): Mabel Lockerby, Mabel May, Kathleen Morris, Lilias Torrance Newton, Sarah Robertson, Anne Savage.
AGT, Toronto, *Exhibition of the Group of Seven*: Anne Savage.

1927 NGC, Ottawa, *Annual Exhibition of Canadian Art*: Prudence Heward, Mabel May, Kathleen Morris, Lilias Torrance Newton, Sarah Robertson, Anne Savage, Ethel Seath.
Musée du Jeu de Paume, Paris, *Exposition d'art canadien*: Prudence Heward, Mabel Lockerby, Mabel May, Kathleen Morris, Lilias Torrance Newton, Sarah Robertson, Anne Savage, Ethel Seath.

1928 NGC, Ottawa, *Annual Exhibition of Canadian Art*: Prudence Heward, Mabel Lockerby, Mabel May, Kathleen Morris, Lilias Torrance Newton, Sarah Robertson, Anne Savage, Ethel Seath.
AGT, Toronto, *Exhibition of Paintings by the Group of Seven*: Prudence Heward, Mabel Lockerby, Mabel May, Sarah Robertson.

1929 NGC, Ottawa, *Annual Exhibition of Canadian Art*: Prudence Heward, Mabel Lockerby, Mabel May, Kathleen Morris, Lilias Torrance Newton, Sarah Robertson, Anne Savage.

1930 NGC, Ottawa, *Annual Exhibition of Canadian Art*: Prudence
Heward, Mabel May, Kathleen Morris, Lilias Torrance
Newton, Sarah Robertson, Anne Savage.
Corcoran Gallery of Art, Washington, D.C., and circu-
lating, *An Exhibition of Paintings by Contemporary
Canadian Artists*: Prudence Heward, Mabel Lockerby,
Mabel May, Kathleen Morris, Lilias Torrance Newton,
Sarah Robertson, Anne Savage.
AGT, Toronto, *Exhibition of the Group of Seven*: Prudence,
Heward, Mabel May, Lilias Torrance Newton, Sarah
Robertson.
Hart House, Toronto, Lilias Torrance Newton, Solo
Exhibition.
AAM, Print Room, *Paintings by a Group of Contemporary
Montreal Artists*: Nora Collyer, Prudence Heward, Mabel
Lockerby, Mabel May, Kathleen Morris, Lilias Torrance
Newton, Sarah Robertson, Anne Savage, Ethel Seath.

1931 NGC, Ottawa, *Annual Exhibition of Canadian Art*: Emily
Coonan, Prudence Heward, Mabel May, Kathleen
Morris, Lilias Torrance Newton, Anne Savage, Ethel Seath.
Baltimore Museum of Art, *First Baltimore Pan American
Exhibition of Contemporary Painting*: Prudence Heward,
Lilias Torrance Newton, Sarah Robertson, Anne Savage.
AGT, Toronto, *Exhibition of the Group of Seven*: Prudence
Heward, Mabel May, Lilias Torrance Newton, Sarah
Robertson, Anne Savage.

1932 NGC, Ottawa, *Annual Exhibition of Canadian Art*: Nora
Collyer, Prudence Heward, Mabel Lockerby, Mabel
May, Kathleen Morris, Lilias Torrance Newton, Sarah
Robertson, Anne Savage, Ethel Seath.
Roerich Museum, International Art Centre, New York
City, *Exhibition of Paintings by Contemporary Canadian
Artists*: Prudence Heward, Sarah Robertson.
W. Scott & Sons, Montreal, Prudence Heward, Solo
Exhibition.

1933 NGC, Ottawa, *Annual Exhibition of Canadian Art*: Prudence

Heward, Mabel May, Kathleen Morris, Lilias Torrance
Newton, Sarah Robertson, Anne Savage, Ethel Seath.
Eaton's Fine Art Gallery, Montreal, *Exhibition of
Paintings by Canadian Women Artists*: Mabel May, Kathleen
Morris, Sarah Robertson.
Heinz Art Salon, Atlantic City, New Jersey, *Paintings by
the Canadian Group of Painters*: Prudence Heward, Mabel
May, Lilias Torrance Newton, Sarah Robertson, Anne
Savage.
AGT, Toronto, *Exhibition of Paintings by Canadian Group of
Painters*: Nora Collyer, Prudence Heward, Mabel
Lockerby, Mabel May, Kathleen Morris, Lilias Torrance
Newton, Sarah Robertson, Anne Savage, Ethel Seath.
Also shown at the AAM, Montreal, January 1934.

1934 Hart House, Toronto, Three-Woman Exhibition by
Prudence Heward, Isabel McLaughlin, Sarah Robertson.
Also shown at W. Scott & Sons, Montreal.
AGT, Toronto, *Canadian Paintings, The Collection of the
Hon. Vincent and Mrs. Massey*: Mabel Lockerby, Mabel May,
Kathleen Morris, Lilias Torrance Newton, Sarah
Robertson, Anne Savage, Ethel Seath.

1936 NGC, Ottawa, *Exhibition of Contemporary Canadian
Paintings, Arranged on Behalf of the Carnegie Corporation of
New York for Circulation in the Southern Dominions of the
British Empire*: Prudence Heward, Mabel Lockerby,
Mabel May, Kathleen Morris, Lilias Torrance Newton,
Sarah Robertson, Anne Savage, Ethel Seath.
AGT, Toronto, and NGC, Ottawa, *Canadian Group of
Painters*: Nora Collyer, Prudence Heward, Mabel
Lockerby, Mabel May, Kathleen Morris, Sarah Robert-
son, Anne Savage, Ethel Seath.

1937 Arts Club, Montreal, group show of Modernists, organ-
ized by John Lyman: Prudence Heward, Mabel
Lockerby, Sarah Robertson.
Royal Institute Galleries, London, *Exhibition of
Paintings, Drawings and Sculpture by Artists of the British*

Empire Overseas (Coronation Exhibition): Nora Collyer, Prudence Heward, Mabel Lockerby, Mabel May, Kathleen Morris, Lilias Torrance Newton, Sarah Robertson, Anne Savage, Ethel Seath.

AGT, Toronto, *Canadian Group of Painters*: Nora Collyer, Prudence Heward, Mabel Lockerby, Mabel May, Kathleen Morris, Lilias Torrance Newton, Sarah Robertson, Anne Savage, Ethel Seath. Also shown at the AAM, Montreal, January 1938.

1938 Tate Gallery, London, *A Century of Canadian Art*: Prudence Heward, Mabel Lockerby, Mabel May, Kathleen Morris, Lilias Torrance Newton, Sarah Robertson, Anne Savage, Ethel Seath.

2037 Peel street, Montreal, *Sale Aid to Spanish Democracy*: Prudence Heward, Kathleen Morris, Lilias Torrance Newton, Anne Savage.

1939 James Wilson & Co., Ottawa, *Exhibition of Paintings by H. Mabel May, ARCA*.

Department of Fine Arts, San Francisco, *Golden Gate International Exposition of Contemporary Art*: Prudence Heward, Sarah Robertson, Anne Savage.

New York World's Fair, *Exhibition by the Royal Canadian Academy of Arts*: Mabel May, Kathleen Morris, Lilias Torrance Newton.

New York World's Fair, *Exhibition by the Canadian Group of Painters*: Nora Collyer, Prudence Heward, Mabel Lockerby, Mabel May, Lilias Torrance Newton, Sarah Robertson, Anne Savage, Ethel Seath.

AAM, Print Room, Kathleen Morris, Solo Exhibition.

AAM, Print Room, Lilias Torrance Newton, Solo Exhibition.

AGT, Toronto, *Canadian Group of Painters*: Nora Collyer, Prudence Heward, Mabel Lockerby, Kathleen Morris, Sarah Robertson, Anne Savage, Ethel Seath. Also shown at the AAM, Montreal, January 1940.

1940 AGT, Print Room, Four-Woman Exhibition: Prudence

Heward, Sarah Robertson, Anne Savage, Ethel Seath.
NGC, Ottawa, *Canadian National Committee on Refugees,
Exhibition and Auction of Paintings*: Nora Collyer, Prudence
Heward, Mabel Lockerby, Mabel May, Kathleen Morris,
Lilias Torrance Newton, Sarah Robertson, Anne Savage,
Ethel Seath.
AAM, Montreal, *Contemporary Arts Society*: Prudence
Heward, Mabel Lockerby, Kathleen Morris, Sarah
Robertson, Ethel Seath.

1941 AGT, Print Room, Four-Woman Exhibition: Mabel
Lockerby, Kathleen Morris, Marian Scott, Pegi Nicol
MacLeod.

1942 AGT, Toronto; AAM, Montreal; and NGC, Ottawa,
Canadian Group of Painters: Nora Collyer, Prudence
Heward, Mabel Lockerby, Mabel May, Kathleen Morris,
Lilias Torrance Newton, Sarah Robertson, Anne Savage,
Ethel Seath.
NGC, Ottawa, *Contemporary Arts Society*: Prudence
Heward.

1944 AGT, Toronto, and AAM, Montreal, *Canadian Group of
Painters*: Prudence Heward, Mabel Lockerby, Kathleen
Morris, Lilias Torrance Newton, Anne Savage, Ethel
Seath.
Yale University Art Gallery, New Haven, *Canadian Art
1760-1943*: Prudence Heward, Mabel Lockerby, Lilias
Torrance Newton, Sarah Robertson, Anne Savage, Ethel
Seath.
Museu Nacional de Belas Artes, Rio de Janeiro, *Pintura
Canadense Contemporanea*: Prudence Heward, Mabel
Lockerby, Mabel May, Kathleen Morris, Sarah Robert-
son, Ethel Seath.
AGT, Toronto, *Contemporary Arts Society*: Prudence
Heward.
AAM, Print Room, *Oil Paintings by Lilias Torrance Newton,
RCA, Prudence Heward, Anne Savage, and Ethel Seath*.

1945 Photographic Stores, Ottawa, Lilias Torrance Newton, Solo Exhibition.

Willistead Art Gallery, Windsor, Ontario, Three-Woman Exhibition: Prudence Heward, Anne Savage, Ethel Seath.

AAM, Montreal, and AGT, Toronto, *The Development of Painting in Canada 1665-1945*: Prudence Heward, Mabel May, Lilias Torrance Newton, Sarah Robertson, Anne Savage.

AGT, Toronto, *Canadian Group of Painters*: Prudence Heward, Kathleen Morris, Lilias Torrance Newton, Anne Savage, Ethel Seath. Also shown at the AAM, Montreal, 1946.

Harris Memorial Gallery, Charlottetown, P.E.I., Kathleen Morris, Solo Exhibition.

1946 AAM, Montreal, *Contemporary Arts Society*: Prudence Heward, Mabel Lockerby.

Dominion Gallery, Montreal, Nora Collyer, Solo Exhibition.

1947 Riverside Museum, New York; NGC, Ottawa, and circulating, *Canadian Women Artists*: Prudence Heward, Mabel Lockerby, Mabel May, Kathleen Morris, Lilias Torrance Newton, Sarah Robertson, Anne Savage, Ethel Seath.

AGT, Toronto, *Canadian Group of Painters*: Mabel May, Kathleen Morris, Lilias Torrance Newton, Sarah Robertson, Anne Savage, Ethel Seath. Also shown at the AAM, Montreal, 1948.

1948 NGC, Ottawa, and circulating, *Memorial Exhibition, Prudence Heward 1896-1947*.

1949 AGT, Toronto; MMFA, Montreal; and circulating, *Canadian Group of Painters*: Mabel Lockerby, Mabel May, Kathleen Morris, Lilias Torrance Newton, Anne Savage, Ethel Seath.

West End Gallery, Montreal, *Canadian Women Painters*: Prudence Heward, Mabel Lockerby, Lilias Torrance

Newton, Sarah Robertson, Anne Savage, Ethel Seath.
AGT, Toronto, *Fifty Years of Painting in Canada*: Prudence
Heward, Mabel May.

1950 Dominion Gallery, Montreal, *Special Sale of Paintings by
H. Mabel May, ARCA*.
MMFA, Gallery XII, *Six Montreal Women Painters*: Nora
Collyer, Beatrice Hampson, Mabel Lockerby, Kathleen
Morris, Anne Savage, Ethel Seath.
AGO, Toronto, *Canadian Group of Painters*: Mabel
Lockerby, Kathleen Morris, Lilias Torrance Newton,
Anne Savage, Ethel Seath. Also shown at the MMFA,
Montreal, 1951.

1951 Roberts Gallery, Toronto, Mabel May, Solo Exhibition.
NGC, Ottawa, and circulating, *Memorial Exhibition, Sarah
Robertson 1891-1948*.

1952 VAG, Vancouver, Mabel May, Solo Exhibition.
MMFA, Gallery XII, Three-Woman Exhibition: Frances-
Anne Johnston, Mabel Lockerby, Ethel Seath.

1954 AGO, Toronto, *Canadian Group of Painters*: Anne Savage,
Ethel Seath. Also shown at NGC, Ottawa, and circulat-
ing, 1955.

1955 AGO, Toronto, and MMFA, Montreal, *Canadian Group of
Painters*: Mabel Lockerby, Ethel Seath.

1956 YWCA, Montreal, Anne Savage, Solo Exhibition.
Cownsville Art Centre, Quebec, *Inaugural Exhibition
of Paintings*: Nora Collyer, Kathleen Morris, Anne
Savage, Ethel Seath.
Arts Club, Montreal, Kathleen Morris, Solo Exhibition.
AGO, Toronto, *Canadian Group of Painters*: Anne Savage,
Ethel Seath. Also shown at VAG, Vancouver, 1957.

1957 MMFA, Montreal, *Canadian Group of Painters*: Anne
Savage, Ethel Seath.
YWCA, Montreal, Ethel Seath, Solo Exhibition.

1958 AGO, Toronto, and VAG, Vancouver, *Canadian Group of Painters*: Mabel Lockerby, Kathleen Morris, Anne Savage, Ethel Seath.
Victoria College, Toronto, Lilias Torrance Newton, Solo Exhibition.

1959 AGO, Toronto, *Canadian Group of Painters*: Anne Savage.

1960 MMFA, Montreal, *Canadian Group of Painters*: Mabel Lockerby, Anne Savage, Ethel Seath.

1962 Arts Club, Montreal, Two-Artist Exhibition: Kathleen Morris and Lincoln G. Morris.
MMFA, Gallery XII, Two-Artist Exhibition: Ethel Seath and T.R. MacDonald.
AGO, Toronto, *Canadian Group of Painters*: Mabel Lockerby, Kathleen Morris. Also shown at NGC, Ottawa, 1963.

1963 MMFA, Montreal, *Canadian Group of Painters*: Kathleen Morris, Anne Savage. Also shown in Calgary, 1964.
Artlenders Gallery, Montreal, Two-Artist Exhibition: Anne Savage and André Biéler.

1964 Walter Klinkhoff Gallery, Montreal, Nora Collyer, Solo Exhibition.
Continental Galleries, Montreal, Prudence Heward, Solo Exhibition.

1965 Art Gallery of Greater Victoria, and AEAC, Kingston, *Canadian Group of Painters*: Mabel Lockerby, Mabel May, Kathleen Morris, Anne Savage.

1966 NGC, Ottawa, and circulating, *The Beaver Hall Hill Group*: Nora Collyer, Emily Coonan, Prudence Heward, Mabel Lockerby, Mabel May, Kathleen Morris, Lilias Torrance Newton, Sarah Robertson, Anne Savage, Ethel Seath.

1967 MMFA, Montreal, *Canadian Group of Painters*: Anne Savage.

1969	Sir George Williams University, Montreal, *Anne Savage: A Retrospective*.

1971 Gallery of the Golden Gate, Vancouver, *Mabel May, ARCA*.
Kastel Gallery, Montreal, *Paintings by Nora F. Collyer*.

1974 Sir George Williams Art Galleries, Montreal, and circulating, *Annie D. Savage: Drawings and Watercolours*.

1975 NGC, Ottawa, *Canadian Painting in the Thirties*: Prudence Heward, Lilias Torrance Newton, Sarah Robertson, Anne Savage.
AEAC, Kingston, *From Women's Eyes: Women Painters in Canada*: Prudence Heward, Mabel May, Kathleen Morris, Lilias Torrance Newton, Sarah Robertson.

1976 Walter Klinkhoff Gallery, Montreal, *Kathleen Morris, ARCA*.

1979 AGW, Windsor, *Prudence Heward and Friends*: Prudence Heward, Kathleen Morris, Sarah Robertson.
MMFA, Montreal, and circulating, *Anne Savage: Her Expression of Beauty*.

1980 Walter Klinkhoff Gallery, Montreal, *Prudence Heward Retrospective Exhibition*.

1981 AEAC, Kingston, *Lilias Torrance Newton, 1896-1980*.

1982 Sir George Williams Art Galleries, Montreal, *Women Painters of the Beaver Hall Group*: Nora Collyer, Emily Coonan, Prudence Heward, Mabel Lockerby, Mabel May, Kathleen Morris, Lilias Torrance Newton, Sarah Robertson, Anne Savage, Ethel Seath.

1983 London Regional Art Gallery, London, *Visions and Victories: 10 Canadian Women Artists*: Prudence Heward, Lilias Torrance Newton, Sarah Robertson.
AEAC, Kingston, *Kathleen Moir Morris*.

1986 AEAC, Kingston, and circulating, *Expressions of Will: The Art of Prudence Heward*.

1987 Walter Klinkhoff Gallery, Montreal, *Ethel Seath Retrospective Exhibition*.
Concordia Art Gallery, Montreal, *Emily Coonan (1885-1971)*.

1989 Walter Klinkhoff Gallery, Montreal, *Mabel Lockerby Retrospective Exhibition*.

1991 Walter Klinkhoff Gallery, Montreal, *Sarah Robertson Retrospective Exhibition*.

Kaspar Gallery, Toronto, *Beaver Hall Hill Group*: Nora Collyer, Emily Coonan, Prudence Heward, Mabel Lockerby, Mabel May, Kathleen Morris, Lilias Torrance Newton, Sarah Robertson, Anne Savage.

1992 Walter Klinkhoff Gallery, Montreal, *Anne Savage Retrospective Exhibition*.

1995 Walter Klinkhoff Gallery, Montreal, *Lilias Torrance Newton Retrospective Exhibition*.

1997 MMFA, Montreal, *Montreal Women Painters on the Threshold of Modernity*: Emily Coonan, Prudence Heward, Mabel Lockerby, Mabel May, Kathleen Morris, Lilias Torrance Newton, Sarah Robertson, Anne Savage, Ethel Seath.

Selected Bibliography

ARCHIVAL MATERIAL

Art Association of Montreal Annual Reports, 1881-1943. Montreal Museum of Fine Arts.
Art Association of Montreal Scrapbooks. Montreal Museum of Fine Arts.
Artists' Files. Art Gallery of Ontario.
———. Montreal Museum of Fine Arts.
———. National Gallery of Canada.
Canadian War Records. 5.42 M. National Gallery of Canada.
Jackson, A.Y. and Sarah Robertson. Correspondence. National Gallery of Canada.
Newton, Lilias Torrance. Newton Papers. National Gallery of Canada.
Phillips, Mary. "The Story of the Montreal Women's Art Society." Typescript of lecture, 2 January 1917. McCord Museum, McGill University, Montreal.
Savage, Anne. Anne Savage Fonds. Concordia University Archives, Montreal.
———. Savage papers. MG 30, D374. 2 vols. National Archives of Canada.
Smith, Frances K. Frances K. Smith papers. Collection 3726.1. Queen's University Archives, Kingston, Ont.
Transcripts of the Royal Canadian Academy. MG28 I 126. Vol. 17. National Archives of Canada.

BOOKS AND ARTICLES

Antaki, Karen. "H. Mabel May (1877-1971): The Montreal Years, 1909-1938." Unpub. M.A. thesis, Concordia University, 1992.
———, and Sandra Paikowsky. *Emily Coonan (1885-1971)*. Exhibition catalogue. Montreal: Concordia Art Gallery, 1987.
Armstrong, Julian. "Former Billiard Room Now a Home." Montreal *Gazette* 25 February 1960.
———. "Montreal Artist Ready to Paint Queen." Montreal *Gazette* 16 February 1957.
"Au fil de L'heure: Le Groupe Beaver Hall." *La Presse* 20 January 1921.

Avon, Susan. "The Beaver Hall Group and Its Place in the Montreal Art Milieu and the Nationalist Network." Unpub. M.A. thesis, Concordia University, 1994.

Ayre, Robert. "Gentlmen, the Ladies!" *Montreal Star* 25 April 1964.

——. "Lilias Torrance Newton, Painter of the Queen." *The Montrealer* February 1957.

——. "Renewal and Discovery—The Art of Anne Savage." *Montreal Star* 12 April 1969.

——. "Sarah Robertson." *Montreal Star* 23 February 1952.

——. "Significant Exhibition at Toronto by Diligent Canadian Group of Painters." Montreal *Standard* 19 November 1939.

Blanchard, Paula. *The Life of Emily Carr*. Vancouver: Douglas & McIntyre, 1987.

Braide, Janet. *Anne Savage: Her Expression of Beauty*. Exhibition catalogue. Montreal: Montreal Museum of Fine Arts, 1979.

Brooke, Janet. *Discerning Tastes: Montreal Collectors, 1880-1920*. Exhibition catalogue. Montreal: Montreal Museum of Fine Arts, 1989.

Burgoyne, St. George. "W. Scott & Sons leaving Business as Art Dealers in Firm's 80th year." Montreal *Gazette* 4 March 1939.

Calvin, Arthur. "Anne Savage, Teacher." Unpub. M.A. thesis, Sir George Williams University, 1967.

"Canadian Women in the Public Eye: Lilias Torrance Newton." *Saturday Night* 12 November 1927.

Cherry, Deborah. *Painting Women: Victorian Women Artists*. London: Routledge, 1993.

Conde, Valerie. "New Art Exhibition." *Windsor Daily Star* 3 February 1945.

Constable, W.G. "Artists of the Empire." *The Listener* 5 May 1937.

Cook, Ramsay. *Canada, Quebec, and the Uses of Nationalism*. 2nd ed. Toronto: McClelland & Stewart, 1995.

Davis, Ann. "The Wembley Controversy in Canadian Art." *Canadian Historical Review* 54/1 (1973): 48-74.

De La Lune, Jean. "Sarah Robertson." *Le Droit* (Ottawa) 6 November 1951.

Dignam, Mary Ella. "Canadian Women in the Development of Art." *Women of Canada, Their Life and Work*. Ed. National Council of Women of Canada. 1900; rpt. N.p.: NCWC, 1975. 209-15.

"Distaff Side Active in Art." *Montreal Star* 17 March 1952.

Duval, Paul. "Montreal Artists Establishing New Landmarks in Canadian Art." *Saturday Night* 10 November 1945.

——. "Prudence Heward Show." *Saturday Night* 24 April 1948.

Farr, Dorothy. *Lilias Torrance Newton, 1896-1980*. Exhibition catalogue. Kingston, Ont.: Agnes Etherington Art Centre, 1981.

——, and Natalie Luckyj. *From Women's Eyes:Women Painters in Canada*. Exhibition catalogue. Kingston, Ont.: Agnes Etherington Art Centre, 1975.

First Annual Loan and Sale Exhibition of the Newspaper Artists' Association. Exhibition catalogue. Montreal: Art Association of Montreal, 1903.

"Foremost CanadianWoman ArtistVisits City on FirstTripWest." *Lethbridge Herald* 30 August 1946.

Foss, Brian. "Molly Lamb Bobak: Art andWar." *Molly Lamb Bobak: A Retrospective*. Exhibition catalogue. Cindy Richmond. Regina, Sask.: MacKenzie Art Gallery, 1993. 93-116.

Haskins, HeatherVincent. "Bending the Rules:The Montreal Branch of the Woman's Art Association of Canada, 1894-1900." Unpub. M.A. thesis, Concordia University, 1995.

Hicks, Laureen. "Well Known Art Teacher Retires after 45 Years." *Montreal Star* 26 October 1962.

Hill, Charles. *Canadian Painting in theThirties*. Exhibition catalogue. Ottawa: National Gallery of Canada, 1975.

——. *The Group of Seven: Art for a Nation*. Exhibition catalogue. Ottawa: National Gallery of Canada, 1995.

Holgate, Edwin. "Prudence Heward." *Canadian Art* IV/4 (Summer 1947): 160-61.

Housser, Frederick. "The Amateur Movement in Canadian Painting." *The Yearbook of the Arts in Canada,1928-29*. Ed. Bertram Brooker. Toronto: Macmillan, 1929. 83-90.

Huneault, Kristina. "Heroes of a Different Sort: Gender and Patriotism in the War Workers of Frances Loring and Florence Wyle." *Journal of Canadian Art History* XV/2 (1993): 26-45.

Jackson. A.Y. *A Painter's Country: The Autobiography of A.Y. Jackson*. Toronto: Clarke, Irwin, 1958.

——. Introduction. *Prudence Heward Memorial Exhibition*. Ottawa: National Gallery of Canada, 1948.

——. Introduction. *Sarah Robertson Memorial Exhibition*. Ottawa, National Gallery of Canada, 1951.

Kingston Conference Proceedings. 1941. Kingston, Ont.: Agnes Etherington Art Centre, 1991.

Laberge, Albert (unsigned). "Des Artistes qui Affirment de Beaux Dons." *La Presse* 21 January 1922.

———. (unsigned). "Une visite à l'exposition de peintures." *La Presse* 22 March 1922.

Lacroix, Laurier, et al. *Peindre à Montréal, 1915-1930: Les peintres de la Montée Saint-Michel et leurs contemporains.* Exhibition catalogue. Québec: Musée du Québec et Galerie de l'UQAM, 1996.

Lemerise, Suzanne and Leah Sherman. "Cultural Factors in Art Education History: A Study of English and French Quebec, 1940-1980." *Framing the Past: Essays on Art Education.* Ed. Donald Soucy and Marianne Stankiewicz. Restan, Virginia: National Art Education Association, 1990. 183-98.

Lismer, Arthur. "Works by Three Canadian Women." *Montreal Star* 9 May 1934.

Luckyj, Natalie. *Expressions of Will: The Art of Prudence Heward.* Exhibition catalogue. Kingston, Ont.: Agnes Etherington Art Centre, 1986.

———. *Visions and Victories: 10 Canadian Women Artists, 1919-1945.* Exhibition catalogue. London, Ont.: London Regional Art Gallery, 1983.

Lyman, John. "Art." *The Montrealer* 1 February 1938.

———."Borduas and the Contemporary Arts Society." *Paul-Émile Borduas 1905-1960.* Exhibition catalogue. Ed. Evan Turner. Montreal: Montreal Museum of Fine Arts, 1962. 40-41.

———. *Inédits de John Lyman.* Ed. Hedwige Asselin. Montreal: Bibliothèque Nationale du Québec, 1980.

MacDonald, Colin S. *Dictionary of Canadian Artists.* 7 vols. Ottawa: 1967-90.

McCullough, Norah. Exhibition catalogue. *The Beaver Hall Hill Group.* Ottawa: National Gallery of Canada, 1966.

McDougall, Anne. *Anne Savage: The Story of a Canadian Painter.* Montreal: Harvest House, 1977.

McInnes, Graham Campbell. "World of Art," *Saturday Night* 4 December 1937.

———. "Upswing in Art has Come?" *Saturday Night* 4 November 1939.

McIntosh, Terresa. *Other Images of War: Canadian Women War Artists of the First and Second World Wars.* Ottawa: Carleton University, 1990.

McMann, Evelyn de R. *Montreal Museum of Fine Arts, Formerly Art Association of Montreal, Spring Exhibitions, 1880-1970.* Toronto: University of Toronto Press, 1988.

———. *Royal Canadian Academy of Arts / Académie Royale des Arts du Canada: Exhibitions and Members, 1880-1979.* Toronto: University of Toronto Press, 1981.

"Memorial Exhibition at National Gallery." *Ottawa Citizen* 5 March 1948.

Millar, Joyce. "The Beaver Hall Group: Painting in Montreal, 1920-1940." *Woman's Art Journal* 13/1 (1992): 3-9.

Morgan-Powell, S. "Art Association Exhibition Shows Notable Advance." *Montreal Star* 20 November 1913.

——. "Forty-Ninth Annual RCA Exhibition at Art Galleries Here." *Montreal Star* 25 November 1927.

——. "Spring Exhibition at Art Galleries Is an Indifferent Show." *Montreal Star* 7 April 1926.

Page, Anne Mandely. "Canada's First Professional Women Painters, 1890-1914: Their Reception in Canadian Writing on the Visual Arts." Unpub. M.A. Thesis, Concordia University, 1991.

Parker, Rozsika and Griselda Pollock. *Old Mistresses: Women, Art and Ideology*. London: Pandora Press, 1981.

Pfeiffer, Dorothy. "At the Arts Club." Montreal *Gazette* 3 March 1962.

"Pictures Shown at Spring Exhibition of the Art Gallery Reach a High Level." *Montreal Star* 15 March 1912.

Pollock, Griselda. *Vision and Difference: Femininity, Feminism and the Histories of Art*. London: Routledge, 1988.

Press Comments on the Canadian Section of Fine Arts, British Empire Exhibition, 1924-1925. Ottawa: National Gallery of Canada, n.d.

"Public Profession of Artistic Faith: Nineteen Painters Represented in 'Beaver Hall Group's' Exhibition." Montreal *Gazette* 18 January 1921.

Read, Herbert. "At the Tate Gallery." *The Listener* 27 October 1938.

Reid, Dennis. *A Concise History of Canadian Painting*. 2nd ed. Toronto: Oxford University Press, 1988.

Reynald, "Femmes-peintres dont l'art est viril." *La Presse* 9 February 1933.

Rider, Wini. "Portrait of the Artist as an Expression of Joy." Montreal *Gazette* 16 June 1976.

Robertson, Heather. *A Terrible Beauty: The Art of Canada at War*. Toronto: James Lorimer, 1977.

Sherman, Leah. "Anne Savage: A Study of Her Development as an Artist/Teacher in the Canadian Art World, 1925-1950." *Histories of Art and Design Education*. Ed. David Thistlewood. Longman Group, U.K., 1992. 142-151.

Sisler, Rebecca. *Passionate Spirits: A History of the Royal Canadian Academy of Art, 1880-1980*. Toronto: Clarke, Irwin, 1980.

Smith, Frances K. *Kathleen Moir Morris*. Exhibition catalogue. Kingston, Ont.: Agnes Etherington Art Centre, 1983.

Tippett, Maria. *Art at the Service of War: Canada, Art and the Great War*. Toronto: University of Toronto Press, 1984.

——. *By a Lady: Celebrating Three Centuries of Art by Canadian Women*. Toronto: Viking, 1992.

Trépanier, Esther. "Modernité et conscience sociale: La critique d'art progressiste des années trente." *JCAH* VIII/1 (1984): 80-109.

——. Rev. of *Les Esthétiques Modernes au Québec de 1916 à 1946*, by Jean-René Ostiguy. *JCAH* VI/2 (1982): 232-39.

——. "A Tribute to Marian Dale Scott, 1906-1993." *JCAH* XV/2 (1993):85-92.

Index

volunteer work 152; war artists
155; women as war artists 155-56;
as subject of art: 156-57
Seiden, Regina 62, 93
Separate spheres 26
Sherman, Leah 56, 139, 140, 142,
145, 174
Smith, Jori 42, 118, 134
Southam, H.S. 113, 121, 158
Spinsterhood 80-81
Square Mile 22
Steinhouse, Tobie 171
Stevens, Dorothy 119-20
Study School 15, 106-07, 114, 138-
39, 140, 145-46, 174

Tippett, Maria 18, 35
Torrance, Alice Stewart 26
Torrance, Forbes 26, 36, 96
Trafalgar School 29, 81, 107, 146-47
Traill, Catharine Parr, 35

Underhill, Frank 118, 124

Van Gogh, Vincent 82, 124
Van Kirk, Lilias Savage 29, 31

Wales, Shirley 146
Walter Klinkhoff Gallery 15, 18, 172
War *see* First World War, Second
World War
Watson, William R. 57
Wembley, British Empire Exhibition
16, 68, 69, 71
Wembley controversy 68, 71
Willingdon Arts Competition 79
Woman's Christian Temperance
Union (WCTU) 27, 28
Women artists: early Canadian 32-35;
French-speaking: 35-36, 78; as
professionals 16, 32, 66-67
Women's Art Association of Canada

(WAAC) 33, 78
Women's Art Society (Montreal) 33-
34, 64
Women's education 29, 31
Women's suffrage 28, 72
Women's voluntary societies 25-26,
49
Wonish, Lake 25, 53, 89, 125-26,
172
Wood, Elizabeth Wynn 71, 124
Woolf, Virginia 81-82
Works Progress Administration
(WPA) 113, 154
Wyle, Florence 64, 78

Young Women's Christian Association
(YWCA) 27, 28, 49